emotional_digital

West I									
	Service	86.							
	CA AMPUS	See To							
		EMO							
LANGLEY ROAD WATFORD HERTS WD17 4YH									
	TEL 01923 812250	4060123							
Return on or before the last date stpou bolow.									
		×							

emotional_digital

A Sourcebook of Contemporary Typographics

Edited by
Alexander Branczyk
Jutta Nachtwey
Heike Nehl
Sibylle Schlaich
Jürgen Siebert

Any copy of this book issued by the publisher as a paperback is sold subject to the condition that it shall not by way of trade or otherwise be lent, resold, hired out or otherwise circulated without the publisher's prior consent in any form of binding or cover other than that in which it is published and without a similar condition including these words being imposed on a subsequent purchaser.

First published in the United Kingdom in 1999 by Thames & Hudson Ltd, 181A High Holborn, London WC1V 7QX

First published in the United States of America in hardcover in 1999 by Thames & Hudson Inc., 500 Fifth Avenue, New York, New York 10110

First paperback edition 2001

© 1999 Verlag Hermann Schmidt Mainz

All Rights Reserved. No part of this publication may be reproduced or transmitted in any form or by any means, electronic or mechanical, including photocopy, recording or any other information storage and retrieval system, without prior permission in writing from the publisher.

British Library Cataloguing-in-Publication Data

A catalogue record for this book is available
from the British Library

Library of Congress
Card Catalog Number 99-70866

ISBN 0-500-28310-9

Printed and bound in Singapore

_Contents

Jürgen Siebert: More is more _6

Erik Spiekermann: Font advertising _12

2Rebels_16
Adobe_20
Agfa Typographic Systems _24
Apply Design Group _28
Bitstream_32
brass_fonts_34
Command (Z) _36
Creative Alliance_42

Alessio Leonardi: Letters are actors_44

Device _46
Dutch Design _58
Dutch Type Library _60
Elliott Peter Earls _62
Elsner+Flake _72

Ian Swift:
Typo-matic_74

Emigre_76
Face2Face_88
Faith_98
fontBoy_102

Zusanna Licko: The Future of Bitmaps_106

The Font Bureau_110
FontFabrik_116
Fontology_120
FontShop International (FSI)_124
The Foundry_136

Erik van Blokland/Just van Rossum: RobotFonts_138

Garagefonts_140 garcia fonts&co. _148 House Industries _156 ITC_164 kametype _172

Rian Hughes: A Word from the Laboratory of the Visual_174

Alessio Leonardi _176 LetterPerfect _180 LettError _184 lineto _190 Linotype Library _196

Gerard Unger:
Make it yourself, sell it yourself_202

LUST _204
Monotype Typography _208
Optimo _212
Dennis Ortiz-Lopez _216
ParaType _220
Porchez Typofonderie _224
Fabrizio Schiavi Design _232

Michael Horsham: Dot Gain or The Endless Repetition of Dot_236

Stone Type Foundry _240
Judith Sutcliffe:
The Electric Typographer _242
[T-26] _244
Thirstype _254
Type-Ø-Tones _262
Typerware Font Foundry _272

Günter Gerhard Lange: Typotheses _278

Typomatic_280
Gerard Unger_286
Frank Heine, U.O.R.G._290
(URW)++_296
Virus_300

Addresses_304

Type designers _308

Fonts _310

__More is more

Jürgen Siebert

People who work with fonts are often confronted with the old design principle

- 'less is more'. Many a time, we've heard old-school typographers claim,
- 'I have never used more than the same three type families in my work'.

'I have never used more than the same three

This is a commendable limitation that can make life easier. But look at the vast selection of type available internationally and you'll see that the less-is-more approach no longer holds true. Every day new fonts and foundries spring up from the soil like mushrooms.

Today it is easier than ever before to produce and distribute fonts independently. All you need is a computer and the proper software, and you're in business. The Internet promotes this trend: our Web browser, for example, contains over five hundred bookmarks detailing original typeface manufacturers. We have to condense them into alphabetically sorted submenus just to keep sight of them all.

When asked by a journalist why so many typefaces exist, Adrian Frutiger, whose international reputation was made with the creation of Univers typeface (1957), responded with a question of his own, 'Why are there so many wines?'. There is no justification for complaining about the constantly expanding selection. You can never have too much choice.

Why are there so many wines?'

The font market has been in turmoil for over ten years. A font-designing application called Altsys (now Macromedia) Fontographer first enabled type users, i.e., graphic designers and layout artists, to digitally produce fonts themselves. Things that previously could only be done with punchcutter and hot-metal compositors, or that required filmsetting equipment costing millions, suddenly became possible for everyone to do – it was a revolution.

This revolution spread like a Marxist uprising, with mottoes such as 'Wipe out the ruling class!', 'Take back the means of production!', 'Destroy what is destroying you!'. Many took these mottoes literally. 'Holy' type, protected for centuries under the quasi-religious cloak of an élite circle, is

now bent and distorted and sometimes even ruined by the power of the mouse attached to a computer. Anything goes. The rules of typography are melting away like snow in the spring.

Every revolution causes heads to roll. Traditionalists, in particular, soon end up in history's junkyard. Leading typesetter companies and large type manufacturers, such as Compugraphic, Scangraphic or Letraset, slowly disappeared from the screen, or monitor. The names of big font libraries, such as Berthold or Monotype, may live on, but they are now pawns in the hands of the young group of experimental typographers who have provided new models for many graphic designers: Neville Brody, David Carson, Erik van Blokland, Just van Rossum, Max Kisman, Rian Hughes, Jonathan Hoefler and Zuzana Licko.

www.emodigi.de

a short time.

cards, type specimen books and much more. We selected the material accor-

ding to the originality of the artwork

and to the important status that

some of the fonts have achieved in

Special than<u>ks</u>

Ingo Krepinsky

André Ringel

Diana Simon

Annette Wüsthoff

Thomas Nagel

Uwe Otto

Heidi Specker

Bertram Schmidt-Friderichs

Brigitte Raab

Louise Wood

Catherine Hall

These adventising modic not only not

These advertising media not only reflect market trends as authentically as possible, they reveal a variety of cultural groups and provide communication designers with a broad spectrum of ideas for their everyday work. They are not just any old application examples; in many cases, the type designers themselves made them to show each font's unique perspective – that of the designer.

emotional_digital is a snapshot of the current state of typography: it provides an overview of the international type scene; it gives information about the designers and foundries; and serves as a history book and future-oriented reference work in one.

Many of the fonts shown here will be with us for many years in advertising, books, magazines and on the Internet. The producers of fonts are ahead of their times. They have an instinct for predicting the coming trends in visual communication.

_Font advertising

Erik Spiekermann

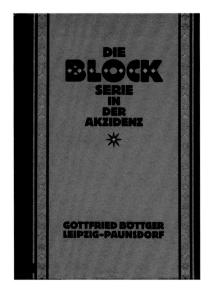

Berthold specimen no. 206, 1926 Designed for the Block family, with the imprint by Gottfried Böttger, Leipzig.

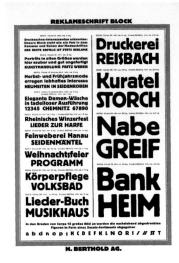

Reklameschrift (display typeface) Block was first published by the Berlin foundry H. Berthold in 1908. It was extended into a series of ten weights until 1929.

Typefaces have always been commercial products, designed and produced for a specific market. There's no point in a type designer spending hundreds of hours drawing a new alphabet, which then sits on his desk with nowhere to go. Today, designing a trendy face may not require as much work as it used to and the result may consist of data, not drawings, but the public still needs to be told about the new typeface: what it looks like and how to use it.

Typographic advertising, therefore, is not a new invention, but is as old as the craft of type founding. The earliest known example is a specimen by Konrad Berner, a type founder from Frankfurt, published in 1592. The text (in very quaint Old German) says something like 'Specimen and print of the most noble and very best typefaces ever seen, produced with great care and at large expense...' Praise of this kind makes today's advertising slogans sound modest in comparison.

Well into the eighteenth century type foundries used broadsheets like Berner's to announce new faces. When they had to show large type families, they were folded into brochures with several pages. The most famous specimen book, in my opinion, must be Giambattista Bodoni's Manuale Tipografico, published by his widow in Parma in 1818. I am the lucky owner of a complete reprint.

Now and again I come across original letterpress type specimens, mainly dating to the beginning of this century. They are very popular among typomaniacs - where else would they find an alphabet displayed in all sizes, with an almost complete showing of characters? Essentially, these are nothing more than technical data sheets, but can any other industry claim to have such exquisitely designed and good-looking material? The most beautiful examples don't just show complete character sets in all the available sizes, but actually display each type in use. The type foundries' in-house print shops pulled out all the stops when it came to colour printing and graphic design.

The 1970s saw more typefaces appear for various photosetting systems than ever before. Again, competition between type manufacturers provided users with professionally designed specimens, which today serve as perfect reminders of design styles and fashions. At MetaDesign, we developed a concept for Berthold's Exklusiv Probes, as they were called, each of which was dedicated to a family and designed by a different designer.

At that time fonts cost ten times as much as they do today and only worked on one manufacturer's system. As these systems also cost ten times as much as they do today, expensive specimens were worth the investment. In 1989 Agfa paid for journalists and opinion-makers to fly to Paris for the introduction of their latest typeface, Rotis! No type house can afford that sort of lavish performance any more.

The tradition of type specimens, however, still exists, albeit on a more modest scale. The democratization of font manufacturing has actually created many more varied and interesting methods of introducing new typefaces. In the age of multimedia, there are hardly any objects that can't be covered in type: T-shirts, postcards, beer mats and packaging, not to mention multimedia shows on CD-ROM and the Web. And there are still posters and brochures for freshly published typefaces.

This project, emotional_digital, by Alexander Branczyk, Jutta Nachtwey, Jürgen Siebert and the moniteurs has gathered new type specimens from around the world. For me, browsing through this collection sometimes feels like meeting almost forgotten friends, discovering many new ones and affirming my suspicion that only time will tell what may become a classic.

What a friend we have in cheeses!

In 1979 Berthold published LoType, Erik Spiekermann's redesign of Louis Oppenheim's typeface dating to 1911. He also designed a sixteen-page specimen for the new face, which appeared as the first brochure in the Berthold Exklusiv series.

I had never seen many of these examples before and I had totally forgotten about others – as happens with a lot of advertising. Even some of the specimens I had been involved in myself, as a member of FSI FontShop International's typeboard, suddenly looked completely new and different in this context. Thanks to emotional_digital, examples of typographic advertising, which are too often short-lived, are kept alive. They are a good mirror of the times, past and present.

2Rebels

Location_Montreal, Canada

Established_1995

Founders_Denis Dulude, Fabrizio Gilardino

Type designers_Annie Bastien, Robert Beck, Marc Borgers
Christine Côté, Denis Dulude, Patrick Giasson
Fabrizio Gilardino, Marie-Frédérique Laberge-Milot
Anna Morelli, Clotilde Olyff, Martijn Oostra
Serge Pichii, Jean-François Rey, Marc Tassell
Michel Valois and others

Distributors_2Rebels, FontShop International (FSI), FontHaus Faces, MindCandy, [T-26]

Dirty, blurry, scratched up and cut through, 2Rebels' designs are edgy

Fabrizio Gilardino left Milan in 1990 and emigrated to Montreal. He had completed a traditional design training programme, but did not know how to work a computer. Consequently, he chose to explore the experimental music scene, write articles and work in radio, during which time, however, he became computer literate and took up design again.

It was in Montreal that he met and collaborated with Denis Dulude, who had worked in various ballet ensembles before starting a second career as a designer. Under the name 2Rebels, they published their first font catalogue in 1995: a brochure, stapled together by hand, showing twenty fonts that they had designed using everyday items as starting points. The collection has now grown to contain more than one hundred fonts by twenty-two type designers. Caught between the classical and the chaotic – and just on the cusp of legibility – their irreverent fonts fly in the face of tradition. Denis Dulude and Fabrizio Gilardino have also worked together for certain customers as graphic designers under the name 2Rebels. Each also has his own studio for graphic design: Gilardino Design and K.O. Creation.

Stupid game 1 and 2, 1997 13 x 7.5 cm Both games were included in a font kit with four fonts and four posters.

Design: 2Rebels Type design: Marie-F. Laberge-Milot _Fred

CUTY

abcdefghijklmn oparstuvwxyz **ABCDEFGHIJKLMN OPORSTUVWXYZ** 1234567890 ?!#\$¢£%&(@)[©]{®}™ ÆŒæœ+ÀĒĨÕÛC. ":àeïoûç;...

> Font catalogue, 1996 18 x 12.5 cm

Design: 2Rebels Type design: Denis Dulude _2Rebels Un

_2Rebels Deux

_Cuty

_PlasticMan

_ThinMan

_Menace

Anna Morelli _Gonza Family

_Manomessa

Fabrizio Gilardino _Non Linear

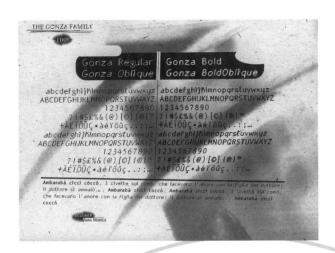

lettres

Parce que dans notre civilirative moderne la lattre tend, de plus en plus, à redevenir image. Abbéle et là pour rappeler qu'en typographia, comme en morique, il u'y a pus que la cherique. Notre doppes et ginératiric de styles auveraux et deur l'autivers inajures en nouvement de la typographia. Zabelh e aus approche subvervive : elle cret de fontes qui outrat des senties battre, parient un mode et l'orant le message. Des fontes qui fontes de senties va l'autivers, qui mirquet et qui impressionent. Des fontes qui chantes, c'illent, c'intet, abbels et la pour l'autivers. Les lattres-images investionent et vampirient. Les lattres-images investionent et vampirent. Les lattres-images investionent parties de l'appear de l'a

rappeler que la révolution typographique

Diskette Sleeve, 1997 9 x 9.5 cm The background fonts are derived from a street sign in Montreal.

> Design: 2Rebels Type design: Fabrizio Gilardino _Scritto

Promotional card for 2Rebels' Fonts at [T-26] 12 x 12 cm

Design: 2Rebels
Type design: Denis Dulude _2Rebels Un
_Nameless
Patrick Giasson _Proton

Font catalogue, 1997 14 x 29.5 cm Design: 2Rebels Type design: Clotilde Olyff _Perles Denis Dulude _K.O. dirty Marie-F. Laberge-Milot _Fred

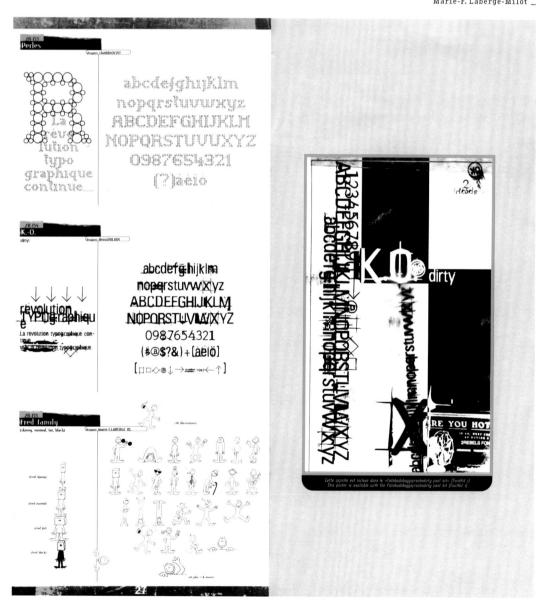

Font catalogue, 1997
14 x 29.5 cm

Design: Marie-F. Laberge-Milot
Annie Bastien
Type design: Marie-F. Laberge-Milot _Fred
Annie Bastien _Sofa
_ScratchNsniff
_SemiSans

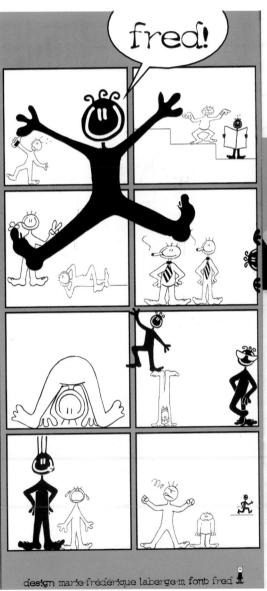

ABCDEFGHIJKLMNOPORSTUVWXYZ

ABCDEFGHIJKLMNOPQRSTUVWXYZ

abcdefghijklmnopqrstuvwxyz

Type design: Richard Lipton, 1997 _Bickham Script
Joachim Müller-Lancé, 1997 _Flood

Julian Waters, 1997 _Waters Titling Tim Donaldson, 1998 _Postino Robert Slimbach, 1996 _Kepler

abcdefghijklmnc

Adobe

Location_San Jose, California, USA Established_1982

Founders_John Warnock, Chuck Geschke

Type designers_Richard Lipton, Robert Slimbach

Mark Jamra, Tim Donaldson, Julian Waters

Joachim Müller-Lancé, David Siegel, Jim Wasco

Jovica Veljović, Carol Twombly and many more

Distributors_Adobe, FontShop International (FSI)
Elsner+Flake and others

Adobe's goal is to help people effectively use computers to create, assemble and deliver information

Adobe started the desktop publishing revolution in the mid-1980s with the PostScript page-description language, a mathematical computer description that determines the appearance of a page, including such elements as text, graphics and scanned images to a printer or other output device. All Adobe fonts are available in Type 1, the outline font format invented by Adobe that is a key component of the PostScript language. By bringing high-quality, scaleable type to desktop-computer users, Adobe Type 1 fonts have made it less expensive and more efficient to create professional-looking documents.

The most prestigious type foundries in the world produce fonts in the Type I format and license their typeface designs to Adobe. Now, with more than 2400 typefaces from internationally renowned foundries such as Agfa, Berthold, ITC, Linotype Library and Monotype, as well as sixty-seven Adobe original designs, the Adobe Type Library offers one of the largest collections of superlative type in the world.

Minion

stuvwxyz

Brochures for Adobe Jenson, Tekton, Ex Ponto, Myriad, 1991-96 10 pages 14.5 x 22.8 cm

Design: Fred Brady Robert Slimbach, Min Wang James Young, Laurie Szujewska Type design: Robert Slimbach _Adobe Jenson

Jovica Veljović _Ex Ponto Carol Twombly, Robert Slimbach _Myriad David Siegel, Jim Wasco _Tekton

TEKTON a two-axis multiple master typeface Detail taken from the Minion brochure, 1994 10 pages 14.5 x 22.8 cm Design: Min Wang Type design: Robert Slimbach _Minion 21 Throughout the process, the Adobe Originals team assisted with aesthetic commentary and technical advice, and provided inspiration during the difficult moments. Ex Ponto represents the process of combining my calligraphic and typographic experience. I found the transcription of handwriting into a digital typoface to be very challenging. My focus was to preserve the spontaneity and individuality of handwriting while creating a graphically balanced and captivating design.

vino kijem-bola bijem bola ispisnijem, ", duša koće s

abedefskyklningsonsturmyz

Veljović's writing studies for the typeface, including his notes. From many handwritten pages, he chose letterforms for further development into type characters.

ABCDEFGabcdefghijklm ABCDEFGabcdefghijklm

Top to bottom. Legende, designed by Ernst Schneidler in 1937; Reiner Script, designed by Intre Reiner in 1951; Codex-Kursiv, designed by Oddrich Menhart in 1930. Says Veljović: "Some of the script typefaces I admire were done by the 20th century designers Intre Reiner, Ernst Schneidler and Oddrich Menhart. They practiced other graphic disciplines alongide type design, such as calligraphy, illustration, painting, wood engraving and etching. Each art influences the other, and this is reflected in their type designs."

Ex Ponto has an alternating rough and smooth outer contour, reflecting what actually happen to pen strokes on rough paper. To produce this rough edge on the computer, vehyoive fanced hundreds of Beite routins strategically on each character of the typeface. The Z, for example, has 95 Bézier elements defining its contour, including both curves und straight life.

Pages from the Ex Ponto brochure, 1995 14.5 x 22.8 cm

Design: James Young Type design: Jovica Veljović _Ex Ponto A set of primary fonts is supplied with each multiple master typeface, and comprises a complete, ready-to-use typeface family. In addition to the custom fonts that can be generated along the weight and width axes, Myriad and Myriad Italic each include the fifteen pre-built primary fonts highlighted below. Primary fonts are named according to their position along each axis in the typeface. Myriad's weight and width axes have been assigned a specific numerical range within an overall range of 1 to 999; other multiple master typefaces will have different numerical ranges depending on their relative weight and width. See the Adobe Multiple Master User Guide for detailed information on multiple master font names.

tangible	tangible
tangible	tangible

angible angible angible angible angible angible angible angible angible

tangible tangible

tangible tangible tangible tangible tangible tangible tangible tangible tangible tangible tangible

tangible

tangible

tangible tangible

tangible tangible tangible tangible tangible tangible tangible tangible tangible tangible tangible tangible tangible

tangible tangible tangible tangible tangible tangible tangible tangible tangible tangible tangible tangible tangible

tangible tangible tangible tangible tangible tangible tangible tangible tangible tangible tangible tangible tangible

Metro-North Commuter Railroad CASH FARE RECEIPT

FORM C-9

		F	PASSEN	IGER'S	RECEI	PT		
TI	CKET N	10.	26440	5074	BETW	EEN		TIONS HDSN
DATE OF ISSUE		QUINS	QUINSBORD 125th					
JAN		MAR	£ 3	s ak	11	:	2	2
APR	MAY	JUN	Metro-North Commuter Railroad COMDUCTOR'S TRAIN TICKET. This receipt must be purched before it is separated and this	unia greetio (postistigati, recepti a storievo pira transsa, unautus prantos prantos nove entreta Plaunia frija os Specials Y aftrough TV. Receptip punched Volf Pearl Y in at good on pearl hour trains marked in public time tables, Monday to Friday inclusive. Good on all trains Saturiays, Sundays and Holidays, Subject to Tariff Regulations.	12	-	3	3
JUL	AUG	SEP	separa	not go	12	-		
ост	NOV	DEC	Dad	eak" is sive. G	13	4	4	4
1	2	3	ilre	roff P y inclu ations.	14	!	5	5
4	5	6	r Re	unchec to Fride Regul	15		5	6
7	8	9	ute	ceipt p onday o Tarif	13		_	
10	11	12	Commuter Railroad This receipt must be punched before it is	D. Re bles, M	16	1	7	7
13	14	15	Con	uning green to passenger, neepen to non-wood groen brees, communing Planut fairy' or Specials "4" through "1". Receipt punched "O'lf in hour trains marked in public time tables, Monday to Friday incl Saturdays, Sundays and Holidays. Subject to Tariff Regulation	17	1	В	8
16	17	18	the TICKET.	s "A" the public and Holic	18	-	0	9
19	20	21	Nor	Special Special rked in days an	10	-	,	7
22	23	24	TOR'S	n to po frip" or ins mai rs, Sum	19 SAME			
25	26	27	Met	all give Sound 7 our trai aturday	20	2	ZO	NE
28	29	30	á	24.5%	Emming	gton	Prur	nesquare
31			9		51 Delphi	Tr	avis	31 Lockspur
SPECIALS			43	1	42	41		
A			18 P	EN	NSFER	OB		
			В			E IX	AL	_
		6	c	di consedit	1			2
D			\$30.00	\$2	0.00	\$10.00		
COMMENTS			\$9.00	\$	8.00	\$7.00		
			\$6.00	5	5.00	\$4.00		
				\$3.00	5	2.00	\$1.00	
ROUND TRIP			\$1.75	5	1.50	\$1.25		
FAMILY FAIR			.75		.50	.25		
S	PECIAL SCOUNT		Additional Collection	Child				Off Peak

Pages from the Myriad brochure, 1991 14.5 x 22.8 cm Design: Laurie Szujewska Type design: Carol Twombly

Robert Slimbach _Myriad

Leaflets, 1996
23 x 38 cm (unfolded)

Design: Jean-François Porchez
Type design: Olivier Nineuil _Comedia
Franck Jalleau _Virgile
Albert Boton _Scherzo
Thierry Puyfoulhoux _Cicéro

Agfa Typographic Systems

Location_Wilmington, Massachusetts, USA

Established 1982

Founder_The Compugraphic Type Group

Type designers_Otl Aicher, Dave Farey, Carolyn Gibbs
Cynthia Hollandsworth, John Hudson
Franck Jalleau, Richard Lipton
Christian Schwartz, Pierre di Sciullo
and many more

Distributors_Agfa, Monotype Typography, FontShop International (FSI), FontWorks, FontHaus

and many more

Agfa aims to become the most important supplier of design tools for professional graphic designers.

The type group at Agfa, now called Typographic Systems, was originally the type-drawing office and font production group at Compugraphic Corporation. Bill Garth, a former Photon employee, founded Compugraphic in 1968. Agfa purchased Compugraphic in the early 1980s and the group became Agfa Typographic Systems.

Agfa Typographic Systems is made up of two groups: the retail font group and the OEM (original equipment manufacturer) group. The retail group is in charge of the development, marketing and sales of fonts licensed to users worldwide. Agfa Direct, the Agfa Direct Commercial Website and the Creative Alliance (see p. 44) also fall within the distribution range of the retail font group. The OEM group is responsible for developing and marketing its products to companies such as Hewlett Packard, Microsoft, Xerox and Lexmark and comprises engineers and software developers, marketing personnel and sales representatives. Agfa is a leading supplier of OpenType technology components, designed to be an industry-standard portable document solution.

Booklet cover, 1995 18 x 18 cm

Design: Robin Farren
Type design: Lennart Hansson _Runa Serif, Medium,
Light, Italic

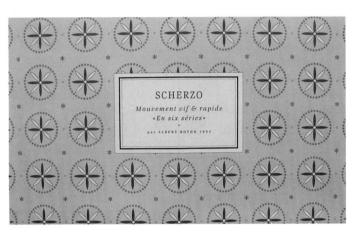

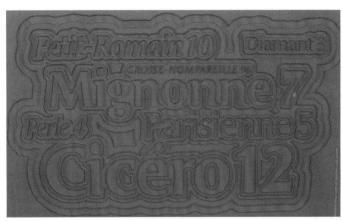

Booklet, 1995 22 pages 18 x 18 cm

Design: Robin Farren Type design: Franck Jalleau _Oxalis

Pierre di Sciullo _Le Gararond

Promotional poster for the Agfa, Icon and Type Series, 1997 28 x 64.5 cm The poster can be divided into twelve postcards.

Design: Robin Farren

Franck Jalleau

Parisin Franck Islieau has saudied typography and iettering design in France endoza § Stansias Mandel. Foday, he designs type and creates fronts for the french imprimeric Nationale and creates fronts for the french imprimeric Nationale and seather typography at the jet stitune. Mileau's Osalis family is an exciting new creation which is available exclusively through Agria

Oxalis has the grace and the flow of form that can only come from the callingsher's hand, but it never sacrifices werstallity and functionality for artistic expression. The result is a typeface that looks good 6, wears well. Oxalis is a lovely design which will add sparkle to a block of text copy or a display headline. Its affernate capitals also create a sportnarous, pen drawn quality not found in most sans serif faces. This page is set in Oxalis Regular 69 Medium.—both new Agfa Exclusives from Franck Jalleau.

An Agfa Exclusive

Pierre di Sciullo

teonoclast Rere di Schillo has been crating common designation with a taste for institutional cities and typographic. With a taste for institutional cities and very unusual projects, he pushes the envelope in experiments with graphic techniques. Thirry these year old di Schillo has developed several highly interpretus types faces, and he hap ublished a series of nine manuals which combine text and image, di Schillo's latest endeavor, le Gazarond, is an Agfa Evdusive.

Le Gararond is an irreverent homage to the historic typeface Garamond. dl Sciullo has used the same proportions & structure as the classic face, but has designed le Gararond with all

Le Gararo

Apphale Black Condensed, Cralia Regular, and le Garanond—all Ayla Exclusives . An Ayla Exclusive

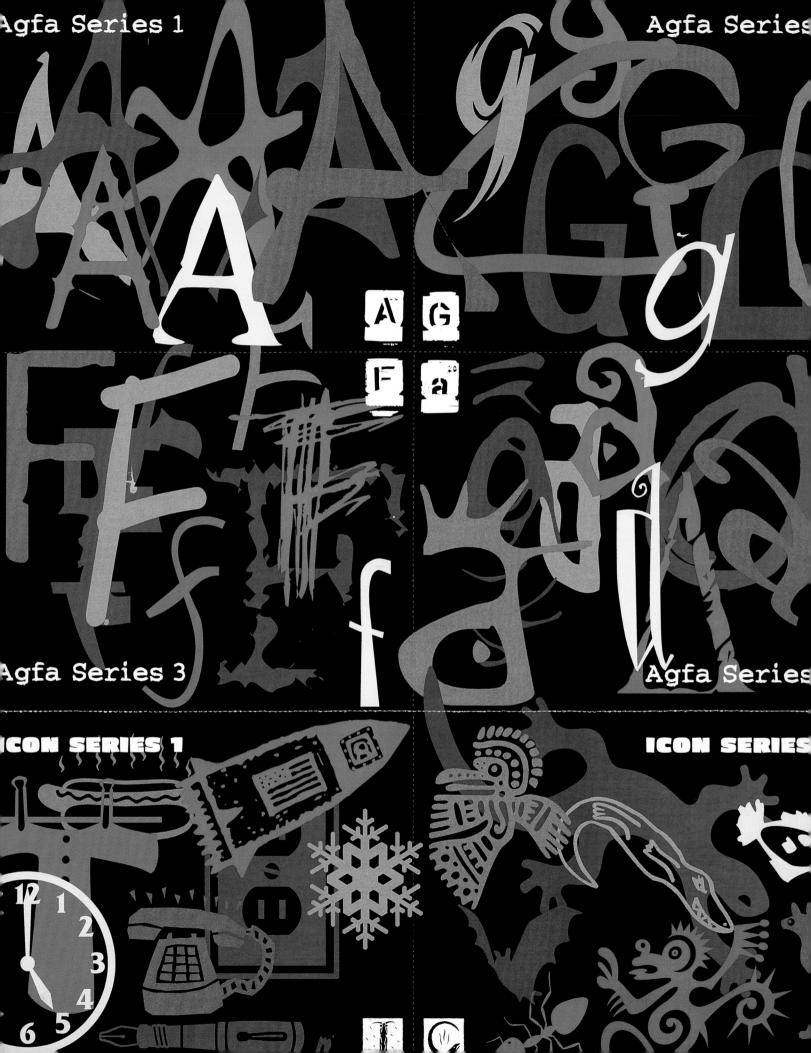

Type design: Yanek Iontef, 1997 _CaseSeraSera

Don Synstelien, 1998 _Nurse Ratchet

Harald Oehlerking, 1996 _Aspera

Apply Design Group

Location_Hanover, Germany

Established 1989

Founder_Thomas Sokolowski

Type designers_Steven Boss, Jens Gehlhaar, Yanek Iontef Catinka Keul, Manfred Klein, Alexander Koch Carlo Krüger, Harald Oehlerking, Alfred Smeets Thomas Sokolowski, Don Synstelien

Christian Terbeck, Antje Wolf and others Distributors_FontHaus, EF fontinform [Germany]

Form follows fun

In the early 1990s Apply Design Group became known as an independent font label producing cutting-edge typefaces. Twenty type designers have so far published more than one hundred fonts through Apply. In Germany the design group became well known through it's magazine Apply, even though many subscribers have been irritated by the magazine's irregular publications. The award-winning design magazine features Apply's latest font creations and other articles about design and the aesthetics of everyday life. Since most innovative typefaces have become mainstream and even typosaurs like Linotype and Letraset have discovered 'grunge' fonts, Apply designers have shifted their activities to the illustration and photo CD market.

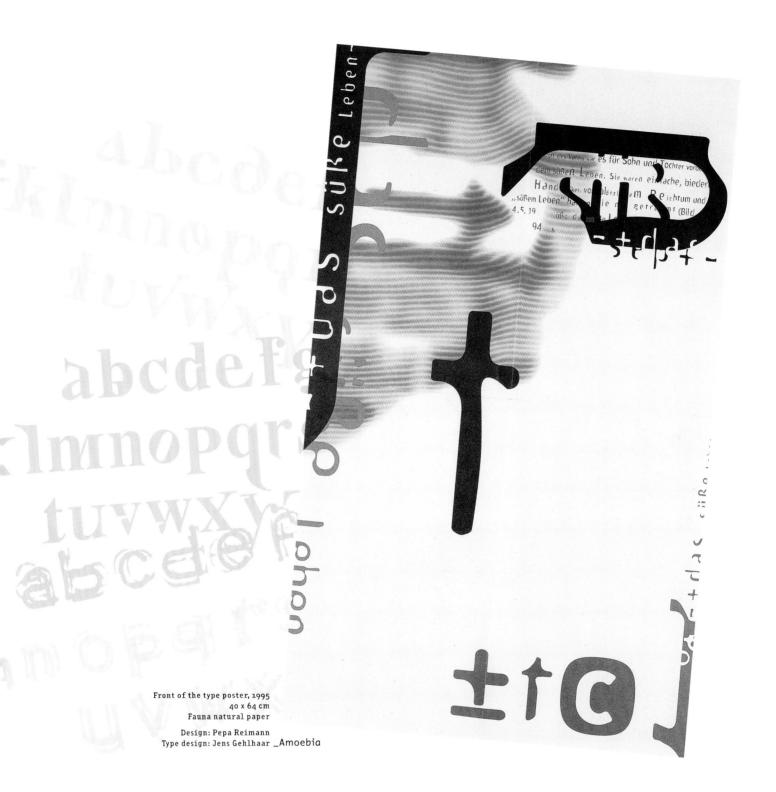

Specimen fan, 1994
9,9 x 21 cm
Fauna natural paper
The array includes sample cards
for a total of thirty-six fonts. The front
of each card presents a design example
and the back shows a complete
character set.

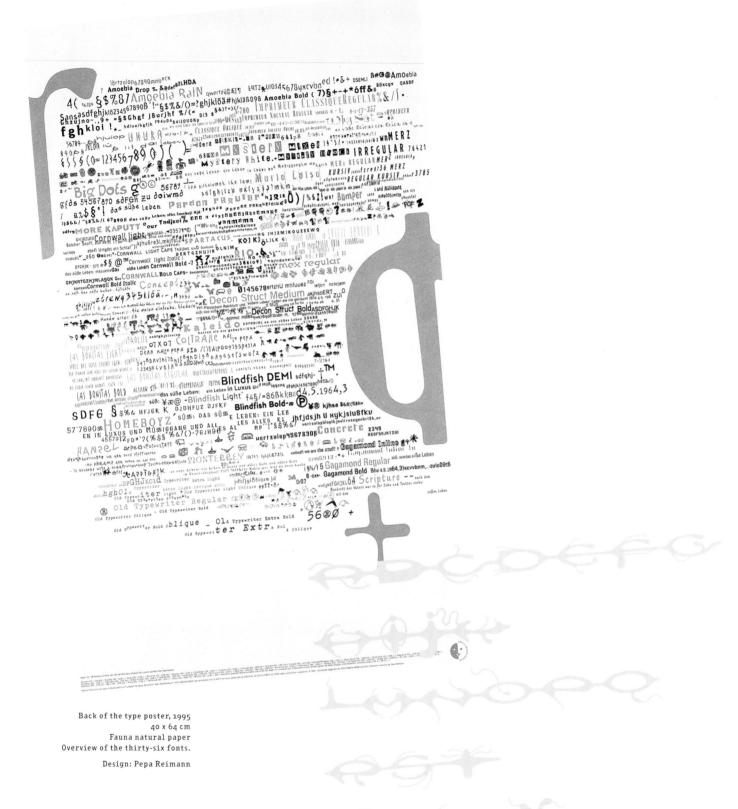

ABCDEFGHIJKLMNOPORSTUVWXYZ
abcdefghijklmnopqrstuvwxyz 1234567890
oÄAUÀÁĀÇËÉÈÊSSGÎÑĠĎHÒÔÕŒÜŰĬÄ
gäáàããaçëéèêfiffĭñĵJñşöóòôõœüűûûÿß uß ° e`KZ~RtM¬
("..;′"""»«!1?¿/-&†S¢£yf%)[...\sNB§stehj@rge]
8+=-}
β+τ↔0xæpl/zvM.D\\$2twl*m3ibwPnökz4d9

APPLY Digital Typefaces

Leise flüsterte sie mir in mein Ohr. Wie wohl ist mir ihre Nähe.

Oh, so süß Ihr Duft. Was gäb ich ihrer Treme mich hinzugeben.

Eine Berührung erzittert mein Herz – so erfüllt meine Seele mit Glück. Dienen werd ich, hofieren ihre Wünsche. Ihre Gedanken sind mir Ahnung. Erfahren wir, was Glückseligkeit bedeutet.

Gesamtübersicht

Digital font catalogue, 1995
The typographic information
has been transformed into a
digital application. Users select a
font from the main menu (above),
in this case Gagamond, and then
call up the character set and design
example. Another level contains
information about the font.
When activated, the application
example is displayed blurred in
the background.

Design: Carsten-Andres Werner Thomas Sokolowski Type design: Manfred Klein _DeconStruct Jens Gehlhaar _Gagamond

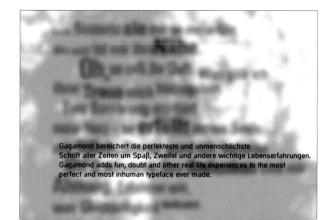

abcdefghijklmnopqrstu ABCDEFGHIJKLMNOP

The font Galaxy is based on the text of the <u>StarTrek</u> film, adapted for digital use.

> Type design: George Ryan Dave Robbins _Semaphore Mike Leary _Galaxy Frank Pendrell _Space

Bitstream

Location_Cambridge, Massachusetts, USA

Established_1981

Founders_Mike Parker, Matthew Carter Cheri Cone, Rob Freedman

Type designers_Matthew Carter, Denis Pasternak
Richard Lipton, Jackie Sakwa
Jim Lyles, George Ryan and many more

Distributors_Bitstream, FontShop International (FSI)
International FontBolaget, FontWorks
Elsner+Flake, Fontinform and many more

TypeShop Pro catalogue and CD-ROM, 1995
The CD-ROM contains the additions to
the Bitstream library, developed since the
release of the original TypeShop in 1994.
It includes nine new symbol/Pi fonts,
thirty-eight typographer sets, and thirtynine other faces that are either new and
original designs or additions to type
families already in the library.

Design: Andrew Joslin

Publish. Once and for all.

Bitstream was one of the world's first digital type foundries. Over the years the company's focus has expanded to include type rasterization and portability technology (TrueDoc™). Following the acquisition of Archetype in 1987, the company has developed an interest in page-composition technology (NuDoc™) and on-demand publishing servers (PageFlex™). Bitstream's philosophy blends creativity and innovation with high-quality production and service standards, within a company culture that promotes integrity and personal growth to meet the evolving needs of their customers in the graphics communication industry.

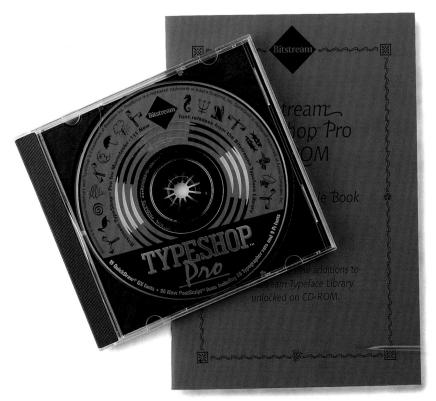

Pages from the <u>TypeShop Pro</u> catalogue, 1995

Design: Andrew Joslin

Alphabet Soup Tilt

ABCD37GHIKLMNOPQRSTUVWXYZ

ABCD37GHIKLMNOPQRSTUVWXYZ

1284557390 &\$?? GGĀŠNOŪSS

A new display typeface designed by the Bitstream type design staff. Note that using the shift key tilts the characters the other way.

Bitstream Chianti ™ 1 abcdefghijklnmopqrstuvwxyz ABCDEFGHIJKLMNOPQRSTUVWXYZ 1234567890 &\$?! ÇŒäéñôûß

abcdefghijklmnopqrstuvwxyz
ABCDEFGHIJKLMNOPQRSTUVWXYZ
1234567890 &\$?! CΊéñòûß

1212 abcdefghijklmnopqrstuvwxyz ABCDEFGHIJKLMNOPQRSTUVWXYZ 1234567890 &\$?! CΊéñòûß

abcdefghijklmnopqrstuvwxyz
ABCDEFGHIJKLMNOPQRSTUVWXYZ
1234567890 &\$?! CΊéñòûß

abcdefghijklmnopqrstuvwxyz
ABCDEFCHIJKLMNOPQRSTUVWXYZ
1234567890 &\$?! CΊéñòûß

abcdefghijklmnopqrstuvwxyz
ABCDEFGHIJKLMNOPQRSTUVWXYZ
1234567890 &\$?! ÇŒäéñôûß

Chianti is a new sanserif design by Dennis Pasternak drawn in 1991. The inspiration behind the face was to provide a sanserif of high readability at a wide range of sizes. See the "Typographer Sets" section for more information.

Galaxy

abcdefghijkInmopqrstuvwxyz ABCDEFGHIJKLMNOPQRSTUVWXYZ 1234567890 &\$?! ÇŒäéñòûß

Galaxy is a new display face by the Bitstream design staff.

Horizon

abcdefghijkInmopqretuvwxyz ABCDEFGHIJKLMNOPQRETUVWXYZ 1234567890 6671 C΀ÉñòûB

Horizon is a new display face by the Bitstream design staff.

Incised 901

degrafinijainmoparstuvwwyz Abgederghikkumnoparstuvwwyz 1234567390 &\$7! ÇCEĞĞÑÖÜB

This weight of Incised 901 (Bitstream's version of Antique Olive $^{\sim 15}$) rounds out the selection already in the Library.

Kuenstler 165

abcdelshúklnmopgrstuvvosyz
ABCDEFOHIJKLMNOPQRSTUVWXYZ
1234567890 &\$91 ÇQEséñöüß

abedefghijklnmopgrstuvwxyz ABCDEFGHIJKLMNOPQRSTUVWXYZ 1284567890 &\$?! CΊśñôûß

abcdefghíjkinmopqrstuvwxyz
ABCDEFGHIJKLMNOPQRSTUVWXYZ
1234567890 &\$?! ÇŒäéñòùß

During the first half of the 20th century, a group of german artists reworked the oldshife model with buches from the traditions of the German blackletter. The result is a mannered and seasily recognized skyle that we call Kuenstier. Kuenstier 165 is Bitstream's version of Koch's 1922 Koch Artique.

Revival 555 Cont'd

abcdefghijklnmopqrstuvwxyz ABCDEFGHIJKLMNOPQRSTUVWXYZ 1234567890 &\$?! ÇÆäéñòûß

abcdefghijklnmopqrstuwwxyz
ABCDEFGHIJKLMNOPQRSTUVWXYZ
1234567890 &\$?! CΊéñòûß

Revival 555 is Bitstream's version of Horley Old Style, "4 a 1920s oldstyle revival with shades of Jenson, Caslon and Goudy.

SnowCap™ 1
abcdefęhijklnmopqrstuvwxyz
ABCDEFGHIJKLMNOPDRSTUVWXYZ
1234567890 &\$?! (Œāēñôûß

SnowCap is a wintry display face with snow effects dropped onto Mister Earl. $^{\rm int}$

Sonic

 1248
 AACDEFGHIJKLAMOPDASTUVWXYZ

 AACDEFGHIJKLAMOPDASTUVWXYZ

 1234567890
 6\$?! ÇŒÄÉÄÖÛSS

Sonic Cut Through

ABCDEFGHIKLNMOPORSTUVWXYZ ABCDEFGHIKLMNOPORSTUVWXYZ 1234567890 6\$?! ÇŒÄÉÑÒÛSS

Sonic is a new display face by the Bitstream design staff.

Space

ABCDEFGHIJKLNMOPQRSTUVWXYZ
ABCDEFGHIJKLMNOPQRSTUVWXYZ
1234567890 &\$?! ÇŒÄÉÑÕŮß

Space is a new display face by the Bitstream design staff.

Maritime Pi

Maritime Reversed

Semaphore

Zodiad

732 00‱BHH=MSSIVY

brass_fonts

Location_Cologne, Germany

 $Established_1996$

Founders_Hartmut Schaarschmidt, Guido Schneider René Tillmann, Rolf Zaremba

Type designers_Martin Bauermeister, Hartmut Schaarschmidt Guido Schneider, René Tillmann, Rolf Zaremba Astrid Groborsch

Distributor_brass_fonts

brass_fonts plans the hostile takeover of all large type foundries.

brass_fonts was established in 1996 by designers Hartmut Schaarschmidt, Guido Schneider, René Tillmann and Rolf Zaremba. Since mid-1997 the 'brass band' has been strengthened by the addition of Martin Bauermeister and Andrea Markewitz to the team. The company experienced great success in its founding year with many trash and deconstructed fonts and then set itself the goal of offering sophisticated and contemporary alternatives to conventional and frequently used fonts. brass_fonts took a particular interest in the area of flowing text, in which typefaces like Meta, Rotis and, for decades, Helvetica have been employed in an almost inflationary way.

With the appearance of the new catalogue in autumn-winter 1998, an additional five typefaces and a dingbat series were made available. In total brass_fonts now offers twenty-six typefaces. Since early 1999 brass_fonts has created an on-line shopping facility for fonts and devotional items. It allows users to download layout fonts from the entire products (www.brassfonts.de). In addition, all brass_fonts contain a symbol for the euro that is consistent with the typeface.

Additional set of cards for the basic
brass_fonts catalogue, summer 1998
11.7 x 13.5 cm

Design: Hartmut Schaarschmidt
René Tillmann, Rolf Zaremba
Guido Schneider, Martin Bauermeister
Andrea Markewitz
Type design: Guido Schneider _Jaruselsky
_Corpa Gothic

Cover of the basic brass_fonts catalogue, spring 1997 11.7 x 13.5 cm Design: Hartmut Schaarschmidt Type design: Guido Schneider _SoloSans

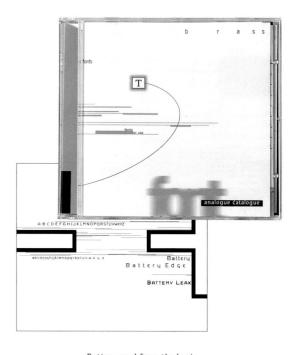

Battery card from the basic brass_fonts catalogue, spring 1997 11.7 x 13.5 cm Design | Type design: Guido Schneider _Battery

34

Amnesia

Amnesia

Amnesia

Annesia

Nobody card/Anorexia card from the basic brass_fonts catalogue, spring 1997 11.7 x 13.5 cm

Design | Type design: Guido Schneider _Nobody _Anorexia

Design: Rolf Zaremba Type design: René Tillmann _Amnesia

11.7 X 13.5 cm

Amnesia card from the basic

brass_fonts catalogue, spring 1997

Command (Z)

Location_London, UK

Established_1995

Founder|Type designer|Distributor_Ian Swift (Swifty)

In 1995 Swifty asked himself a fundamental question: why do fonts cost so much when they sell for so little? His search for an answer led him to look for possibilities to both publish and sell fonts cheaply. The concept of FUSE, the experimental type journal established by Jon Wozencraft and Neville Brody, served as a model: the user not only receives fonts, but also application examples and a pamphlet covering a specific topic. Swifty's goal was to create a more accessible project that would appeal to a broader public.

The first and only edition so far of Command (Z) consists of two fonts, Dolce Vita and Miles Ahead, as well as an A6 fan magazine with eighty-two pages. The fanzine shows the fonts in various applications, introduces material from Swifty's scrapbook and presents the work of, among others, the illustrator Ian Wright. It appeared in a limited edition of one thousand copies and was intended as a collector's item for enthusiasts. In the future, new editions of Command (Z) are expected to appear, but in 1998 Swifty started another typographic project, Typomatic (see p. 280).

Slipcase and fanzine 1995
10.5 x 14.9 cm
Included is a disk containing
the fonts Dolce Vita and Miles Ahead
and a fanzine. The signs for the logo
were scanned from the computer
keyboard.

Design | Type design: Swifty _Dolce Vita _Miles Ahead

ABCDE EGHLKLMNOPQRSTU

Type design: Swifty _Dolce Vita

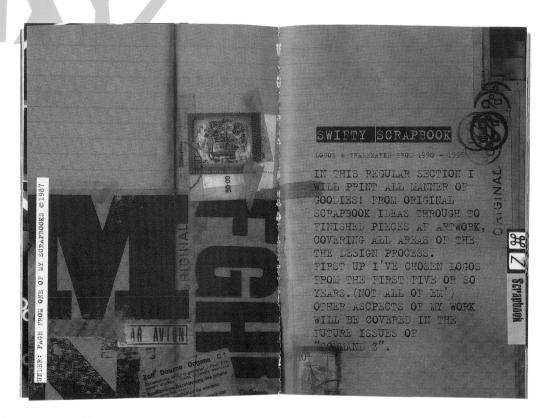

Pages from Command (Z) fanzine, 1995 10.5 x 14.9 cm Collage from Swifty's student scrapbook. Design: Swifty Type design: Swifty _Miles Ahead

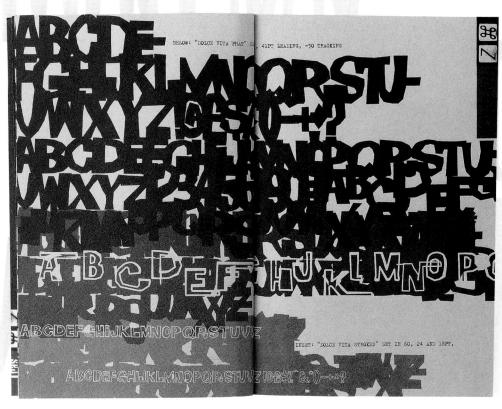

Pages from <u>Command (Z)</u>
fanzine, 1995
10.5 x 14.9 cm
Design | Type design: Swifty _Dolce Vita

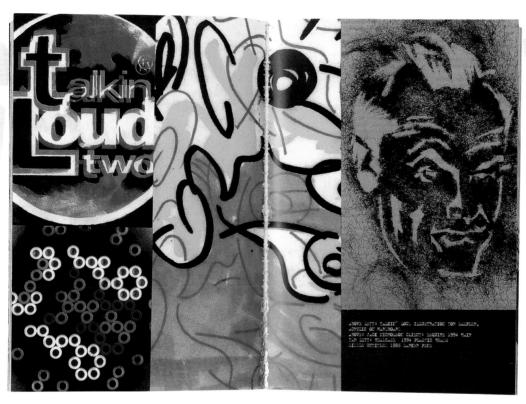

Pages from <u>Command (Z)</u>
fanzine, 1995
10.5 x 14.9 cm
A feature on the painter and
illustrator Ian Wright.
Illustration: Ian Wright
Design: Swifty

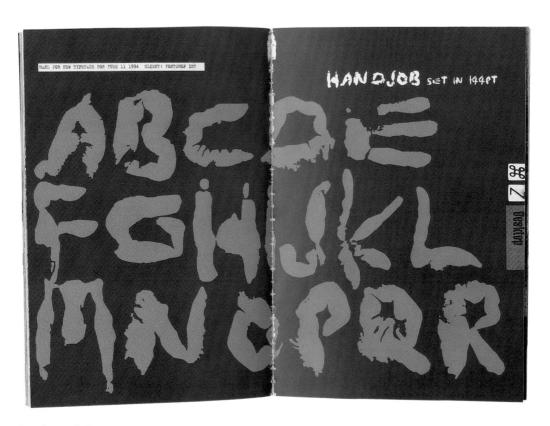

Pages from Command (Z)
fanzine, 1995
10.5 x 14.9 cm
The typeface Hand Job created by
Ian Wright was commissioned for
FUSE 11, 1994, which was devoted to the
issue of pornography.

Design: Swifty Type design: Ian Wright _Hand Job

Promotional Poster, 1995
42 x 59.4 cm
Produced on recycled paper.

Design | Type design: Swifty _Dolce Vita
_Miles Ahead

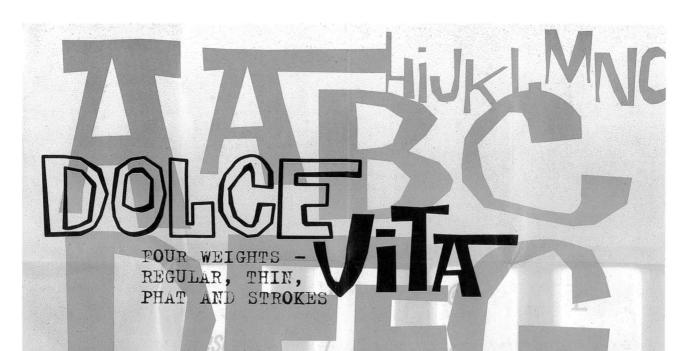

A BRAND NEW FONT PACKAGE DESIGNED AND PRODUCED BY SWIFTY.

PRICE: £30.50+V.A.T(inc p+p) SPECIAL INTRODUCTORY OFFER FOR STUDENTS, ALL INCLUSIVE! £25.50(inc V.A.T+p+p) FUNKY FONT

INCLUDES SWIFTY FANZINE PLUS TWO TYPE 1TM MACINTOSH TYPEFACES POSTSCRIPTTM,

REGULAR AND OUTLINE

TWO WEIGHTS

Creative Alliance

Catalogue, 1997 364 pages 15 x 22.8 cm

Design: Robin Farren
Type design (cover):
Ted Szumilas _Ovidius Demi
Tom Rickner _Amanda Bold

Location_Wilmington, Massachusetts, USA Redhill, Surrey, UK

Established_1994

Founder_Agfa

Type designers_David Berlow, Bo Berndal, Albert Boton
Philip Bouwsma, Lennart Hansson
Franck Jalleau, Oliver Nineuil, Aldo Novarsese
Jean-François Porchez, Poul Søgren
and many more
Distributors_Agfa, Monotype Typography, FontShop International (FSI), FontWorks, FontHaus and
many more

The goal is to become the most important font resource for professional graphic designers.

Agfa was a major provider of fonts sold mainly to high-end imagesetter customers. As desktop-publishing technology advanced, it changed the way graphic designers worked. At first Agfa continued to concentrate on providing tools and equipment to those who serviced designers. This proved to be a good decision in 1985, but times and market needs changed. In 1994 Agfa saw the need for fresh, new typeface designs and created the AgfaType Creative Alliance. Three years later, in 1997, Monotype Typography joined Agfa to develop the Creative Alliance typeface library, a growing resource of new and exclusive typefaces specifically for the graphic design community.

Every quarter Agfa and Monotype release between fifty and one hundred new typefaces as part of the Creative Alliance programme. Today, there are over 6800 typefaces in the Creative Alliance, and over eight hundred of these are exclusive to Agfa.

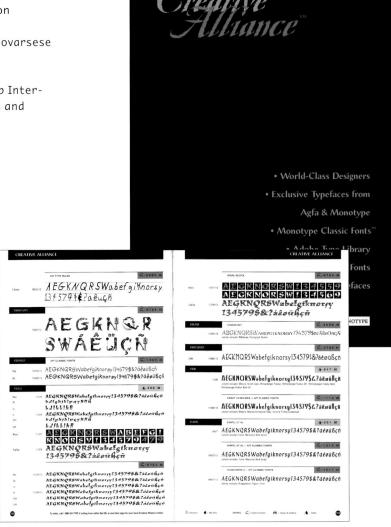

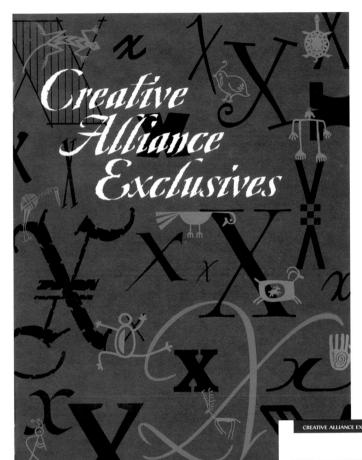

Pierre di Sciullo

Gararond Light
Gararond Light Italic
Gararond Medium
Gararond Medium Italic
Gararond Bold
Gararond Bold Italic

Tobias Frere-Jones

Asphalt Black
Asphalt Black Condensed
Citadel Solid
Citadel Inline
Pilsner Light
Pilsner Regular
Pilsner Bold
Pilsner Black

Carolyn Gibbs

VALUE COCK

905 AL X AL

912 AL X AL

912 AL X AL

913 AL X AL

914 AL

915 AL

915 AL

916 AL

917 AL

917 AL

918 AL

Val Fullard

Science Regular

Lennart Hansson

Crane Light
Crane Light Italic
Crane Medium
Runa Serif Light
Runa Serif Medium
Runa Serif Medium

Runa Serif Medium

X-Luxum 4. Mar Colo 1888/15 C-Curron Albura 2 November 1888/15 C-Cu

Exclusive catalogue, 1997 44 pages 15 x 22.8 cm

Design: Robin Farren
Type design (cover):

Lennart Hansson _Runa

Richard Lipton _Avalon

Steve Matteson _Curlz

Tobias Frere-Jones _Asphalt Black

0

__Letters are actors

Alessio Leonardi

In Italian we call letters caratteri, that is, characters - and this is not mere coincidence. In fact, every letter has its own character and qualities that distinguish it clearly and unmistakably from all others. Despite these differences, all letters belonging to a specific font look amazingly similar. They are all related: brothers and sisters, sons and daughters, from the same hand, the same epoch, the same idea. Letters are actors who always bring new theatrical pieces to the stage. A kind of roaming compagnia teatrale, that in accordance with the audience's cultural level and taste - constantly sets new plays in scene and attempts to present them as well as possible. There are ensembles that specialize in classical pieces; others that make their best appearance in light comedies; or still others that have experimental ambitions. As an audience, we are free to applaud or boo these performances.

Context of the text: a political responsibility

Good and bad fonts are often discussed without considering the context. Some people might say, 'There are fonts that are good and that we should use.' These are readable, proper and familiar fonts that preserve the values of our culture and can save us from decline. In contrast, other type styles are perceived to be the product of a sick society, a subculture that will eventually infect our great culture. I do not find this argument very funny. If we transfer it to the human level, it becomes even less funny: the good people are serious, like classical theatre, they earn a proper living and make neither dirt nor noise.

Throughout the course of history, from the Romans to Charlemagne to Mussolini, numerous attempts have been made to express principles of order, absolutist thoughts, or the immortality of an empire through a uniform typography. Such megalomania was communicated by a totalitarian typography. It is a welcome fact that they did not succeed: how boring it would be if every message were set in the same type! Always the same actor: on one occasion, he tries to appear tragic, the next, dramatic; now he is dressed as a woman, now he is trying to be funny. But, without exception, he is proper, serious, well-spaced. Terrible! How beneficial it is to go unshaven occasionally, to wear ripped trousers and to sleep a bit longer!

Resistance: on the necessity of typo-terrorism

As typographers or designers we not only have the right to defend ourselves, we also have the political duty to offer resistance. We must, if necessary, commit typo-terrorist acts in order to show clearly that we will not conform under any circumstances, that we will not accept a clinical typographic death. The computer can help us, and has already supported us considerably. When the barons were able to control hot-metal type, it was very difficult for the individual to develop something personal because the production process was too complicated and expensive. Today, we can all draw letters ourselves for our own needs. It does not matter if the results are not always brilliant: if we see more beautiful letters designed by someone else, we can always buy them.

My life as a passionate typo-terrorist

I have developed an allergy to all rules that are based on dogma. Type has a long and lively history, so it is not only interesting to see how a font was created, but also to see how it works. A font is a code that people use to understand each other in writing. Still, it always communicates more than we think.

YOP

When considering my fonts, I have tried to analyze some of the mechanisms of typography to see to what extent they are used in communication, consciously or unconsciously, and how much we can change fonts without destroying their functionality. These were small experiments that gave different results, and often contradicted each other.

One of the aspects that fascinates me most is the meeting of digital and analogue, the coldness of the binary code and the warmth of imperfect handwork. I have tried to turn these elements around by creating fonts that, while digital, appear home-made. Conversely, I have given handmade fonts impersonal characteristics, as if they were computer-generated.

Furthermore, I have tried to transform alphabetic characters into pictures – precisely the opposite of the development of the alphabet, which was created from ideograms. The signs and drawings that resulted tell the story contained in the text, but at the same time transport it to a further narrative level: it is its own story, completely accidental, not explicit, but open to interpretation.

I have wondered if it is possible to change the traditional forms of letters and replace them with new ones, and, if so, where the limits of this transformation could lie. I have also drawn more practical fonts to understand how an alphabet takes on personality and how it loses its individual characteristics. Finally, I have treated letters as people: we do not always agree, but we respect each other.

Foonky poster, 1997
42 x 59.4 cm
Foonky and its more decorative variant
Foonky Starred are full-on disco
fonts that should have existed in the
1970s, only someone omitted
to design them.

Design | Type design: Rian Hughes _Foonky Heavy, Starred

Device

Location_London, UK

Established_1997

Founder|Type designer_Rian Hughes

Distributors_FontWorks, FontShop International (FSI), [T-26]

How can there be too many typefaces in the world? Are there too many songs, too many films, too many books?

Rian Hughes studied graphic design at the London College of Printing, and later gained further experience at <u>I.D.</u> magazine (UK) and at the Studio da Gama operated at that time by John Warwicker. Eight years ago Hughes became a freelancer and since then has been working primarily in the music and fashion industries, as well as in the field of comics and magazines.

In 1997 Rian Hughes established the type label Device to market the special fonts he had created for a large number of jobs. The collection so far comprises more than 120 fonts, drawn for the most part in Illustrator then imported to Fontographer. As far as Hughes is concerned, there is no difference between letters and illustrations. The computer has lifted all restrictions and has given designers the freedom they need: for Hughes, designing fonts is also about making pictures.

Design | Type design: Rian Hughes _Cyberdelic

_Mastertext Symbols One, Two

_Pic Format

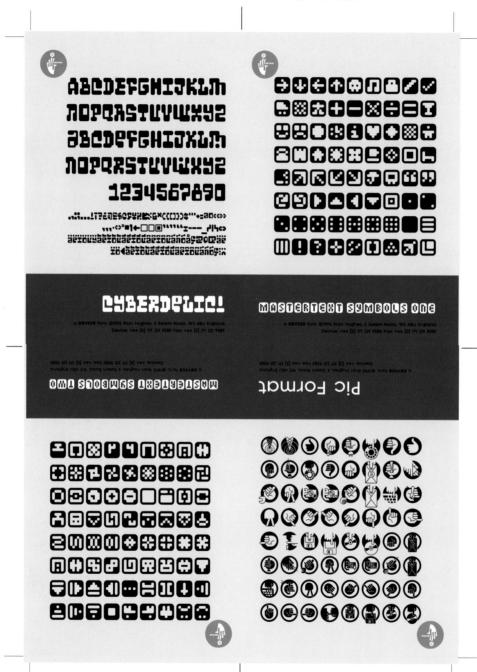

Mastertext poster, 1997
42 × 59.4 cm
Mastertext is a digital font that plainly
shows its digital history.
It refuses to take advantage of today's
transparent technology and is generated
from a simple grid.

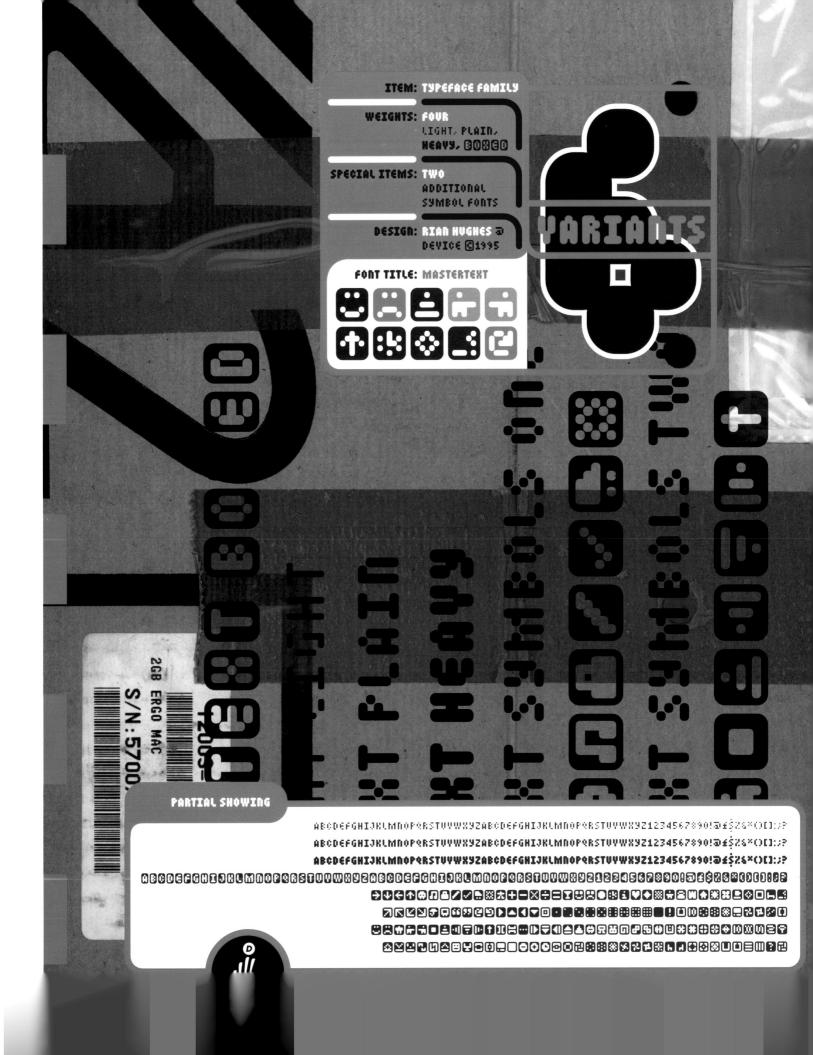

Clektron: a typeface family in four variants designed by Rian Hughes 🖯 Device. 🖸 1995. ABCDGLGHINKrwuobósztnnmxAsapcqstðþjíkjwuobdustnnmxÅsJS242e25&30iú⑤をおうでを[{}]:"' (BCCCCECHINKrwuobdsztnnmxAsapcqelфpijklwobdustnnmxAs1S3426363616급급급하0º쇼({}}]:"" [ABCD&EGHIJKFWUObószinnmXASapcq&l.qhijk|wuobduzfnnmXhsjSz4262&aoiシ国をさいe&({}}]::"' APCDZFCHUKLMNOPQRSTUUWKYZabedzfjhijklmnopqrstuuwkyz1Z54S67590!7[<u>@</u>le\$9fe7{{j}};;,f Electron Light Electron Medium Electron Bold wickeron Shedge

Unpublished postcard, 1996

Design | Type design: Rian Hughes _Lusta One Sixty Sans, One Twenty Sans,
Two Hundred Sans
_Mac Dings

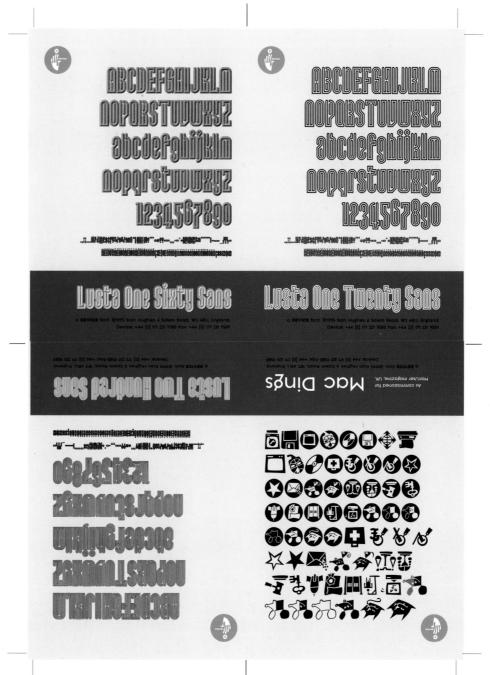

Electron poster, 1997
42 x 59.4 cm
Electron is the TV-as-iconof-the-future typeface that has its faith
in the plastic
future of an artificial world.

CENTRE CONTROL OF THE CONTROL OF THE

Losta a typeface in 7 variants
designed by Lian Hughes
a Device. © 1995.

- go Lusta Forty Saas
- go Lusta Forty Serif
- 80 Lusta Eighty Saas
- 80 Lusta Eighty Serif
- 120 Lusta One Tuenty Stas
- 160 Lusta One Sixty Sans
- 200 Lusta Two Hundred Sons

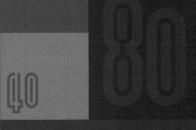

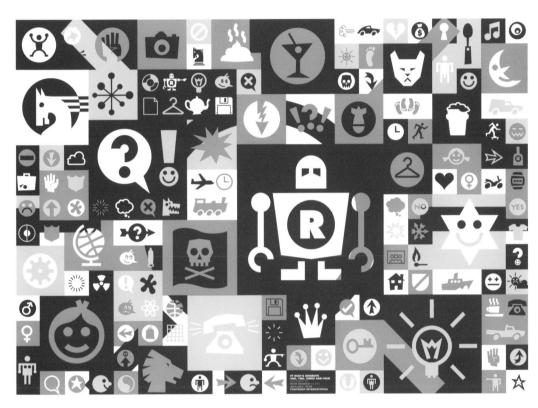

Rian's Dingbats poster, 1993
42 x 59.4 cm
Rian's Dingbats is a pictorial
font with some unusual but
useful icons, for example, a pile of
shit, a range of expressive
heads, a pint of beer
and a condom.

Design | Type design: Rian Hughes _Rian's Dingbats

Lusta poster, 1997
42 x 59.4 cm
Lusta is a strict geometric type family
that grew from the 'inline in
the outline' idea for the letter S and
developed into two styles (serif and
sans) over two weights. Further strictly
mechanical processes were applied to
create the decorative variants.

Design | Type design: Rian Hughes _Lusta Forty Sans, Forty Serif, Eight Sans, Eighty Serif, One Twenty Sans, One Sixty Sans, Two Hundred Sans

THaT REASONIST ME REASON: BLackcurrany by Rian Hughes Part of the Device Collection from [7-26] [T-26] Digital Type Foundry. 1110 North Milwaukee Avenue, Chicago, Illinois 60622.4017 USA, Planet Earth.
Two weights for \$84. Includes *Blackcurrant Cameo*, free with every **Device** order or visit to the **Device** web site.
To order, call 773. 862.1201, fax 773. 862.1214, or e-mail us at 126font4*aol.com.
Visit our website at www.t26fontcom and view the full **Device** collection.
This text set in *Regulator*. Two sets of five and six fonts for \$162 and \$180.
Illustrations by Rian Hughes®. You can contact the designer at rianhughes⁴¹aol.com

Stadia poster, 1997
42 x 59.4 cm
Stadia is built from a limited number
of basic elements and their mirrored
and reflected variations, totalling
thirty-two shapes, and adheres to a
strict square grid - or at least that was
the intention. After much fiddling,
Rian gave in and let elements of the T,
the Y and the accents break the grid and
sit between squares. The name derives
from the O, which resembles a stadium
from above.

Design | Type design: Rian Hughes _Stadia

ABCBEPEHLIKLMBOPERSTRUUKTE abadoffblijblwacperburwyz ABCDEPEHLIKLANOPERSTUUKAY! Abadoffhijkimnoperakurukyz abadoffhijkimnoperakurukyz ABUSCPOO...:*Ym...!PAGŠČCOLIKJKM

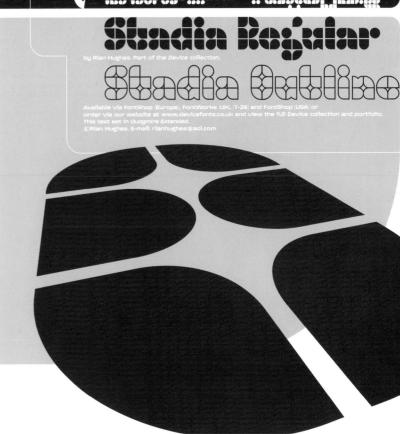

Blackcurrant poster, 1997
42 × 59.4 cm
Blackcurrant was created for a series
of posters designed for Tokyo fashion
house Yellow Boots, a retail clothing
chain aimed at sixteen to twenty-five
year olds. In its original form it
was quite wide (Black), so a more
condensed version was developed
to enhance useability (Squash). This
poster was designed to advertise the
Blackcurrant family.

Design | Type design: Rian Hughes _Blackcurrant

Reasonist poster, 1997 42 x 59.4 cm Reasonist has its roots in a kind of brushstroke-meets-Cooper Black, but tries to have even more fun.

PRESCOLITION DIUM ITALIC

Design | Type design: Rian Hughes _Reasonist

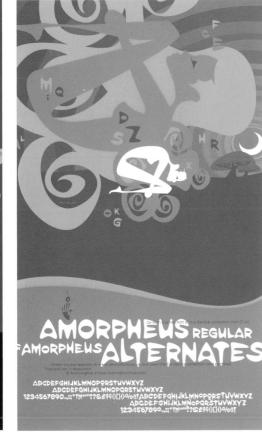

Amorpheus poster, 1997 42 x 59.4 cm Amorpheus has been adopted by the hardcore trance record label Transient as a corporate font, and also by 'Blankety Blank', a light-hearted TV quiz show.

Design | Type design: Rian Hughes _Amorpheus

A scrolling list at the bottom of the page allows the user to select any font or variant (bold, inline) and when clicked upon, brings a sample up in the main window. A free font is available on every visit.

> Design|Type design: Rian Hughes _Customised Foonky Starred

> > _Regulator

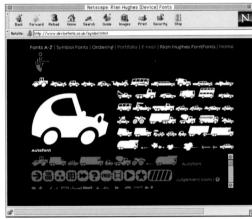

Autofont was developed for a car magazine called <u>Autocar</u>. It provides an exhaustive range of cars, a few bikes, some cones and whizz lines.

Design | Type design: Rian Hughes _Autofont _Regulator

Website, 1998 www.devicefonts.co.uk Promotional material

Design|Type design: Rian Hughes _Customised Foonky Starred _Regulator

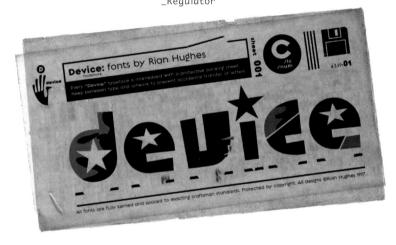

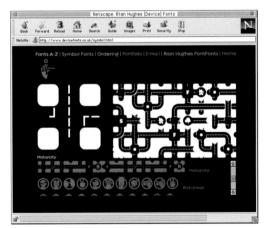

Motorcity is a range of intersections, bends and other road sections that, when set without leading, combine to form a complex maze of streets, resembling a city map from above.

Device fonts poster, 1997
42 x 59.4 cm
The front shows the illustrations from which the fonts were derived. The back of the poster (not shown) lists alphabetically the first hundred fonts.

FontShop mailing card, 1995
Pool considers DIN-Mittelschrift - the
German motorway typeface - to be
'probably the most non-designed typeface
ever made'. Taking this opinion as a
starting point, it seemed logical to
enhance the typographic quality of the
design while maintaining its overall
appearance.

Design: Jürgen Siebert
Type design: Albert-Jan Pool _FF DIN light, regular, medium, bold, black

Dutch Design

Location_Hamburg, Germany
Established_1994
Founder|Type designer_Albert-Jan Pool
Distributors_FontShop International (FSI), (URW)++

The Dutchman Albert-Jan Pool studied graphic design and typography at the Koninklijke Akademie van Beeldende Kunsten in The Hague, before working as a graphic designer. In 1985 he helped to found Letters, a group of young Dutch font designers that also staged exhibitions. Pool worked as a type director at Scangraphic at the end of the 1980s before becoming manager for type design and production at URW Software & Type GmbH in Hamburg in 1991. At that time he designed various fonts for URW. such as Linear, Imperial and Mauritius. He set up Dutch Design in 1994 and now works as a oneman font and graphics studio. Pool is also an author and has taught type design and typography at the Muthesius University in Kiel and the Hanseatic Academy for Marketing and Media in Hamburg. Dutch Design has been a member of the studio group FarbTon Design und Medienbüro in Hamburg since 1997.

Gas pump lettering for the corporate identity manual of Jet petrol stations (Conoco Mineral Oil Company). At the request of the Hamburg agency, Syndicate, Pool designed an exclusive font for the company by adapting the arched wing, angles and bold characters of the corporate logo and simplifying some letter forms to achieve a visual unity.

Design: Syndicate

Type design: Albert-Jan Pool _Jet Bold Italic

Illustrations from FontShop mailing card, 1995 When Pool was asked to rework the typeface OCR-B for FSI, his first thought was: how could he improve this typeface, which is considered to be derived from Adrian Frutiger's Univers? Then he remembered the words of his teacher Gerrit Noordzij, 'Turning things upside-down does not always lead to improvement, but it certainly makes them funnier.' So why not redesign OCR-B and supply designers with a useful typographic toy named FF OCR-F?

> Design: Jürgen Siebert Type design: Albert-Jan Pool _FF OCR-F, light, regular, bold

Page from the loose-leaf type specimen showing Nobel Bold 21 x 29.7 cm
The first edition of this type specimen, which is constantly updated, was published in 1994. There are now about two hundred pages. Nobel was originally designed by Sjoerd H. de Roos for Lettergieterij Amsterdam (now Tetterode) in 1929. The revival was released in 1993; the digitization was carried out by Fred Smeijers and Andrea Fuchs.

Design: Frank E. Blokland
Type design: Sjoerd de Roos
Andrea Fuchs & Fred Smeijers _Nobel Bold

Dutch Type Library

Location_'s-Hertogenbosch, The Netherlands

Established 1990

Founder_Frank E. Blokland

Type designers_Gerard Unger, Jan van Krimpen, Chris Brand Erhard Kaiser, Fred Smeijers, Gerard Daniëls Elmo van Slingerland, Frank E. Blokland and others

Distributors_Dutch Type Library, (URW)++

When it was established in 1990, the Dutch Type Library (dtl) was the first digital type foundry in The Netherlands. Its intention was to make exclusive and original Dutch type designs to a high technical level. dtl has always tried to find the right balance between new designs and revivals of historical typefaces, and as a result supports talented young type designers. So far this has resulted in two premieres: Caspari by Gerard Daniëls and Dorian by Elmo van Slingerland. Among dtl users are museums, publishers of art books and university presses, but also schools, a public transport company, a pharmaceutical magazine and even a hospital. The Dutch Type Library believes that custommade fonts are the future. Examples are the Sans for Haarlemmer, commissioned by Museum Boijmans van Beuningen in Rotterdam and the adaptation of Albertina for the European Union in Luxembourg. Besides the constant extension of existing families, the Dutch Type Library is now working on many new designs such as Unico by Michael Harvey, Rosart (based on an eighteenth-century typeface) by Antoon de Vylder and Sheldon and Romulus by Jan van Krimpen.

Cover of Jan van Krimpen's

Memorandum, 1996
20 pages
24.1 x 16.2 cm
This annotated publication was
meant to introduce Haarlemmer,
a typeface originally designed by
Jan van Krimpen in 1938 and commissioned by de Vereeniging voor
Druken Boekkunst. The production
was carried out at Monotype, but
technical problems and the Second
World War meant that Haarlemmer was
never finished. In 1995 Frank E.
Blokland created the digital revival.

Design: Frank E. Blokland Type design: Jan van Krimpen

Frank E. Blokland _Haarlemmer, Haarlemmer Italic

ABCDEFGHIJK
LMNOPQRSTUV
WXYZ&ήÇ
1234567890
abcdefghijklmno
pqrstuvwxyzϾ
fiflçøñáàâääå
éèêëóòôöùùûü
B?!;:\$£¥¢§€
†©®%#

48/56

10

Nederland heeft in de ontwikkeling van drukketters altijd een grote rol gespeeld. Het zetten en drukken met losse loden letters was een Nederlandse uitvinding. Misschien dat Laurens janszoon Cosset (1962–1468) de uitvinder was ofwel een andere, onbekend gebleven, drukker. In de zeventiende eeuw was Nederland het typografisch erent runn van de werdd. De bekendste Nederlandse stempelsnijder uit de gouden eeuw is Christoffer uit Dijks, wiens ontwerpen door de beroemde uitgevrij Elzevir in Leiden

Nederland heeft in de ontwikkeling van drukletters altijd een grote rol gespeeld. Het zetten en drukken met losse loden letters was een Nederlandse uitvinding. Misschien dat Laurens Janszoon Coster (1405–1468) de uitvinder was ofwel een andere, onbekend gebleven, drukker. In de zeventiende eeuw was Nederland het typografisch centrum van de wereld. De bekend-

Nederland heeft in de onwikkeling was druksteerd.

Het zetten en drukken met intereste in statische open der intereste som der intereste som en der intereste intereste som en Nederlands ein vinstalign. Mitsien delte interest som en Nederlands ein vinstalign. Mitsien des Leitzers som en Nederlands ein vinstalign. Mitvioler was spiele ein vinstalign. Mitvioler was spiele ein der vinstalte ein der weiter. Mitvioler was spiele ein der vinstalte ein weiter. Mit vinstalte sie netzerstalte der vinstalte sie vinstalte vinstalte sie kerkelt vinstalte vinstalte sie vinstalte vinstalte vinstalte vinstalte kerkelt vinstalte vinstalte vinstalte kerkelt vinstalte vinstalte kerkelt vinstalte vinstalte vinstalte kerkelt vinstalte vi ABCDEFGHIJKLM
NOPQRSTUVWXYZ

&ήÇ
1234567890
abcdefghijklmnopqr
stuvwxyzææfiflßçø
áàâäãåéèêëñóòôöúùûü
!?.,:;-\$£¥¢§¶†©®%#
1234567890

24/29

Noderland heeft in de onwikkeling wan drukletters aligit een grote ye gespeeld. He zeiten en drukken met louse loden drukken met louse loden tetter was een Nederlandse uitvinding. Misschien daat Laurens Jamzoon Osster (140-5)–1468) de uitvinder was ofwel een andere, onbekend midtende een was Nederland het typografische ven, drukker. In de zewentende een was Nederland het typografische ven, term wan de wereld. De bekendste Noderlandse

9/12

OHamburgefonstiv

Nederland heeft in de ontwikkeling van drukletters altijd een grote rol gespeeld. Het zetten en drukken met losse loden letters was een Nederlandse uitvinding. Misschien dat Laurens Janszoon Coster (1405–1468) de uitvinder was ofwel een andere, onbekend gebleven, drukker. In de zeventiende eeuw was Nederland het

Nederland heeft in de ontwikkeling van drukletters altijd een grote rol gespeeld. Het zetten en drukken met losse loden letters was een Nederlandse uitvinding. Misschien dat Laurens Janszoon Coster (1405–1468) de uitvin-

15

Page from the loose-leaf
type specimen presenting
Albertina Medium Italic.
21 x 29.7 cm
Albertina was originally designed by
Chris Brand in 1961 and was used only
once: for an exhibition in the Royal
Library of Brussels, named Albert I.
The digital version was produced at
the Dutch Type Library in 1996, with the
full backing of Brand and Monotype.
The European Union recently
selected Albertina as its corporate

Design: Frank E. Blokland Type design: Chris Brand, dtlStudio _Albertina

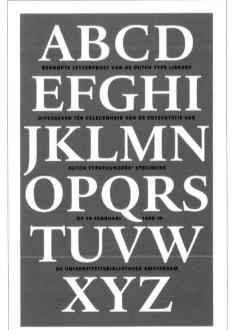

Cover of a type specimen leaflet, 1998 24 x 16 cm
The leaflet gives an overview of the complete library, and was made for the presentation of Dutch Type founders' specimens in the University Library of Amsterdam.

Design: Frank E. Blokland
Type design: Jan van Krimpen

Frank E. Blokland _Haarlemmer

Elliott Peter Earls

Location_Greenwich, Connecticut, USA
Established_1993
Distributors_Emigre, The Apollo Program

Remember to do accounting on Friday

Elliott Peter Earls received his MFA from Cranbrook Academy of Art. Upon graduation, his 'holistic' experimentation with nonlinear digital video, spoken-word poetry, the composition of music and design, led him to form the studio The Apollo Program. The form the work takes is very simple: high-resolution nonlinear digital video compositions are delivered via video projection in theatres and on CD-ROM. Clients include Elektra Entertainment, Nonesuch Records, Scribner Publishing, Elemond Casabella, The Cartoon Network, Polygram Classics and Jazz, The Voyager Company and Janus Films.

Earls has spent time as a visiting artist at Maine College of Art, Cranbrook Academy of Art, Eastern Michigan University and the University of North Carolina and, most recently, at Benetton's research centre in Fabrica. In addition, he has run workshops on design, culture and new media in Europe and America.

Icons from the enhanced CD-ROM 'Throwing Apples at the Sun', 1995 Design: Elliott Peter Earls

→
Poster, 1994
63.5 x 94 cm
The poster'Idle|Idol King Suffered'
was produced to announce the release
of the enhanced CD.

Design | Type design: Elliott Peter Earls _Penal Code

_Toohey and Wynand

_Dysphasia

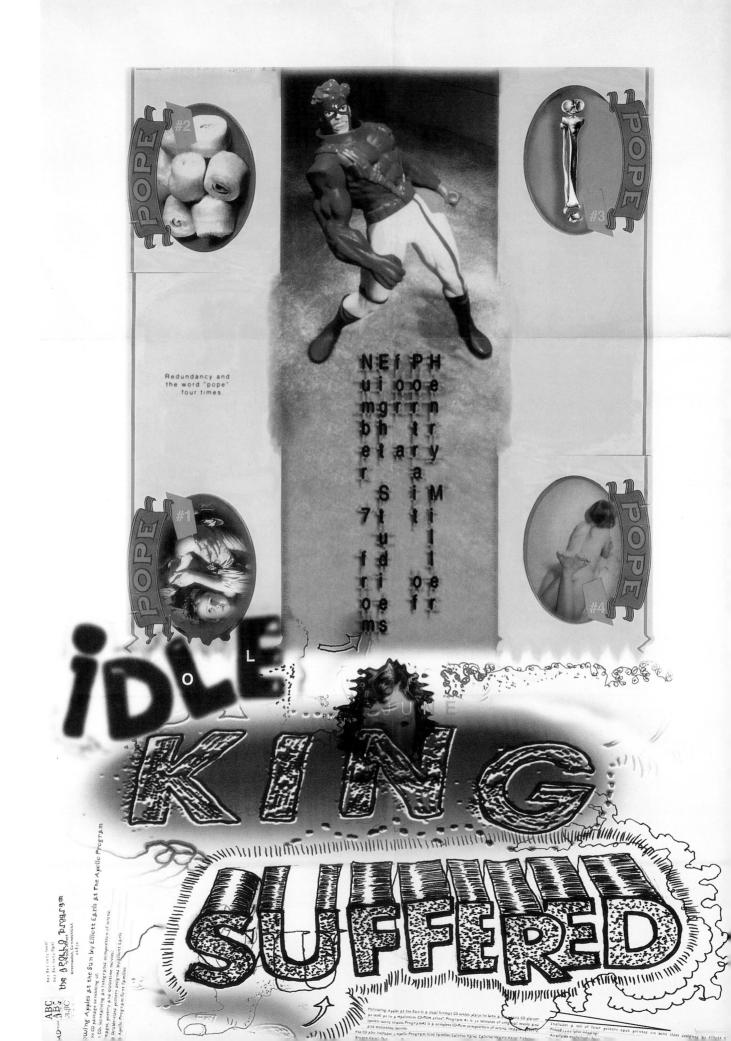

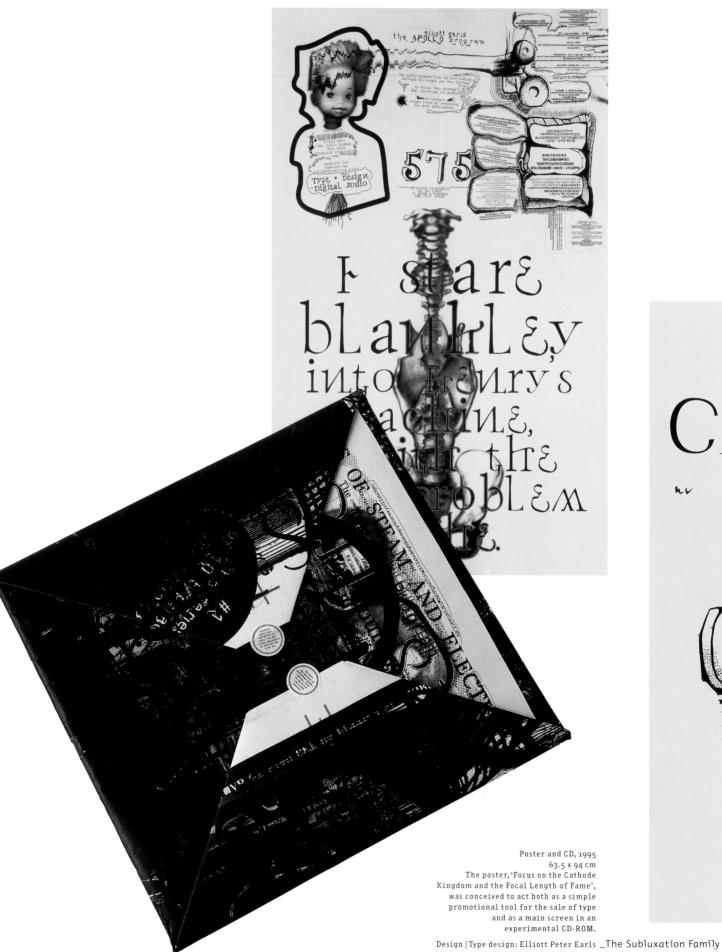

Poster, 1995
63.5 x 94 cm
The poster was created to promote
the design of the font Subluxation.

Design | Type design: Elliott Peter Earls _The Subluxation Family

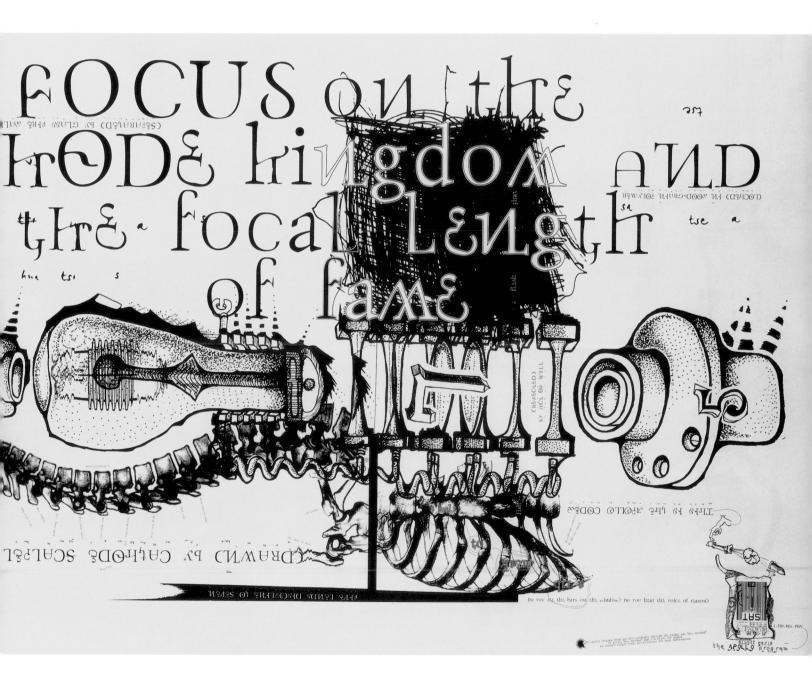

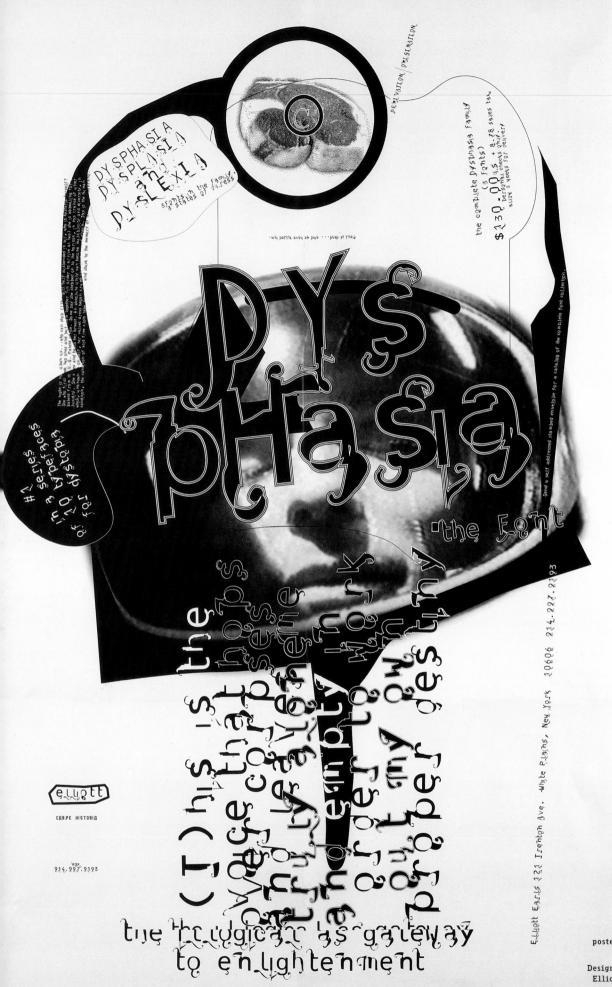

The Dysphasia poster and CD, 1995 63.5 x 94 cm

Design | Type design:
Elliott Peter Earls _The Dysphasia Family

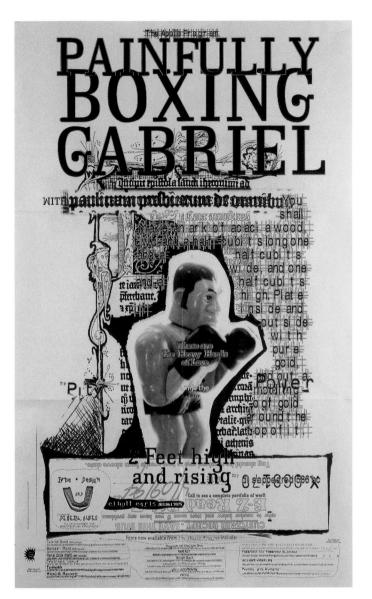

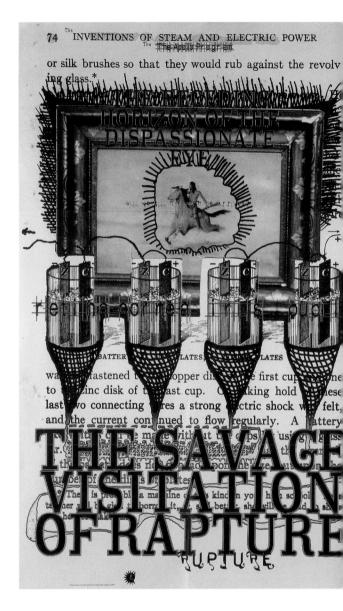

Poster, 1995 63.5 x 94 cm Front and back of the poster 'Painfully Boxing Gabriel'.

Design | Type design:
Elliott Peter Earls _Penal Code

_Bland Serif Bland _Calvino Hand

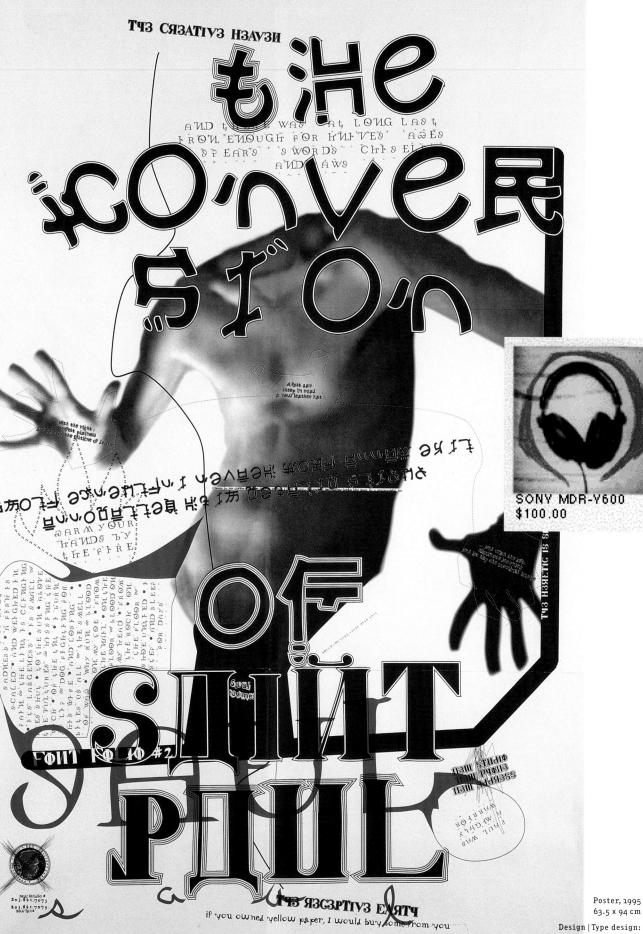

elliott Earls 2 view Street, Greenwhich Connecticut 06830 203.861.7075

63.5 x 94 cm

Design | Type design: Elliott Peter Earls _Mothra Paralax _Subluxation Bland

Fender Strato

(Mexico)- \$39

APS 2 GIG HD - \$1150 Syquest 44 meg - \$250

Microtek Scanmaker 2XE \$1100

@1995. The APOLLO Program, All rights reserved M.F.A. — M.A.Y. १११४ Granbrook Academy of Art Bloomfield Hills, Michigan

Pesign

The Mootto Program

Screenshots from the enhanced CD-ROM 'Throwing Apples at the Sun', 1995 It contains thirty minutes of music, poetry, Quicktime movies, typography and an integrated multimedia composition.

> Design | Type design: Elliott Peter Earls _The Distillation Family _The Subluxation Family

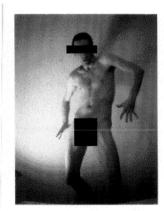

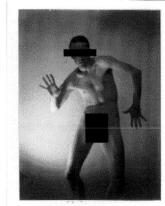

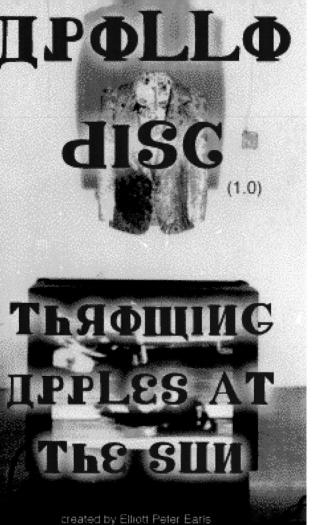

Screenshot and CD case from the enhanced CD-ROM 'Throwing Apples at the Sun', 1995

Design | Type design:
Elliott Peter Earls _The Distillation Family
_The Subluxation Family

© 1995 The Apollo Program. All rights reserved

abcdefghijklmnopqrstuvwxy [äöüßåøæç] A B C D E F GH I J K L M N O P Q RSTUVWXYZ [1234567890 (.,;:?!\$&-* RS T U {ÄÖÜÅØÆŒÇ}

Poster, 1995
63.5 x 94 cm
The poster 'Throwing Apples at the Sun'
was produced to announce the enhanced
CD-ROM. It was recently added to the
permanent collection of the
Cooper-Hewitt National Design Museum.

Design | Type design: Elliott Peter Earls _The Distillation Family _The Subluxation Family

CAMELOI

JKLAMARA PARTIES STULVILLA BODE STULVILLA BODE STULVILLA SOURCES

SHRUGGED

\$20. Suppose for the principle of the pr

% cookreall: 203.861.7075

the APOLLO progra

abedef

Elsner+Flake

Location_Hamburg, Germany

Established 1985

Founders_Veronika Elsner, Günther Flake

Type designers_Charles Bigelow, Kris Holmes, Achaz Reuss Hans Eduard Meyer, Manfred Klein Jessica Hoppe, Frank Baranowski Lisa von Paczkowski, Ralf Borowiak Petra Beiße and many more

Distributors_FontShop International (FSI), FontHaus Linotype Library, Faces, FontWorks Signum Art and others

Tradition and Trend

In January 1985, after a decade of freelance work in the areas of font design, typography and digitization. Veronika Elsner and Günther Flake founded the company Elsner+Flake Design Studios in order to build up a library of their own fonts. The library now contains over 1550 font patterns, ranging from their own exclusive font creations to classical fonts and the grunge fonts Beasty Bodies dating to the 1990s. Apart from central-European character sets like Polish, Czech and Hungarian, Elsner+Flake offers Greek, Turkish, Cyrillic, Asian, Arabic and Hebrew fonts. Their mail-order house, Elsner+Flake Fontinform, was established in 1992 to meet the growing demand for fonts from other libraries and to offer advice on installation, application or inclusion of fonts in text and graphic programs. As exclusive partner of the American font company FontHaus, Elsner+Flake Fontinform offers fonts from several dozen producers.

Postcards, 1997

Design: Factor Design

Type design: Verena Gerlach _Aranea Normal, Outline

Jessica Hoppe _Carpediem

el

ch

ch

Fritz litters

Fixhstäbehem Fermsehzeisung Toilessempapier

ErBesen Weihmach + stollen

Tee

3 Eier

Zucker, dem sur gen 2l Milch

Postcard, 1997 Fritz Dittert was born in 1903, one of eleven children. He worked as a tailor, farmer and construction worker and experienced two world wars and two periods of hyperinflation. The font shows his handwriting, which reflects his life's experiences. Uwe Melichar $\,$ and Manuela Frahm digitized Dittert's handwriting.

Design: Factor Design Type design: Uwe Melichar, Manuela Frahm _Fritz Dittert

Postcard, 1997 Design: Factor Design Type design: Petra Beiße _Petras Script ___Typo-matic

Ian Swift

As we move towards the new millennium, styles and fashions come and go like the changing of the wind. Type design, like all creative disciplines, must move with the times and reflect contemporary moods and philosophies. New categories of type design are emerging from the inner depths of our underground movements, from club culture, street life and design fetishism. There will be more styles and options (stencils, interlocks, scripts) and flavours (funky, electic and plain groovy!) available in an already over-saturated market, where type speaks to the hip dudes on the street.

My own attitude towards type is somewhat throwaway. Much to the traditionalists' regret, I'm not about to spend the next ten years designing one font when I could do at least one a week or one a day. In my opinion, type design is addictive and I'm definitely hooked. As a practising graphic and typographic designer I feel the need to draw a new typeface for almost every job that comes into the studio, thus ensuring that different projects receive their own look right down to an exclusive font for a price! Fonts are used in the studio until they are exhausted, then put on to the pile marked 'to sell'.

Type design is in a revolutionary state. With the right software anyone can design a font, but the industry is still a closed shop when it comes to distribution and marketing. The Internet has opened up the world to independent trading in cyberspace with low overheads, right up there with the major players. Type design is very prominent on the Internet, with over two hundred font foundries at present and increasing all the time. However, the Internet is mostly still dominated by existing font companies going on-line to flex their corporate wings. Yet there are a small number of cutting-edge foundries that offer something a little bit different. Some propose free fonts to entice you on to their pages, others offer packages of competatively priced fonts, others just show fonts that aren't for sale, leading to the inevitable bootlegging.

This is an interesting development for the type design and distribution market. More and more independent type designers will start selling and providing fonts over the Internet, making as much profit as possible on their own product and not selling up to anyone. The age of the entrepreneurial funky font designer is upon us!

The collection known as Typomatic features designs from all over the globe from a vast array of type 'Headz' from all backgrounds.

Typomatic has concentrated so far on headline and display fonts, but intends to introduce a few grungy text faces. The viewer is able to select a font, pay for it and receive it on-line, as well as by conventional methods of payment and despatch. Type buying needs to be instant because of the crazy deadlines to which designers have to work – when you need a font you need it quickly!

Cutting-edge type for a cutting-edge market requires obscure ideas as source material. A font can be made from almost anything you find: from rusty old signs that have been discarded to old tickets thrown in the dustbin. We are obsessed and need to feed our obsession on

a constant basis. Stencil fonts are cut out, sprayed, scanned, streamlined and imported. Other letter forms are provided as hand-drawn specimens, which are outlined and thus retain the hand-drawn look. Others are simply drawn as outlines in Freehand and imported.

Texture is very important to type at the moment and better software that offers more options when digitizing fonts is needed. Distressed, manipulated and merged, true creative font design is still in its infancy... there are lots more avenues to explore. Fonts are being submitted from a variety of people, such as graphic designers, students, graffitti artists, illustrators and font 'train spotters' who just fancy having a go!

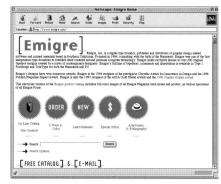

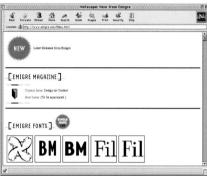

Website, 1998 www.emigre.com

Design: Emigre Graphics

Type design: Zuzana Licko _Hypnopaedia Pattern Illustrations

_Base Monospace

_Filosofia

Location_Sacramento, California, USA Established 1984

Founders_Zuzana Licko, Rudy Vanderlands Type designers_Mark Andresen, Bob Aufuldish Jonathan Barnbrook, Barry Deck Edward Fella, Frank Heine Jeffrey Keedy, Brian Kelly Nancy Mazzei, Rudy Vanderlans Zuzana Licko and others

Distributors_Emigre, FontShop International (FSI)

Emigre, based in northern California, is a digital type foundry, publisher and distributor of graphic design-related software and printed materials.

Founded in 1984, coinciding with the birth of the Apple Macintosh, Emigre was one of the first independent type foundries to establish itself around personal computer technology. It holds the exclusive licence to over two hundred original typeface designs created by a roster of contemporary designers from around the world.

Catalogue, sixty-four pages in black and white spring 1995 23 x 28 cm

> Design: Emigre with Gail Swanlund Type design: Zuzana Licko _Dogma Outline

> > Poster, summer 1995

Design: Rudy Vanderlans Type design: Zuzana Licko _Modula Remix

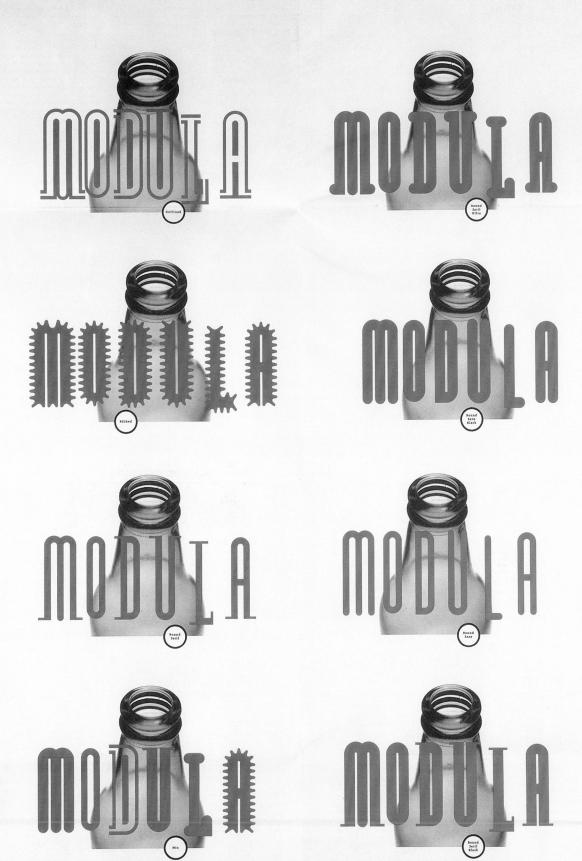

Extended Remix

NOT CASLON WAS DESIGNED BY MARK ANDRESEN

CIRCA 1995 AMELIAN SECULIARIA SECRETARIA SECULIARIA SEC

THE WILLIAM CASLON LINEAGE

Monatope Corporation, Casiles service in Monatope Corporation, Casiles service in Monatope Corporation, Casiles service, at Monatope Corporation, Casiles service, and Monatope Corporation, Casiles service, in Monatope Corporation, Casiles Service, in Monatope Corporation, Casiles Service, and Casiles Service, and Casiles Service, Monatoperation, Casiles Service, Casiles Service

Partic (1910/18), Poreks Colon Brilliant
Partic (1910/18), Poreks Colon Brilliant
Partic (1910/18), Colon Colon Brilliant
Partic (1910/18), Colon Aduld
Partic (1910/18), Colon Brilliant
Partic (1910/18), Colon Brilliant
Partic (1910/18), Colon Colonya
Partic (1910/18), Colonya
Partic (19

Photo-Interiority, New Carlos
Findin Linearros, Palest Carlos Obaspianolo,
Findin Linearros, Divide Carlos
Findin Linearros, Divide Carlos
Findin Linearros, Paralle Carlos Nedere
Findin Linearros, Panagona English Carlos
Findin Linearros, Panagona English Carlos
Findin Linearros, Panagona English Carlos
Findin Linearros, Panagona Carlos
Findin Linearros
Findin

\$\frac{1}{8} \frac{1}{8} \frac{1}{8}

Not Casion (1)	NOT CASLON (2)	NOT CASLON (1)	Not Caston (2)	NOT CASLON (1)	NOT CASLON (2)
AA		B	BB	Cc	Gc
D 2	DD	Ee	E E	FF	FF
GG	GG	$\mathcal{H}\mathcal{H}$	HH	Ii	I i
	9		KK	LL	L
74 M	MM	NN	Nn	00	00
Po	PP	'Q Q	QQ	R_{r}	RR
S S	SI	TT	71	UU	UU
	DV	200V	$\mathcal{M}_{\mathcal{M}}$		XX
Ty	Yy	" 2	4 %	(?	??

1234567890

DIGITAL F	ont Ch.	ARACTER	SET
-----------	---------	---------	-----

D [L]	The first process of the content of the content on the proof (step) and the process of the content of the cont	And continues in which we presented a finite primary in the appearance of the continues of	See that of the control of the contr
-------	--	---	--

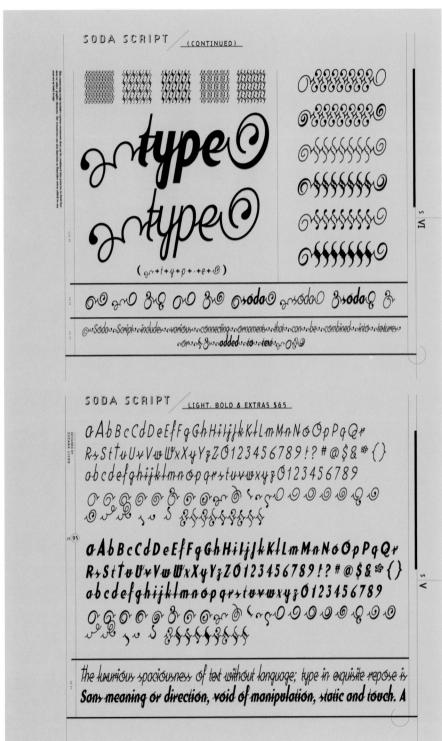

Page from the Emigre font catalogue, 1995 23 x 28 cm

Design: Emigre with Gail Swanlund

Type design: Zuzana Licko _Soda Script

← Poster, 1995 83 x 47 cm

Design: Rudy Vanderlans Type design: Mark Andresen _Not Caslon Base-12 / Base-9

A series of font families for use in print and multimedia environments, with mutually compatible screen and printer fonts. Available exclusively from Emigre Fonts.

BaseTwelve

Sans

Regular Italic

Bold | Bold Italic

Outline Bitmap

It is ironic that for years, piencers of emerging computer technologies have been slighting the validity of bitmaps, judging them to be mercy temperary solutions to a display polem that would soon be fixed by the introduction of high definition IV It is ironic that for years, piencers of emerging computer technologies have been slighting the validity of bitmaps, judging them to be mercy temperary solutions to a display problem that would soon be fixed by the introduction of high definition IV.

BaseTwelve

Serif

Regular Italic

Bold | Bold Italic

Outline

Bitmap

It is ironic that for years, pioneers of emerging computer technologies have been slighting the validity of bitmaps, judging them to be merely temporary solutions to a display problem that would soon be It is ironic that for years, pioneers of emerging computer technologies have been slighting the validity of bitmaps, judging them to be merely temporary solutions to a display problem that would soon be

It is ironic that for years, pioneers of emerging computer technologies have been slighting the validity of bitmaps, judging then to be enery temperary subtains to a display problem that would soon be fixed by the introduction of high definition Tv and It is ironic that for years, pioneers of emerging computer technologies have been slightling the validity of bitmaps, judging then to be nersy temperary southers to a display problem that would soon be fixed by the introduction of high definition Tv and

Regular Italic

Bold Bold Italic

BaseNine

EMIGRE FONTS.

BaseTwelke BaseNine BaseTwelve BaseNine

Underline Ombling Spegon

Introduction

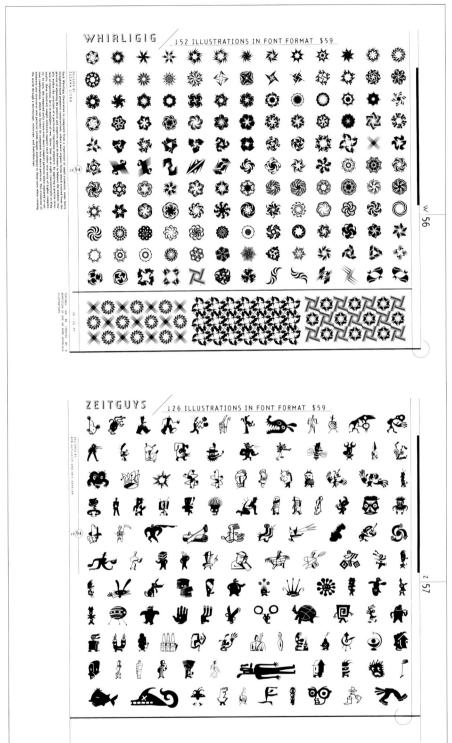

Page from the Emigre font catalogue, 1995 23 x 28 cm

Design: Emigre with Gail Swanlund

Type design: Zuzana Licko _Whirligig Bob Aufuldish, Eric Donelan _Zeitguys

> Poster, 1996 83 x 47 cm

Design: Rudy Vanderlans Type design: Zuzana Licko _Base Twelve _Base Nine

DA DECO CELEG GALIZADA DE CO DOR SEG GALIZA FREE BARKNEY PEDO PRIESTRED BAKNEY BY FEDO G+TMARRAMA FIFE FEFE UNIVERSE DA BEECH DOE SEG GIOHIJG DA BEECH DOE SEG GIOHIJG TREE BARKNEW FOOD PRISTREPLANTENES OF FOOD PRIS be and the first shall be at the first shall go a be be at the shall go and the state of the sta PLANTANTO PPOEFRESTREPLANTANTO PPOEFRES | 日井 本 有 go # G # 15 fb 17 8 / 9 * Q ! Q # まっち からま (二) THA HORE OF OF ELERGY CALENDA A HORE OF OF ELERGY CALENDA ROLL THINK TO FIRE OF PISC STR ROLL THINK HON SO F POR OF PISC S ANSTO J & 9 D 1 P n + \$ & 6 & * * * * * ANSTO J & 9 D 1 P n + \$ % 6 & * * * * *

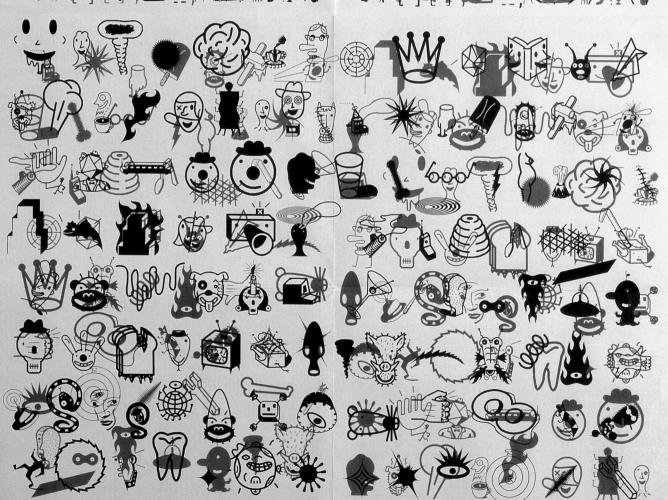

John Hersey's Thingbat and Blockhead Fonts. Available exclusively from Emigre Fonts.

DOGMA BOLD. SCRIPT & BLACK \$95

The Depart Script had, had and high scripts have special keeps.

□AbBcCdDeEfFgGhHiljJkKlLmMnNoO pPqQrRAStTuUvVwWxXyYzZO12345678 90123456789!?#@\$&*

A b B c C d D e E f F g G h H i I j J k K l L m M n N o O p P q Q r R A S t T n U v V w W x X y V 3 Z O 1 2 3 4 5 6 7 8 9 0 1 2 3 4 5 6 7 8 9 ! ? # @ \$ & *

■ A b B c C d D e E f F g G h H i I j J k K l L m M n N o O p P q Q r R ∧ S t T u U v V w W x X y Y z Z 0 1 2 3 4 5 6 7 8 9 0 1 2 3 4 5 6 7 8 9 ! ? # @ \$ & ₽

The luxurious spaciousness of te Without language; type in exq Repose sans meaning or dir

OR DIRECTION

DOGMA OUTLINE OUTLINE & EXTRA OUTLINE \$59

QAbbccdDcEfFgGhHiljJkKlL mMmNoOpPqQrRAStTwVvVwWx XqY3Z0123456789

Q A b B c C d D c E f F g G b H i i j J k K i L m M m N o O p P q Q r B a S f T m U v V w W m X q Y g Z O 1 2 S 4 5 6 7 8 9 o 1 2 5 4 5 a 7 a o 1 ? # @ \$ 8 8 5

HFFQ5

Page from the Emigre font catalogue, 1995 23 x 28 cm

Design: Emigre with Gail Swanlund

Type design: Zuzana Licko _Dogma, Dogma Outline

Poster, 1995 83 x 47 cm

Design: Rudy Vanderlans
Type design: John Hersey _Blockhead
_Thinqbat

Type design: Zuzana Licko _Hypnopaedia Pattern Illustrations

Illustrations from the Hypnopaedia booklet, 1997 By rotating the letter forms of different fonts, individual patterns were created.

Type design: Zuzana Licko _Hypnopaedia Pattern Illustrations

β

Hypnopaedia booklet, 1997 32 pages 13.5 x 21 cm Containing 140 patterns in full colour.

Design: Rudy Vanderlans Type design: Zuzana Licko _Hypnopaedia Pattern Illustrations

Art project at documenta X, Kassel

licit.de

42 x 59.4 cm

Design: czyk

Face 2 Face

Location_Berlin and Frankfurt, Germany $Established_1993$

Founders_xplicit ffm, Moniteurs

Type designers_Alexander Branczyk, Stefan Hauser Alessio Leonardi, Thomas Nagel Heike Nehl, Sibylle Schlaich

Distributors_Face2Face, FontShop International (FSI) Verlag Hermann Schmidt Mainz

Open your font!

Collaborating on anarchistic typography, font drafting and rejection, publication of the F2F magazine and difficult to classify performances.

Publishing Projects

1994_F2F 1 The Hirsch Issue

1995_F2F 2 The Virtual Issue 1995_F2F3 LoveBangLove

1996_F2F 4 Alphabeat

1998_F2F5 Der Typografische Spielfilm t. de/f2f

_Art Projects, Performances

1995_The Screen Scream (Fuse 95 Berlin) 1996_Attitudes for the next millennium

(Int. Design Conference, Aspen/USA) _Type vs.Typo vs.Text (Typo96 Berlin)

1997_Hybrid WorkSpace (documenta X)
_DerTypografische Spielfilm

(The Mind Lounge, Berlin)

_Millennium Countdown

(mind S21 initiation, Stuttgart) ****.leo*ol.de

1998_Radio Dazed

(Deutscher Hörfunkpreis, Stuttgart) _typemotion(typo[media], Frankfurt)

_energija, Münster

_Exhibitions

1994_Flyer Art (Chromapark Berlin)

1995_Frontpage (Chromapark Berlin)

1996_Type//Face (Chromapark Berlin)

_EWerk Medialounge (RedBox Berlin)

1998_Behind the Wall

(mind S21 presentation, Stuttgart)

Websites

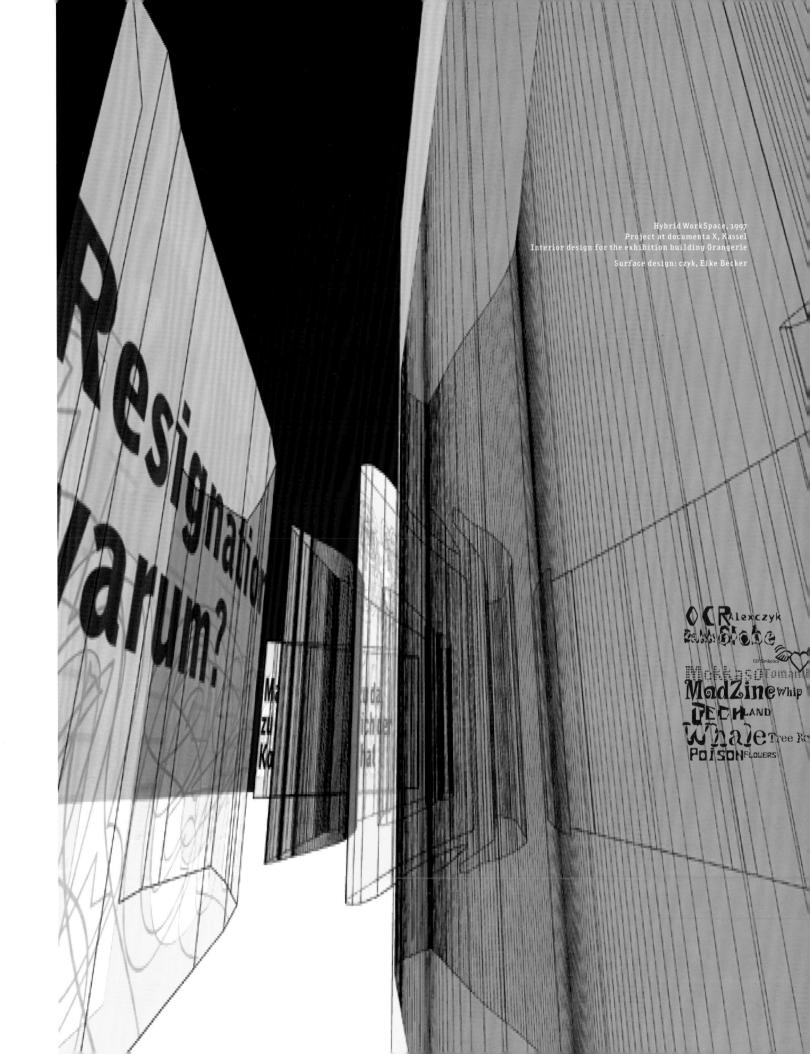

F2F 3 LoveBangLove, 1995 32 x 32 cm

Poster design: czyk, Alessio Leonardi Packaging design: Thomas Nagel Scarf: Heike Nehl

Type design: czyk _Madzine-Dirt

_OCR-AlexczykShake

Thomas Nagel _Madame-Butterfly

_Shpeetz

_Tyrell-Corp

Heike Nehl _Lego-Stoned

_Twins

Alessio Leonardi _AlRetto

Performances, 1995-98 70 x 100 cm Poster design: czyk

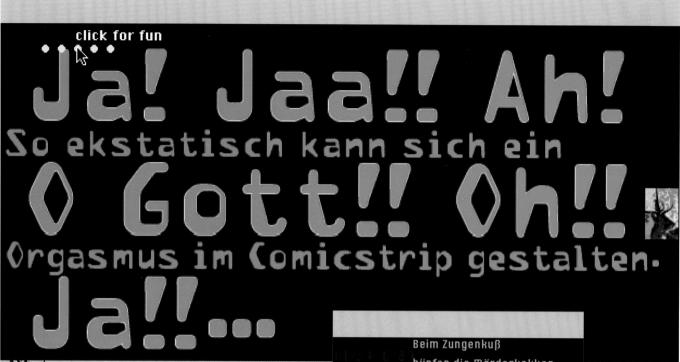

盟 stoned

F2F 5 Der Typografische Spielfilm, 1998 Screenshots from the CD-ROM

Beim Zungenkuß
hüpfen die Mörderkokken
von Mund zu Mund.

Face2Face 5 FZFCzykagoLight

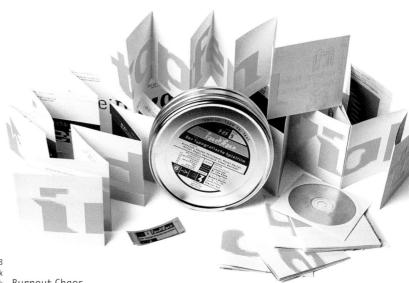

F₂F₅ Der Typografische Spielfilm, 1998 Packaging and booklet design: czyk

Type design: czyk _Burnout Chaos

_Czykago Light

_Frontpage Four

_Monako Stoned

Thomas Nagel _El Dee Cons

Heike Nehl _Starter Kid

Alessio Leonardi _Mekanik Amente

Stefan Hauser _Haakonsen

Sibylle Schlaich _Styletti Medium

Font films directed by: Alexander Branczyk Stefan Hauser Andrea Herstowski Torsten Meyer-Bautor Annette Müller Thomas Nagel Markus Remscheid Diana Simon Annette Wüsthoff

> Soundtracks by: Jammin'Unit Gerard Deluxxe Glory B. General Magic Fact Interrupt Akustik Shift

Lyrics compiled by: czyk & elNag

Special Effects Engineering: Peter Schmidt

annette müller | sząk | irankiebog sukram | sząk | das schöne

122. díf lastchankoltstan lmakkasa tamanik sukram 122. díf lastchankoltstan lmakkasa tamanik maskus

F₂F₅ Der Typografische Spielfilm, 1998 Pages from the 12-metre-long leporello Design: czyk

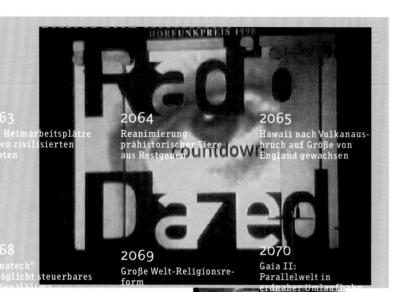

Performance, 1998 Radio Dazed 70 x 100 cm

Poster design | Type design: czyk _BellczykMonoMed _MittelczykHole

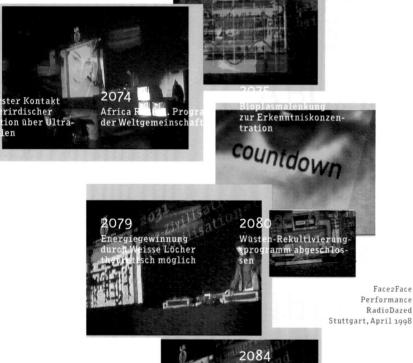

Avatare erwirtsc 2/3 des Welt-Brut alprodukes

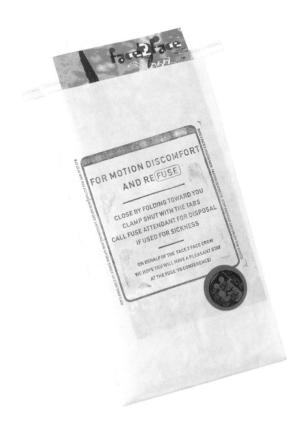

F2F Koetzetuete, 1995 Screen performance For motion, discomfort and reFUSE 13 × 24 cm

Packaging design: Thomas Nagel Movie director: Stefan Hauser Folder design: Alessio Leonardi

raciocazac

F2FCzykagolight
F2FElDeeCons
F2FFrontpageFour
F2FHaakonsen
F2FMekanikAmente
F2FMonakoStoned
F2FStylettiMedium

Styletthedium

anikamente akostorio Modium

Money film
Typonetic Performance at Typo 98 Berlin

Banknote design: Heike Nehl

F2F 4 Alphabeat,1996 16 x 22 cm poster: 42 x 59.4 cm

Packaging design: Thomas Nagel Poster design: Heike Nehl, Alessio Leonardi

Type design: czyk _Czykago-SemiSerif

_Madzine-Script

Stefan Hauser _F2FBoneR-Book

Thomas Nagel _Screen-Scream

_Shakkarakk

Heike Nehl _Lovegrid

Alessio Leonardi Prototipa-Multipla

_Tagliatelle-Sugo

Face2Face Performance Energija Münster, November 1998

MoniMoney
Typonetic Performance at Typo 98 Berlin
9 x 15 cm
Banknote design: Heike Nehl

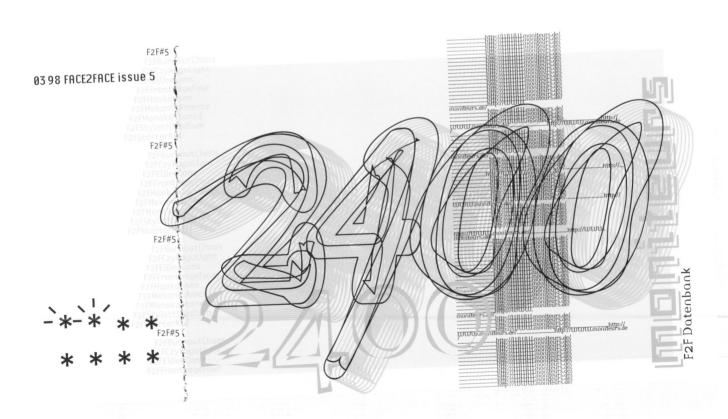

Faith

Location_Toronto, Canada

Established_1990

Founder | Type designer_Paul Sych

Distributors_Thirstype, FontShop
International (FSI)

The work of Paul Sych is testimony to the parallels between music and art. Sych's basic training was acquired at Ontario College of Art (OCA) in Toronto. Due to his interest in jazz, he also enrolled in the Jazz Studies Programme at York University. After completing his studies, he performed at numerous jazz establishments as leader of his own trio ensemble, exploring the art of improvization. His design firm Faith began operating in the autumn of 1990 and is introducing a line of retail products including jewellery, sweaters, watches and T-shirts.

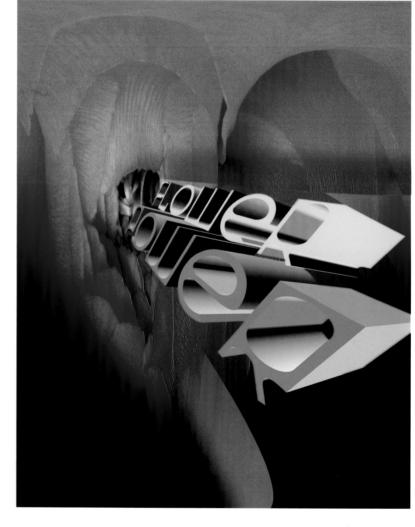

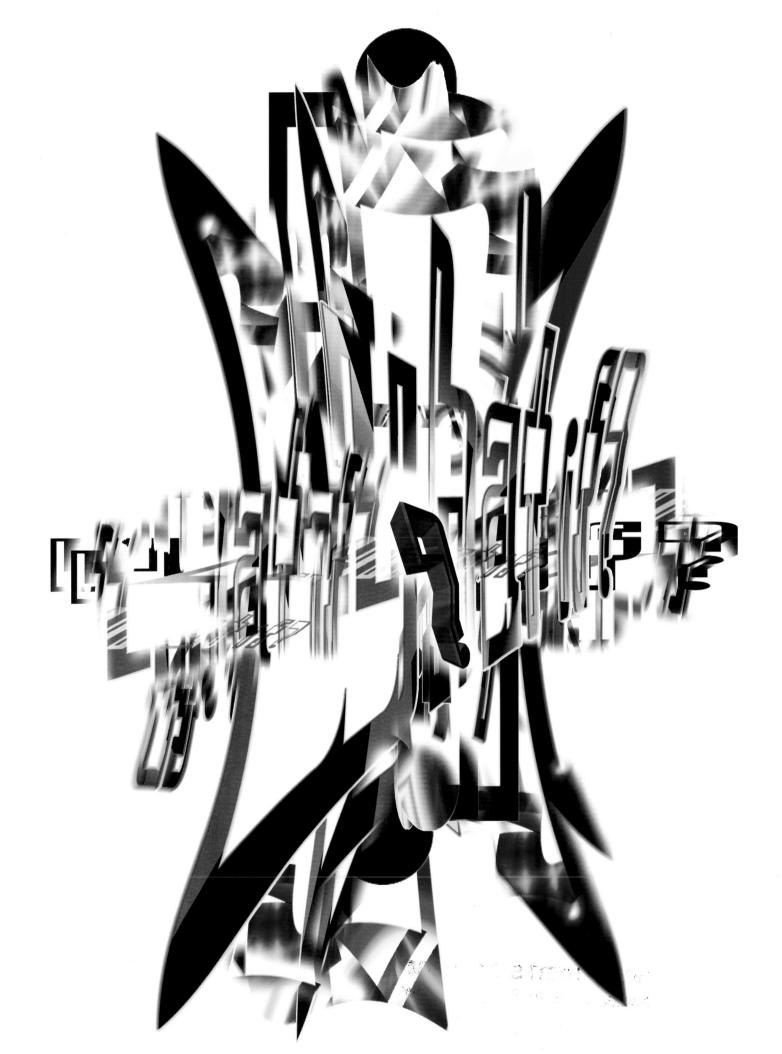

fontBoy

Location_San Anselmo, California, USA
Established_1994
Founder_Bob Aufuldish
Type designers_Kathy Warinner, Bob Aufuldish
Distributor_www.fontBoy.com

Baroque modernism for the new millennium

fontBoy is a product of the vision and explorations of Bob Aufuldish and his partner Kathy Warinner. The foundry has released fonts ranging from the handmade and quirky to the geometrically precise.

A series of dingbat fonts was released between 1995 and 1997; the group now contains 360 dingbats that are all interchangeable and aesthetically interrelated. The current direction of their work incorporates more classical elements into the fonts, using processoriented techniques to defy the designer's expectations. In addition to fontBoy, the partners run the design office of Aufuldish & Warinner.

fontBoy interactive catalogue, 1995
The catalogue allows the viewer to see samples of fonts, print out bitmapped samples, request information and find out about future releases, all within a warm fuzzy environment of goofy colours, witty words and funny sounds.

Design: Bob Aufuldish Writer: Mark Bartlett Sound designers: Scott Pickering Bob Aufuldish

> Screen from the fontBoy interactive catalogue, 1995 Design: Bob Aufuldish

Type design: Kathy Warinner

Bob Aufuldish _Viscosity

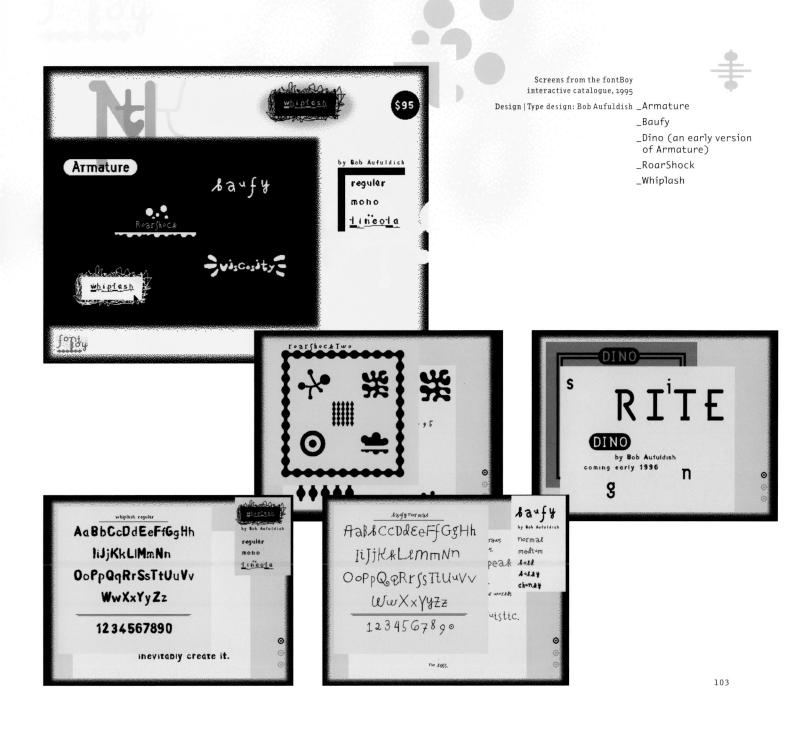

fontBoy screen saver The screen saver uses quotes from Mark Bartlett's essay, 'Beyond the Margins of the Page', juxtaposed with a soundtrack of snoring. The screen saver randomly connects ten quotes with ten typefaces and places the quote on the screen. The quotes flash too quickly to read at first glance, but over time, as the same quotes appear again and again, they begin to acquire a certain sense.

Photographer | Design | Sound design: Bob Aufuldish Writer: Mark Bartlett Coding | Programming: David Karam Dave Granvold

RoarShock one and two are the first two fonts in a series of dingbats/ border/pattern fonts. Traditionally, fonts have had decorative material designed specifically for them; Roar-Shock is contemporary decorative material that relates to the fontBoy aesthetic. The name RoarShock is used to suggest that it is possible to interpret the apparently abstract characters.

Type design: Bob Aufuldish, 1995-97 _RoarShock

The pursuit of meaning requires a type of faith because even when communication is apparently successful it can never be guaranteed to be so

Whiplash demonstrates the meeting of an engineer's template with a pressure-sensitive input device. The underlying structure is rational; the form resting on that structure is process-based. The mono and lineola variations are monospaced, further emphasizing the contrast between the rational structure and the process-based form. Whiplash lineola uses interference to subvert the rational grid structure formed by monospacing.

Armature is the result of an interest

in typefaces that are constructed, rather than drawn. Although it is

basically a monoline design, there are subtle details that compensate for a monoline's evenness. As with all fontBoy fonts, there are dingbats hidden away in the dark recesses of

the keyboard. When first designed in 1992, it was called Dino so the dingbats for Armature are dinosaurs.

Type design: Bob Aufuldish, 1994 _Whiplash

The Viscosity font asks the question,
'Can a typeface be designed without
the repetition of any individual
part, and still be visually unified?'
The two designers - one of whom
drew the upper case, and one the
lower - think the answer is yes, especially when Viscosity is used as text.
The baseline varies to help with the
character fit.

Type design: Kathy Warinner

Bob Aufuldish _Viscosity

curves

twists

doubles back or orbits

plying its course under the tw

fluences

of both verbaland visual force

___The Future of Bitmaps Zuzana Licko

After designing the Emigre website, I was reminded of the need for a comprehensive family of screen fonts with companion printer fonts. To address this need, I set out to design a series of font families, optimized for use in multimedia environments. The result is the Base series of font families, consisting of twenty-four individual faces: two families based on 12-point screen fonts (one serif and one sans serif family), named Base-12; and one family based on 9-point screen fonts, named Base-9.

Outline fonts have a greater degree of flexibility than screen fonts. Therefore, during the design process, the screen fonts tended to dictate the appearance of the printer fonts. The design of the screen font, for example, set exact character widths within which the outline characters were adjusted to fit. (Usually this process is reversed; character widths are normally adjusted to fit around the outline characters.)

The greatest challenge in harmonizing the legibility of screen fonts with printer fonts is that of spacing. Although some existing printer fonts have companion screen fonts that are quite legible on screen, they tend to have two shortcomings: the main problem is that traditional screen fonts are adjusted to fit the shapes and widths of the printer fonts. This causes inherent spacing and character shape problems, since the printer fonts inevitably force unnatural widths or shapes on the screen fonts. The second problem is that of spacing inconsistencies in text sizes due to fractional widths.

In traditional fonts, the width of a bitmap character is a rounded-off measurement. calculated from the corresponding outline character. For example, an outline character with a cell width of 620 at an em-square of 1000 will be rounded down to 6 pixels in a 10-point screen font. The information about the remaining 2/10 of a pixel is stored in the fractional width table. When lines of text are composed, many programs (such as page-layout programs) match the line length of the screen font to the line length of the printer font by calculating the cumulative effect of the character-width fractions. For example, if a 10-point line of type was composed of 10 characters and each character had a remaining 2/10 of a pixel, then the line of type would need to be increased by 1 pixel in order to match the printer output. As a result, an extra pixel of space would be inserted between two of the characters, thereby causing uneven spacing. Moreover, some characters may be moved a pixel to the left or right, thus overriding the spacing intentions of the hand-edited bitmap font.

Rather than deriving the screen font from the printer font, I decided to derive the printer font from the screen font. The first step was to choose the most appropriate screen-font point size. For various reasons, the 12-point size surfaced as the most useful. 12 point is the default size for most applications and Web browsers and 24 point and 36 point (standard sizes to which some applications are limited) are multiples of 12 point. Later on in the development process, I added a family based on the 9-point bitmap to facilitate the other popular sizes: 9 and 18.

The popularity of the 12-point screen font is also due to the relatively coarse screen resolution on computers, which cause the perceived font size on screen to be smaller than the corresponding high-resolution print out. On the screen, 12 point is comfortable to read, 10 point is still readable, 9 point becomes difficult for extensive text and 8 point is difficult to read. When printed out, however, the level of legibility in the various sizes shifts down by at least 2 point sizes.

To clarify the measurement of typefaces, I should explain that each point size is generated by scaling the font em-square. The em-square is the vertical measurement of the body around the font (top to bottom) and needs to allow breathing space for accents,

descenders and other protruding elements. Therefore, the point size does not relate specifically to any part of the typeface's anatomy, that is, a 12-point size measures 12 points from the top to the bottom of the em-square, and the actual dimensions of the x-height or cap-height will vary between typeface designs.

That's the physical measurement of the typeface. However, there are various factors that may make a typeface appear larger or smaller within the same point size. For example, a large x-height or a wide character width makes a typeface appear larger than a design with a smaller x-height or a narrower character width. Since most of the text we read is lower case, the x-height is the most influential element on the perceived size of a typeface. The larger the inside shapes of the x-height (also called counters), the larger the face will appear. Therefore, when relating the perceived point size to screen fonts, it needs to be specified that a 12-point screen font generally has a 6 pixel x-height, which is the pixel size that I used for the Base-12 family.

The next challenge was to relate the measurements of the screen font to the printer font. In order to relate the screen font character widths to those of the printer font, I made the em-square of the scalable printer font divisible by 12. I chose an em-square of 1200 units, thereby making each pixel equal to exactly 100 units in the printer font (this solved the fractional-width problem described earlier). Since the widths of the printer font had to match exactly those of the 12-point screen font, the process was similar to that of designing a monospaced typeface, in that the printer-font character outlines had to be adjusted to fit into predefined character cells. Like the size of the em-square, the size of the character space includes the space around the character and not the measurement of the character itself. The character cell width is the horizontal measurement around a character, including breathing space (left to right). The breathing space around one character when combined with the breathing space around another character creates the space between those two particular letters. If this is done correctly, then words will be recognizable and the typeface will be legible. In most typefaces this breathing space between characters is additionally optimized by adding kerning pairs between problematic pairs. In the case of the Base-9 and Base-12

BASE12/9

Base Twelve Sans
Base Twelve Serif
Base Nine Sans

typefaces, however, kerning pairs would have destroyed the modularity of the spacing, so the spacing had to be optimized solely by adjusting the character shapes. After resolving the measurement and spacing issues, the design of the printer font could depart from that of the screen font. Since the printer font design functions separately from the screen font design, the details of the characters themselves need not follow exactly the structure of the screen fonts; the printer font design needs only echo the implied shape of the screen font. For example, a circle can be implied with as few as 4x4 pixels and geometrically other shapes may similarly be derived. Since there is room for much interpretation at this point, the Base-9 and Base-12 typefaces are merely one design solution and other interpretations may yet be made.

When I first designed bitmaps in 1984 for the Macintosh computer (the Emperor, Emigre, Oakland and Universal families), bitmap fonts were the only fonts available for the Macintosh and my intent was to create a series of legible fonts for the computer screen and dot matrix printer. After the introduction of laser printing and high-resolution outline fonts, I imagined that these bitmaps would be relegated to the status of novelty fonts, as they in fact were for several years. But, with the current interest in multimedia CDs, electronic bulletin boards and the World Wide Web. onscreen design has gained importance. In reevaluating the necessity of screen fonts, I was able to make use of the many lessons I had learned from my early bitmap experiments.

It is ironic that for years pioneers of emerging computer technologies have been slighting the validity of bitmaps, claiming that they are only temporary solutions to a display problem that would soon be fixed by the introduction of high-definition TV and computer monitors. Well, a decade later we're still waiting and it has become obvious that even if such advances were eventually made, the huge installed userbase of today's technology would mean that we would be addressing coarse resolution needs for a long time to come. This is especially significant since there is much talk today about the forthcoming multimedia-style interactive TV programming, with users being able to view such sources as CD-ROM programming, or the World Wide Web directly on their existing TV sets. If this happens, then the US TV monitor (even coarser in resolution than most computer monitors) will be our next challenge.

Certainly there is the need and the creative room for many more legible screen fonts and so it is time for all of you legibility-conscious type designers to finally embrace its technology.

|||||||||| 000000000. ||||||||| 000000000. |||||||||

Top: a line of type set in a 12-point Helvetica screen font with the intended spacing (without using fractional width). Middle: the same line of type set in the same screen font using fractional width. This method produces a line that matches more accurately the printer output, but is detrimental to the legibility of the screen font. Bottom: the same line of type printed out on a high-resolution printer.

The dimensions of the circle correspond with its bitmap. In a screen font, the shapes of the outline font are approximated by crude building blocks on a grid. The two are best married when the shapes and parameters of the outline font work with the limited possibilities of the bitmap.

BaseMonospace BaseMonospace BaseMonospace BaseMonospace BaseMonospace BaseMonospace

The Base Monospace Narrow and Wide families were later added to the series of Base fonts.

monospaced proportional typeface typeface

In a monospaced typeface, such as Base Monospace, each character fits into the same character width (left column). In a proportional typeface, such as Filosofia, each character width is different to accommodate the particular width of each character (right column).

The first step when designing Base Monospace was to choose the model character width. To facilitate a harmonious relationship with the screen fonts, the goal was to select a character width that would have a simple ratio to its em-square. The obvious choice was 100%, or 1:1, the simplest ratio of all, but this idea was discarded since it would have yielded a typeface too wide for practical purposes. Eventually, the 1:2 ratio (50%) was selected as the character width for Base Monospace Narrow and the 3:5 ratio (60%) was chosen for Base Monospace Wide. Since every character in a monospaced typeface must fit into the same space, character shapes become stretched and squeezed accordingly.

c f i l

Some characters, such as c, f, i and l, were made wider than usual to fit into the model character width.

d m w

Other characters, such as d, m and w, were made narrower than usual to fit into the model character width.

il mw

The stretching and squeezing of characters became particularly problematic in the heavier weights; there was usually not enough room to accommodate both the thickness of the stem weight and the complexity of characters such as the m and w. The stem weights therefore had to be adjusted and although the stem weights of the i and l (left) were heavier than the m and w (right), the overall colour density was the same when set in text (below).

AAA WWW

One way to accommodate a bold character is to shift the weight from one part of the letter form to another. The A and W variations above show some of the options. Ultimately, the choice is determined by which is most harmonious within the overall typeface design.

A A

In a monospaced typeface, the spacing can be improved if the characters fill out their spaces evenly. For example, the A with vertical sides (left) is more evenly distributed in the white space within its character cell, and will therefore have fewer spacing problems than the A with diagonal sides (right).

SS

Sometimes the selection of one character variation over another comes down to a choice between the importance of its aesthetic form and its function within the rest of the typeface. Although the open S (right) may have been more appropriate from a formal standpoint, the enclosed S (left) was chosen because of its vertically curved end strokes, which enclose the space more effectively and therefore define more clearly the interior-versus-exterior white space. This reduces spacing problems, as well as giving the appearance of a narrower form that fits more comfortably within the fixed character space.

Cover of Type Specimens, 1995
16.5 x 25.3 cm

Design | Type design:
Richard Lipton _Meno
_Sloop

The Font Bureau

Location_Boston, Massachusetts, USA Established_1989

Founders_David Berlow, Roger Black

Type designers_David Berlow, Roger Black, Leslie Cabarga
Matthew Butterick, Matthew Carter
Tobias Frere-Jones, Richard Lipton
Jim Parkinson, David Siegel, Rick Valicenti
and many more

Distributors_The Font Bureau, FontShop International (FSI)

Agfa, ITF and others

Cover of <u>Type Specimens</u> 2nd Edition, 1997 18.5 x 26.7 cm

Design: Tobias Frere-Jones
Type design: Richard Lipton _Sloop

Tobias Frere-Jones _Interstate

David Berlow entered the type industry in 1978 as a letter designer for the type foundries Mergenthaler, Linotype, Stempel and Haas. He joined the newly formed digital type supplier Bitstream in 1982.

In 1989 he founded The Font Bureau with Roger Black, who has rebuilt some of the world's most prestigious magazines and newspapers over the last twenty-five years. The Font Bureau has developed more than three hundred new and revised type designs for such clients as The Chicago Tribune, The Wall Street Journal, Newsweek and Rolling Stone. The Font Bureau retail library mainly consists of original designs and includes over five hundred typefaces.

Page from <u>Type Specimens</u> 2nd Edition, 1997 18.5 x 26.5 cm

Design: Tobias Frere-Jones
Type design: Leslie Cabarga _NeonStream

Premiere

Festival at Animation

Licket

Matinee

Fresh Buttered Paparin

Silver Screen

Actress

New attractions

Cold Sada

andreas reels at dusty cellulaid

Musical

Blandly glowing strings of letters in chemical colors call up endless memories, of bars and restaurants, of beer and hot dogs, of the Lus Vegus Strip, the arme of neon. Bent glass tubing filled with gas creates the well-known letterform, even weight and even curves mix oddly with challenging colors, promising funky urban pleasures. Leslie Cabarge's NeonStream evokes the Art Deco olamour of the whole thing is now.

Page from Type Specimens
2nd Edition, 1997

Design: Tobias Frere-Jones
Type design: Leslie Cabarga _Magneto Bold, Bold Extended,

.Magneto Bola, Bola Extended, Super Bold Extended

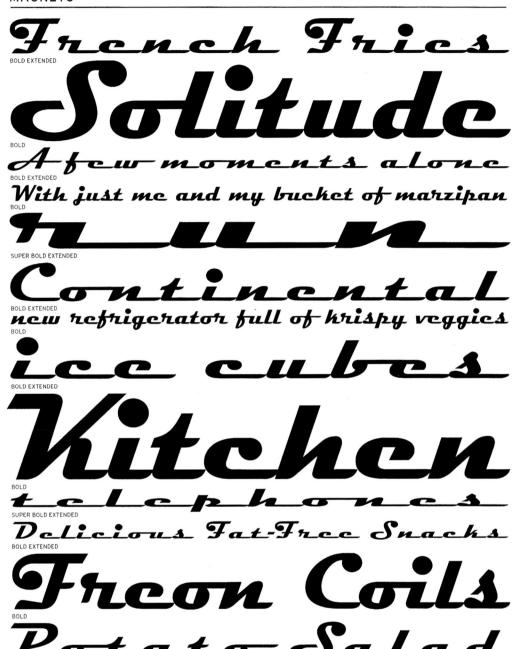

Bold, Bold Extended, Super Bold Extended

Leslie Cabarga has returned to the streamlined scripts prepared by industrial designers at mid-century for the inspiration of his new Font Bureau series. The Magneto trio recall the chrome-strip lettering laid along the rounded shapes of refrigerator doors and automobile trunks in the thirties and forties by a jaunty, self-confident American industry that knew it was going places, doing things, and changing the world; FB 1995.

Black, Black Condensed

Who hasn't admired the energy of Antique Olive Nord? By comparison all other Ultras seem sluggish. Nord exudes Roger Excoffon's animation and Gallic irreverence for typographic rules. Tobias Frere-Jones cross-bred the weight, proportions, & rhythms of Nord with the casual informality and grace of his own Cafeteria, gaining informality, a dancing vitality on the page, in his words, 'a lively if faintly inebriated gyration'; FB 1905.

ABCDEFGHIJKLMNOPQRSTUVWXYZabcdefghijklmnopqrstuvwxyz&ffffffffff ¶\$5£¥#f0123456789%¢°=(+>'"/¿?i!&{/)[\1{1}*..;;....(\b())***'...._•@Jii áàāäääæçéèêēííîññóòôōōøœúùûűÿıÁÀÄÄÄÅÆÇÉÈĒÉÍÍÎÑÓÒÔŌŌØŒŰÙŰŰŸ

First set lasts an unbelievable 3 hours

uliar rhythms of these deceptively casual lette rds. The type brings to paper the syncopated m

Drrembled Masses M m

Light, Light Extended

Lestic Calarga loves mad-century letterforms. Streamine carries to stack to the Joning scripts of the order.

American industrial designers brought these to life in chrome strips flowing across rounded white ename on each new appliance shipped from factories just emerging from the great depression. Symbol of the times these scripts forever call up the world of the 1930 New York World Fair, and all that was to follow, 78 1935

STODE9GH-J9KLMN-OPTIRSTUVWICHTakcheffahlhannpasatarwaga 158LY#501934567892**<>>"68716HINNT.............""-_"-@@@@~/Pfift OTTERRAPE STANDERS S

CITADEI

Description of a metal object

vivian usan replace powerius urtusus somis in the connection form of most geometric subseries. In Citadel Tobias Ferrey-Jones follows a stronger alternative, substituting straights strokes for the curved sides of round characters. Flat horizontal curves play against the variety of serifs in counterpoint to the repeating rhythm of verticals. The inline stripe adds to the rhythm of a type that offers a powerful and stylish geometry, pp 1995.

ABCDEFGHIJKLMNOPORSTUVWXYZabcdefghijklmnopgratuvwxuz8Hffmfff 4SSEX#JUIZ3455789%%C***----"/Z7HGHJHQF*..;__audo---"-.___+1HBEGFW-/ф 4ABBZB@ccde8HTM60005pwddaBQ.4ALLLECCECEHTM6000000000000

Type design: Jean Evans _Dizzy Regular, Alternate Tobias Frere-Jones _Citadel Inline, Solid

FB AGENCY

Neighbors clash over pile of trash

calls on leaders for action ENATORS RUMMAGE THROUGH TRASH

EMPTY MILK CARTON WINS ELECTION

sse Hin, Thin Wide, Thin Extended, Thin Condensed, Thin Compressed, Light, Light Wide, Light Extended, Light Condensed, Light Compressed, Regular, Regular Wide, Regular Extended, Regular Condensed, Regular Compressed, Bold, Bold Wide Jold Extended, Bold Condensed, Bold Compressed, Black Black Wide, Black Extended, Black Condensed, Black Compress

Condensed, and Compressed widths

Type design: Leslie Cabarga _Streamline Light, Light Extended David Berlow _Agency Thin, Light, Regular, Bold and Black weights each in Extended, Wide, Normal,

BIG HUGE MOVING TRUCK All my possessions stuffed into cardboard boxes CONTINENT

From one coast to the other in 35 hours I was pulled over for carrying a futon without a license

Sleeping with intent to snore HEAVY PENALTY

THE EPIC JOURNEY CONTINUED

Still in Trancit

Tasked locals for directions to the highway They sang Sinatra's "My Way" instead

RECORD CONTRACT Toffered them a twelve-album deal, with tour dates in 4.821.975 cities

Dance Hall

Thin, Regular, Bold, Black

LANDLORD
NEW RENOVATIONS
LA LA LE
THE ELEVATORS REMOVED
DIVING BOARDS
NEW POOL
ELEVATOR SHAFTS FILLED WITH WATER
ATTERNATIONAL DIVING
MEDICAL

Revular

Brok appeared in 1925 as powerful characters in a magnificent portrait poster cut in wood by Chris Lebeau for the Willem Brok Gallery in Hibersum, Holland Brok works in figure ground magic when negative leading reduces the white entirps that separate lines to the selender size of those that separate letters, bringing out the dark and blocky shapes. Elizabeth Holzman understood Lebeaus letters, and designed this typeface, as 1935.

ROCKET

NARCISSUS

Arranges historic summit meeting OVERTURES Debate & Discuss A COUNTERPROPOSAL IS SENT FINAL Details All sides agree on Chinese for lunch DELICATE TRUCE TREATY

Handshakes, smiles & side orders Press Conference

In 1921 Walter Tiemann designed Narcissus for Klingspor after a suave set of ornamental inline capitals first cut by Simon Pierre Fournier circa 1795. In 1925 Mergenthaler Linoxype produced Tiemann's type, calling it Narciss. The elegance of Fournier's 1000 six or design created a vogue in late eighteenth century Paris, Narciss and Narcissus sparked a revival in the twenties. Brian Lucid's cut reflects the urbane air of a master, 19395

 $ABCDEFGHIJKLMNOPQRSTUVWXYZabcdefghijklmnopqrstuvwxyzflfffiffffff q$$EY$#f0123456739%%oc^*o-*(**)^*G!lk(f)[\][]]^*......en^**'',<math>_{i_2}$ -14@\$\infty\$^\neg y^* # aaaaaaxcecciiiinooooooccununyi\lambda

Type design: Matthew Butterick _Hermes Thin, Regular, Bold, Black

Brian Lucid _Narcissus

Stratosphere
Realistic Moon Landing Play See

Astronant Helmet

Guided Tour of Cape Canaveral

New Souvenir Shop

Unidentified

the miracles of science

Oxygen

Movements of the Planets

Estate

Color of Cape Canaveral

New Souvenir Shop

Unidentified

Color of Cape Canaveral

New Souvenir Shop

Unidentified

Color of Science

Color of Cape Canaveral

New Souvenir Shop

Unidentified

Color of Cape Canaveral

Color of Cape Canaveral

New Souvenir Shop

Unidentified

Color of Cape Canaveral

New Souvenir Shop

Color of Cape Canaveral

New Souvenir Shop

Unidentified

Color of Cape Canaveral

Rocker – at last, an ultra-Atomic connected script for the nineties – brought to us from the lifties by Leslic Cabarga. He based this typeface on logos from the second wave of the All-American diner, those gleaming buildings which spread across the land dart the war. The greasy fries and gas-guzziling automobiles may be the fabulous lifties' downside. He finds the upode in these hugely coulerant hand-lettered scripts, na 1955

Type design: Elizabeth Cory Holzman _Brok Leslie Cabarga _Rocket

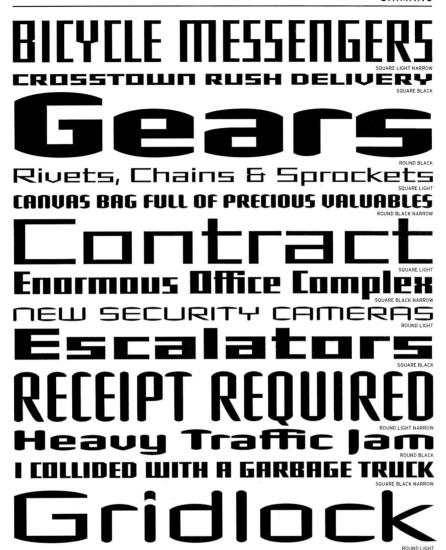

Square Light, Square Black, Square Light Narrow, Square Black Narrow, Round Light, Round Black, Round Light Narrow, Round Black Narrow

This sharp-edged, industrial design from the hand of Richard Lipton was initially inspired by the sight of a single square 'O' in a magazine. Shimano Square and Shimano Round are each drawn in four styles, light & black, for wide & narrow widths. Shimano provides starkly geometric images in contrasting combinations of weight and size, intended for logos, posters, advertising display, and covers for books and records; fb 1995.

ABCDEFGHIJKLMNOPQRSTUVШНYZabcdefghljklmnopqrstuvшнуz8ffffffffff

755£¥#f0123456789%%oc¢*=<+>'"/¿ʔ¡!&(/)[\]{|}*.,;;...«»<>""'·,,__*†‡@@©@™♥

śżśśśśści national special characters: www.vwx

Type design: Richard Lipton _Shimano Light and Black weights
in Normal and Narrow widths
each in Square and Round forms

115

A B C D E F G H I A B C D E F G H I

Promotional postcard for Jesus Loves You All, 1997

Design | Type design:
Luc(as) de Groot _Jesus Loves You All

FontFabrik

Location_Berlin, Germany Established_1997

Founders | Type designers_Luc(as) de Groot, Othmar Motter
Distributors_FontShop International (FSI)
TheTypes

FontFabrik aims to enrich the typographic climate. It offers services such as typeface- and logo-development and digital implementation to design bureaus and advertising agencies.

Luc(as) de Groot and Othmar Motter enjoy microtypographic nit-picking and finding elegant solutions to typographic problems. They work on Mac and PC, from not so early in the morning until late at night, but primarily they put their trust in their eyes, hands, brains and experience. De Groot and Motter design, kern and hint by hand and have a good knowledge of bitmap, Type-1, MultipleMaster and TrueType fonts in many different languages and on various systems.

Agrofont

design Luc(as) de Groot 1997 <luc@fontfabrik.com> commisioned by Studio Dumb

studio@dumbar.nl>

Agrofont Mager Hh Mager cursief aefg

Agrofont Normaa Normaal cursief

Agrofont Vet \$£¢€ *Vet cursief ?!*&

Font commissioned by Studio Dumbar, for the Ministry of Agriculture, 1997

Type design: Luc(as) de Groot _Agrofont

Multiple master font for <u>FUSE</u> 11, 1994, which was devoted to pornography.

Type design: Luc(as) de Groot _MoveMe

Promotional postcard for Nebulae, 1994

Design | Type design: Luc(as) de Groot _Nebulae Promotional postcard for The Types, 1998

Design: Irene de Groot
Type design: Luc(as) de Groot _TheSans Black
_Rondom

lielkes frühe Sünden

"Wozu das alles?" **Orden ohne Alib**i

"Ich glaube, Vera ist da angekommen, wo sie hingehört"

Riesengroßes Fragezeichen

Nr. 52/1996, Titel: Lust am Bösen – Der göttliche leufel; SPIEGEL-Gespräch mit dem Philosophen Rüdiger Safranski über die Aktualität des ösen; SPIEGEL-Umfrage: Gott verliert Mehrheit) Spiegel Headline AaBbCcDd123

Spiegel Book AaBbCcDd123

Spiegel Bold AaBbCcDd123

Sp. Condensed Book AaBbCc123

Sp. Condensed Book Italic EeFfGq

Sp. Condensed SemiBold AaBbCc

Sp. Condensed Bold AaBbCc123

Spiegel Rotation AaBb12345

Sp. Serif Italic AaBbCc12345

Sp. Small Caps der spiegel

Font for the news magazine <u>Der Spiegel</u>, 1997

Type design: Luc(as) de Groot _Spiegel Promotional brochure, 1997 18 pages in four-colour 10.6 x 14.8 cm

Design: Luc(as) de Groot Silke Schimpf Type design: Luc(as) de Groot _Lucpicto Promotional poster for Thesis family, 1994 14.8 x 21 cm (folded)

Design | Type design:
Luc(as) de Groot _TheSans, TheSerif, TheMix

Han e Alleman
Labora et amora
V Q V + R Q D
Mother & Child
Silvius & Arbor
For Her & Him
K&R Clo & Avé
Masters & Mind
You & Me & k
the Sans & Serif
Uit & in & er om
Pen & Potloden

TheSans

TheSerif

TheMix

Promotional postcard for
Jesus Loves You All, 1997

Design | Type design:
Luc(as) de Groot _Jesus Loves You All

Luc(as): 91-95

TAXIATAVAX YOUT STATE OF THE PART OF TAXIATA TAXIATATA TAXIATA TAXIATATA TAX

Promotional postcard, 1997 Design: Alessio Leonardi Type design: Alessio Leonardi _Elleonora d'un Tondo Fabrizio Schiavi _Amsterdam

Fontology

Location_Piacenza, Italy Berlin, Germany Established_1995

Founders_Fabrizio Schiavi, Fabio Caleffi Dina Cucchiaro

Type designers_Fabrizio Schiavi, Alessio Leonardi Distributor_Happy Books

Lettere made in Italy

Fontology intends to revive the tradition of Italian typography. The font designers Alessio Leonardi and Fabrizio Schiavi want to develop a new typography that is specifically Italian. They are also investigating how to combine this research with current impulses from outside Italy. They believe that many designers in Italy draw indiscriminately on their country's typographical tradition and often use established fonts like Bodoni without ever questioning their use. Leonardi and Schiavi would like to promote a critical attitude towards these traditions without overturning them.

The Fontology project is primarily directed at the international type scene and not just at Italian designers. Its objective is to make clear that much is happening in typography in Italy today that can stimulate global communication.

Poster included in the Fontology catalogue, 1995 43 x 54 cm

> Design | Type design: Fabrizio Schiavi _Washed

Logo for Fontology, 1996 Alessio Leonardi designed this logo for Fontology's business papers. It shows that Fontology stands for a relaxed discussion about fonts that people can have over a cup of coffee.

Design: Alessio Leonardi

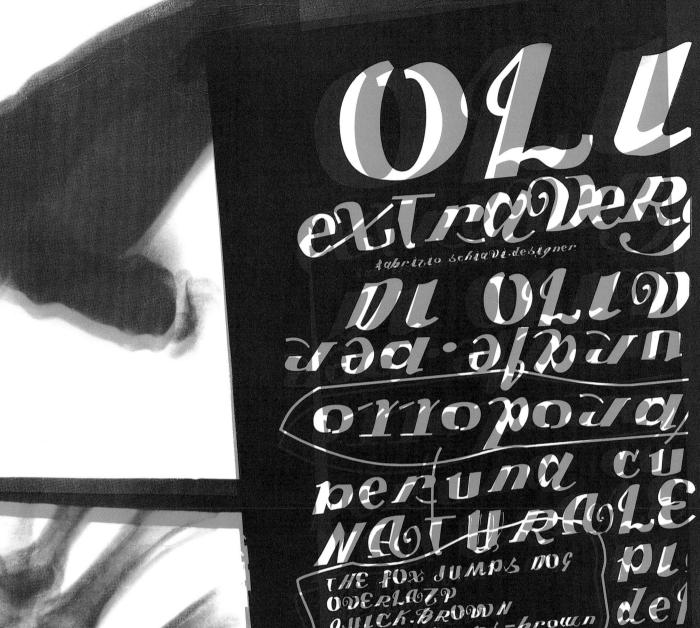

Autek. Brown Cle I dog lazy jumps-brown Cle I U guick fox the over Jumps but of U Dang to the over Dunos for the over but of t

delle olive exterrua.
con sistemi antic
garantiscono,, ini
garantiscono, ini
organoferriche di u

SET In associate from a gradual from the gradual from the

Çoso di Cura San Gioroma

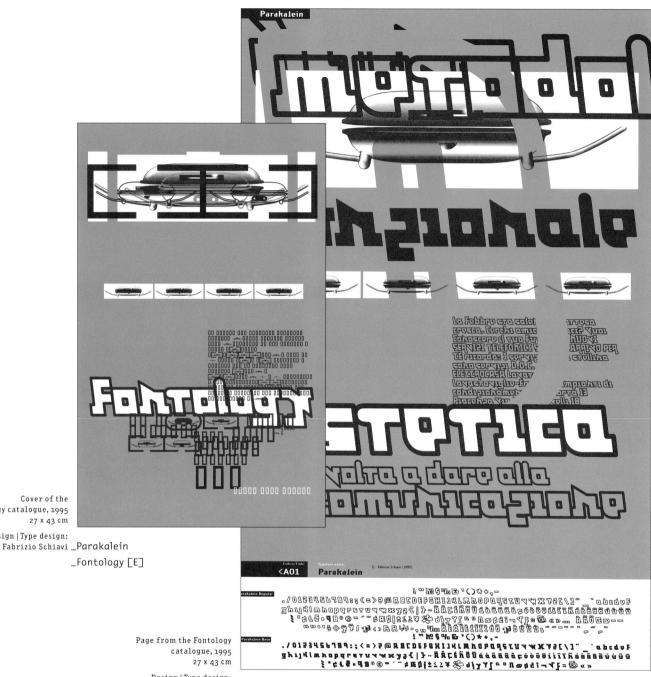

27 x 43 cm

Design | Type design: Fabrizio Schiavi _Parakalein

Cover of the

27 x 43 cm Design | Type design:

Fontology catalogue, 1995

Pages from the Fontology catalogue, 1995 27 x 43 cm

(From left to right) Design|Type design:

Fabrizio Schiavi, Alessio Leonardi _Aurora Nintendo

_Aurora CW

_Cratilo

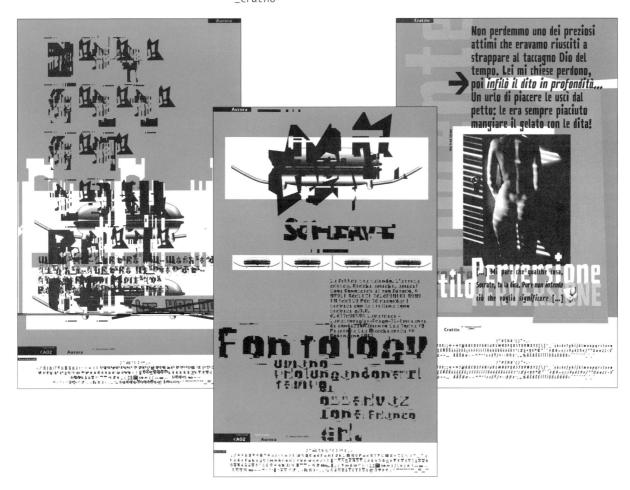

Catalogue supplement, 1995 21.5 x 12 cm (folded) The leaflet shows the keyboard layouts for the Fontology fonts.

Design | Type design:
Fabrizio Schiavi _Amsterdam

FontShop International (FSI)

Location_Berlin, Germany

Established_1990

Founders_Erik Spiekermann, Joan Spiekermann Neville Brody

Type designers_David Berlow, Erik van Blokland, Neville Brody chester, Luc(as) de Groot, Max Kisman, Martin Majoor Just van Rossum, Pierre di Sciullo, Fred Smeijers Erik Spiekermann, Peter Verheul and many more

Distributors_FontShop International (FSI), Type-Ø-Tones, Happy Books, Compress Typewaft, Agfa, FontHaus and others

The most versatile collection of contemporary typefaces

One of FontShop International's main objectives is to build and nurture the FontFont library of typefaces. FSI also regularly releases <u>FUSE</u>, the award-winning experimental typographic publication that has pioneered new territory in the evolution of type design. In addition, FSI also publishes the <u>FontBook</u>, the world's most comprehensive reference book on digital typefaces. FSI is the licensor of the FontShop franchise in many countries around the world, the first branch of which was opened in 1989 by Joan and Erik Spiekermann in Germany and continues to flourish.

FSI released the first edition of FontFonts in 1990 under the title 5 Dutch Designers (Erik van Blokland, Max Kisman, Martin Majoor, Just van Rossum, and Peter Verheul). Still enormously popular, these first typefaces set the standard for the FontFonts that were to follow. They represent the genesis of a typeface library that now holds nearly 1300 fonts and that is internationally known for innovative, contemporary typefaces of the highest quality. What makes the FontFont library unique is its wide variety of original typeface designs. The spectrum of styles ranges from tasteful, high-quality text faces to striking display fonts, to fun fonts that initially reflect the moods of the time and frequently set new typographic trends. The Font-Font library is the largest collection of original, contemporary typeface designs in the world.

Cover of the FontFont catalogue, 1998

Design: Moniteurs, Berlin Type design: Erik Spiekermann

Ole Schäfer $_Info$

Fred Smeijers _Quadraat

Pierre di Sciullo _Minimum

Peter Warren _Amoeba

John Siddle _Boomshanker

Just van Rossum _Brokenscript

Just van Rossum

Erik van Blokland _Beowolf

John Critchley _Bull

Alessio Leonardi _Graffio

_Letterine Archetipetti

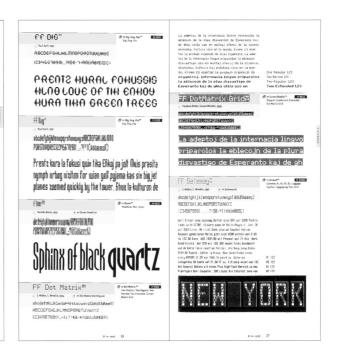

Spreads from the FontFont catalogue, 1998 $$30.4\ x$ 29.7 cm

Design: Moniteurs, Berlin

Type design: Martin Majoor _Scala Sans

Hans Reichel _Schmalhans

Peter Verheul _Sheriff

Luc(as) de Groot _TheMix

Paul Sych _Dig

_Dog

Neville Brody _Dome

Stephan Müller, Cornel Windlin _Dot Matrix

_Gateway

FontFont CD postcard, 1998 14.7 x 10.5 cm

Design: Jürgen Siebert Type design: Martin Wenzel _Rekord

Tony Booth _Sale

Erik van Blokland _Trixie Plain

Just van Rossum _Confidential

_Stamp Gothic

Cover of the FontFont CD-ROM, 1996 13.8 x 12.4 cm

Design: Erik Spiekermann, Jürgen Siebert Type design: Erik Spiekermann _Meta

Font cards

Design (1996): Erik Spiekermann Type design: Erik Spiekermann, Ole Schäfer _Info

Design (1995) | Type design: Pierre di Sciullo _Minimum

Design (1996) | Type design: Tony Booth _Sale

Design (1995) | Type design: John Critchley _Bull

Design (1996): Richard Buhl Type design: Luc(as) de Groot _TheSans Typewriter

Design (1996) | Type design: Alex Scholing _Engine 2

Font card leaflet, 1998 29.7 x 118.4 cm

Design: Judith & Nadja Fischer, Jürgen Siebert

Type design: Martin Majoor _Scala Sans

Johannes Erler, Olaf Stein _Dingbats

Stephan Müller, Cornel Windlin _Dot Matrix

个 Infobahn

Info Normal Info Book

Info Medium Info Semibold Info Bold

All is For the best Tout va pour le mieux dans le meilleur

des mondes possibles.

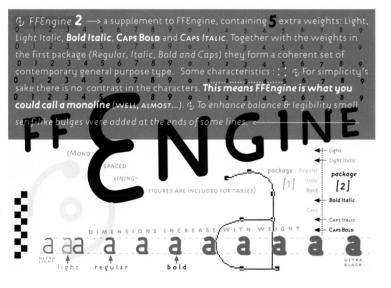

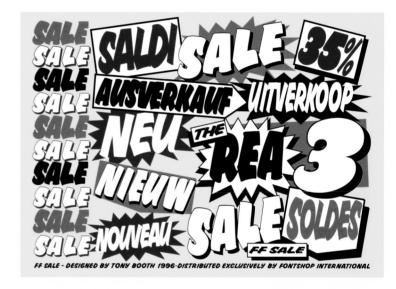

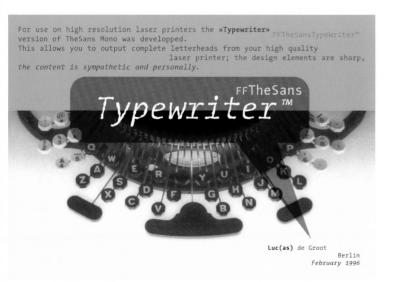

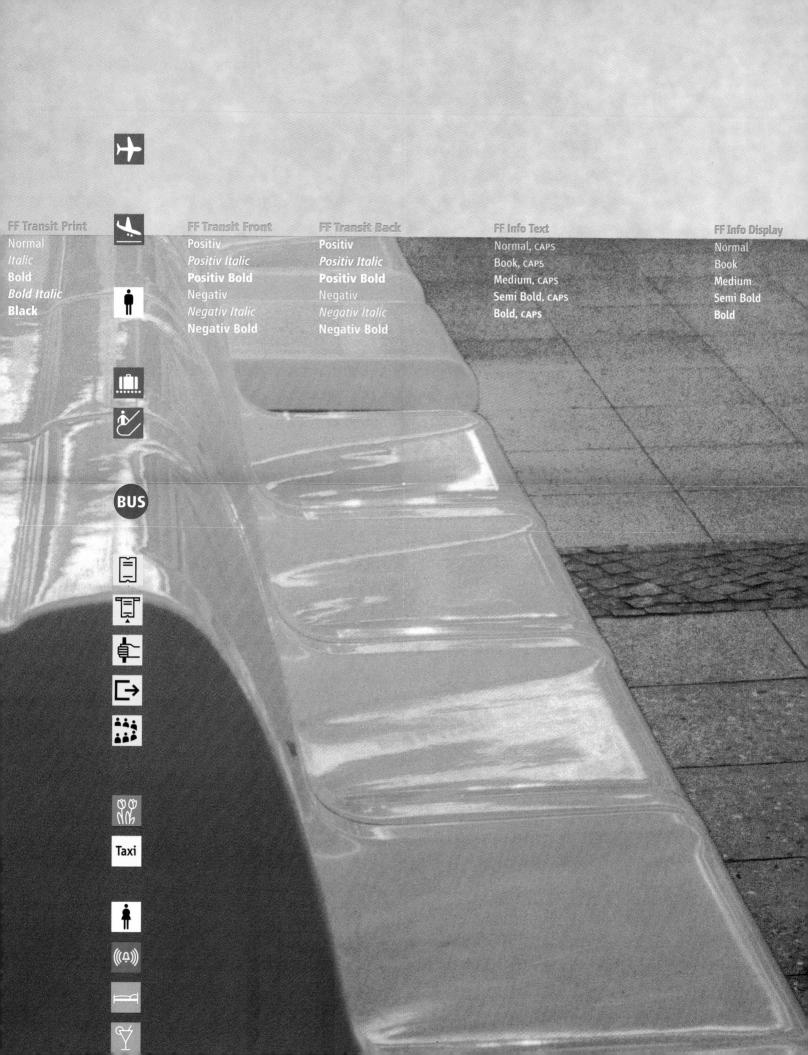

Fonts and Pictograms for Information and Orientation Design

Poster for Dirty Faces 3, 1995
42 x 59.4 cm
Design: Neville Brody

Poster for FF Info and FF Transit, 1997 59.4 x 42 cm Design: MetaDesign Berlin Nadja Lorenz

Type design: MetaDesign Berlin, BVG _Transit

Erik Spiekermann, Ole Schäfer _Info

 ${\tt MetaDesign\ Berlin, BVG, Ole\ Sch\"{a}fer\ _Info\ Pict}$

_Info Produkt

1 1127017

Metaplus Subnormal

Motive light

Motive normal

Votive bold

FF Dirty Faces 3 specimen, 1995

Type design: Simone Schöpp _A Lazy Day

_Littles

Erik Spiekermann, Neville Brody $_$ Metaplus Boiled, Subnormal Stefan Hägerling $_$ Motive

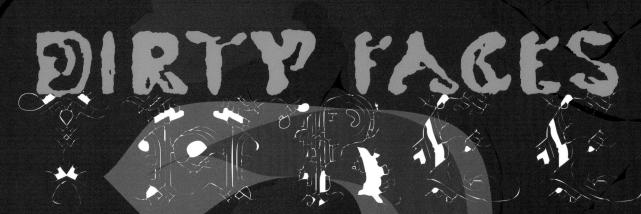

Continuing the FF Dirty Faces Series. Published quarterly, this third set of processed outlines has been

FF Dirty Faces 3 includes 7 crunchy fonts from Simone Schöpp, Erik Spiekermann/Neville Brody and Stefan Hägerling, with accompanying digital poster. FF Dirty Faces 1 and 2 available from the FontShop

SIMONE SCHOOL

FF Meta+Subnormal
FF Meta+Boiled
Erik Spiekermann/Neville Brody

FF Motive
FF Motive
Stefan Hagerling

Font Shop

Packaging for <u>FUSE</u>, 14, 15, 16, 17, 1995-97 17.8 x 22.8 cm

Design: Neville Brody Type design: Morris Fuller Benton _Franklin Gothic

> F Synaesthesis poster, $\frac{FUSE}{42 \times 59.4}$ cm

Design | Type design: xplicit ffm _Synaesthesis

FUSE 14 Propaganda specimen, 1995

Type design: Moniteurs _MMMteurs Real, Cyber

Brett Wickens _Crux95

xplicit ffm _Synaesthesis

Tom Hingston _Chaos Light, Bold

Francis Stebbing, Vera Daucher _Trinity

Neville Brody _Cyber Static

FBITS

it's not getting any better you help me out?

LINAHTI**H**NS

FUSE 15 Cities specimen, 1996

Type design: Paul Elliman
Tobias Frere-Jones _Bits

Frank Heine _Microphone

Peter Grundy _Determination

Darren Scott _DIY Foundation, Skeleton

John Randle _Berliner

Sam Jones _Mayaruler 1

Neville Brody _Smog 1

_City

l'Eurliner

SMU?

二十二 三非二四四非 以以風感以

PCHC66BBC6

F " IL IN

com conmultimodd J. Aperrat

f apparting

FUSE 16 Genetics specimen, 1997

Type design: Alexei Tylevich _Cicopaco

David Crow _Mega-Family

Naomi Enami _Kilin

Tom Hingston, Jon Wozencroft _Condition Birth,

Conception, Mutated, Pulse

Neville Brody _Genetics Second Generation

OURIE OUNTAIN

井子公りしたしままごりまた。 予報を受る

ë5pë € 비비 ºm €

f CHITE -035-9AC

need to be choo threatened: by 'cage. from one or othe

'S at 92.
Toky

'Cannabis is widen the airviters, Croydo s little dru But the tar an nine staff at tut there is see cause proble that they face

FUSE 17 Echo specimen, 1997

Type design: Florian Heiß_Surveillance Date And Time,

Scenes, Suspicious People, Victims, Witness

Function _Where The Dog is Buried Mountain, Top

_Where The Dog is Buried Sea, Bottom

_Shinjuku

Pierre di Sciullo _Spell Me

Anna-Lisa Schönecker _White No Sugar

Neville Brody _Echo Downloaded, Page Three

. Itallowsme to sleep'Flexibly friend 'If emplyers feel able to there is s Q. there "People wilso alleviatewith executive and

Editorial poster for <u>FUSE</u> 17, 1997 42 x 59.4 cm

Design: Neville Brody Type design: Neville Brody _Echo

Function _Where The Dog is Buried

_Shinjuku

Pierre di Sciullo _Spell Me

Florian Heiß_Surveillance

Anna-Lisa Schönecker _White No Sugar

Type design: Wim Crouwel The Foundry, Jürgen Weltin _Foundry Gridnik

The Foundry

Location_London, UK

Established_1989

Founders | Type designers_David Quay, Freda Sack

Distributors_The Foundry, Elsner+Flake
Fontbolaget, FontHaus

Reduce to the maximum

The aim of The Foundry is to develop durable, high-quality typeface designs that are readable, useable and which good designers will choose to use – today's classics. The Foundry studio also develops typefaces for corporate clients such as NatWest Bank, Bg plc (formerly British Gas) and Yellow Pages. It has designed signage typefaces for Railtrack in the UK and for the Lisbon metro system in Portugal.

A secondary range of fonts, the Architype series, has also been developed alongside the main range. Architype concentrates on presenting the work of artists and designers of the European avant-garde. Architype 1 and 2 covers the period from 1919 to 1949, whereas Architype 3 presents the work of a living designer, Wim Crouwel, with whom The Foundry collaborated in the development of six of his designs, from the late 1960s until the early 1970s.

In recent years The Foundry has concentrated on the design of humanistic sans serif typefaces. David Quay and Freda Sack both lecture in type design and are Joint Chairs and Fellows of the Society of Typographic Designers. David is a professor of typography at the Fachhochschule, Mainz and teaches at the London School of Printing.

Information folder entitled Society of Typographic Designers TypoGraphic Awards, held in London, 1996 14.2 x 21.3 cm (folded)

Design: David Quay
Type design: David Quay, Freda Sack _Foundry Sans Extra Bold

abcdefghijk abrak

iklm

Flyers for Architype 1 and 2, 1998
10 X 21 cm
Architype volumes 1 and 2 are collections
of avant-garde typefaces. Architype Tschichold
(flyer 1) was derived from an experimental, single
alphabet by Jan Tschichold in 1929, which was
influenced by Bayer's earlier attempt at a
universal alphabet. Architype Albers (flyer 2)
draws upon Josef Alber's attempt to design a
geometrical stencil alphabet in 1926.

Design: David Quay, Tim Lam Tang Digitization: The Foundry Type design: Josef Albers, Jan Tschichold _Architype Albers

The Country
South Ora
Sout

architype 1

_Architype Albers _Architype Tschichold

abcdefghijklm

Flyer, 1997 10 X 21 CM

Foundry Journal derives its name from its intended use in magazines and brochures, where the narrow column measurements require a more condensed typeface that is economical with space.

Design: David Quay Type design: David Quay, Freda Sack _Foundry Journal

For note information for the formation of the formation o

abcdefghijklm

Flyer, 1997 10 x 21 cm

The idea behind The Foundry Sans came from a conversation between David Quay and Hans Meyer, the designer of the Syntax family.

Meyer revealed that Sabon, designed by Jan Tschichold, was the inspiration behind Syntax.

Meyer's approach forms the basis of The Foundry's design for a sans serif typeface family. Foundry Sans draws its inspiration from Stempel Garamond.

Design: David Quay
Type design: David Quay, Freda Sack _Foundry Sans

Foundry Sans Light
Foundry Sans Book
Foundry Sans Book Italic
Foundry Sans Medium
Foundry Sans Demi
Foundry Sans Bold
Foundry Sans Extra Bold

for now similar for with Aux and T and an a speciated levely from a particular for the format of the

abcdefghijklm

Flyer, 1997 10 x 21 cm

Foundry Old Style is a transitional roman typeface in the classical tradition. The inspiration behind the typeface lay in the pen stroke in incunabula printed type.

Design: David Quay
Type design: David Quay, Freda Sack _Foundry Old Style

Foundry Old Style Book
Foundry Old Style Book Italic
Foundry Old Style Book Italic
Foundry Old Style Book Italic
Foundry Old Style Medium
Foundry Old Style Bold

The Foundry
Studio 1

10-11 Archer Street
Lendon wir 17-16
England

7 4 4 (1017) 74,2605
F 4 (1017) 74,2605
F 4 4 (1017)

__RobotFonts

Erik van Blokland/Just van Rossum

Typefaces are wonderful things. Besides allowing communication through written language, they have become communication devices in their own right. Typographers are always looking for new letter forms and type designers are always trying to make new letter forms. Digital tools have been very important in making both typography and type design much more accessible and flexible. Anything is possible, and - if anything is possible everything will be tried out. And when everything has been tried, one cannot help but notice that everything is not possible. The end of 'Toolspace' (as we call the imagined space that contains all possibilities for tools) has been reached. Toolspace is by definition a finite area: there are always things you cannot do with a tool. The only way to break out of Toolspace is to create a new Toolspace by producing new tools or expanding existing ones.

Image-manipulation tools (such as Photoshop or Illustrator) offer so-called filters, small pieces of software that perform certain effects. The more specific the effect, the easier it can be recognized as the result of a certain filter. And since half the world uses the same filters, there is not much room for originality.

Font tools that offer filtering are not yet very common, and filters as plug-ins for font editors do not exist at all. A lot of type-filtering designers use graphics software to modify their fonts. However, Altsys (now Macromedia) once made a tool called Fontomatic that was designed

to modify existing fonts. It offered some effects that were not terribly useful (for example, it filled all letters with a cow pattern), and never became a success. A more recent attempt - ParaNoise by ParaType - seems to be a bit cleverer: there are lots of parameters and one can layer different effects. Still, the effects are all preprogrammed and therefore quite predictable, and predictability is the last thing a designer should want!

Modifying existing typefaces (preferably one's own!) can be an interesting process. It would be a fast way to experiment with different shapes, but since we don't want to use filters made by others, we have to make our own. Unfortunately, until very recently, there were no tools on the market to do this easily. Petr van Blokland (Erik's brother), who has been developing his own font-editing tools since the early 1980s produced the fully programmable font editor. Macromedia gave their permission for him to use the source code of Fontographer 3.5 and by adding a scripting language, van Blokland (with some help from us) transformed the old program RoboFog.

RoboFog is the name of the new incarnation of old faithful Fontographer 3.5. It has become a two-headed bionic dragon (Fontographer and a full fledged programming language), merged into a single application, with lots of wires running between the two heads. The programming language is Python (powerful, yet easy to learn), which was (and is) developed by Guido van Rossum (Just's brother). It allows one to automate many parts of the type-design process - which involves many repetitive tasks - and to experiment with modifying or creating fonts. Finally individual font filters can be created! The process involves writing a code that modifies an outline and then applying that code to all outlines in the font, or even to all fonts in a folder.

RoboFog is (s)lightly marketed to a professional audience, so others besides us can benefit from its almost endless possibilities (note: some programming skills required!).

Now that designers can program their own filters, there is no need to recycle old ones or to wait for a programmer to come up with ideas for you. Just write a new filter when you need one! Make tools you only need once! Whether you take an existing filter and add something new to it, or you start from scratch, a small change in the code of the filter produces big graphic effects in the type. The homemade filters work as tireless robots in your own font factory, where existing fonts are refitted with new outlines, taken apart and reassembled. The filters can be adjusted either to amplify the good results or to reduce unwanted effects. The filter is the design, the font is just the medium.

Is it really type design? Perhaps filtering type has more to do with typography – the application of type. All filtered fonts are derived works and have to credit the original design, even if it has changed beyond recognition. However, the filter itself can be an original design.

Even with handmade filters, things will begin to look repetitive and predictable at some point. Eventually, new unfiltered typefaces will have the edge over filtered ones. But, in the meantime, there is plenty of opportunity to have fun.

The filters are dead, long live the filters!

Type Design: Nancy Mazzei, Brian Kelly _Teenager

Garagefonts

Location_Del Mar, California, USA

Established_1993

Founders_Betsy Kopshina, Norbert Schulz

Type designers_Mike Bain, Timothy Glaser
Mary Ann King, Betsy Kopshina
Brian Kelly, Nancy Mazzei
Rodney Shelden Fehsenfeld
Gustavo Ungarte and many more

Distributors_Agosto Inc., FontShop
International (FSI), ITF Phil's Fonts

Putting a good face on the future

Garagefonts was created in 1993 primarily as a vehicle to distribute the experimental fonts used in Ray Gun magazine, when art direction was by David Carson Studios. During the period from 1994 to 1998, the font collection grew substantially and took on a noticeably more international flavour. The library illustrates the trend in experimental design and provides an alternative to traditional type. Most of the fonts are created by professional designers and art students from countries around the world including Australia, Canada, Iceland, Italy, Germany and Singapore. Each font comes complete with international characters and all spacing, kerning and construction have been thoroughly tested. Garagefonts will be introducing new fonts regularly and presenting limited-edition faces.

Font catalogue, 1994 18 pages, 2-colour 14 x 14 cm

Design: Betsy Kopshina
Type design: Rodney Shelden Fehsenfeld _Radiente

_Canadian Photographer Script

Pages from the font catalogue, 1994

Design: Betsy Kopshina
Type design: Nancy Mazzei
Brian Kelly _Gladys

Mike Bain _Tooth

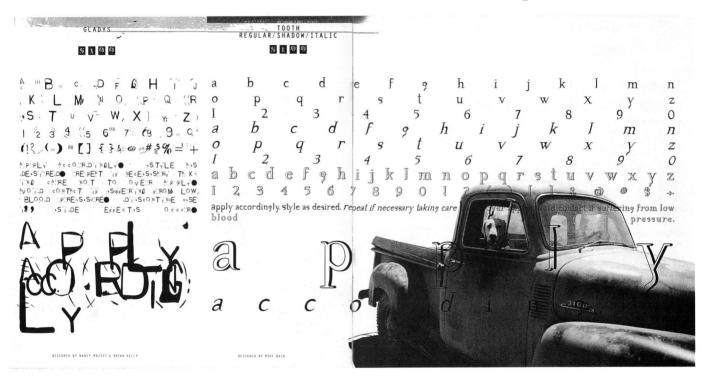

Type design: Rodney Shelden Fehsenfeld _Canadian Photographer Script

ABCDEFGHIJK CYNOP W

Type design: Nancy Mazzei, Brian Kelly _Gladys

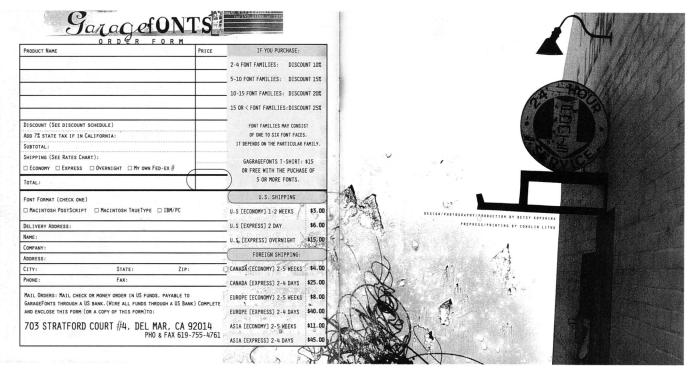

Pages from the font catalogue, 1994

Design: Betsy Kopshina Type design: Rodney Shelden Fehsenfeld _Radiente

 $_$ Canadian Photographer Script

_Pure

Letterhead for Garagefonts, 1995

Design: Betsy Kopshina Type design: Mike Bain _Tooth 31 Shadow Rodney Shelden Fehsenfeld _Pure Capital A B C DEF

STUD POETES
2478 CARMEL VALLEY ROAD , DEL MAR CA 92014

Back cover of the font catalogue, 1994

Design: Betsy Kopshina
Type design: Rodney Shelden Fehsenfeld _Pure Capital

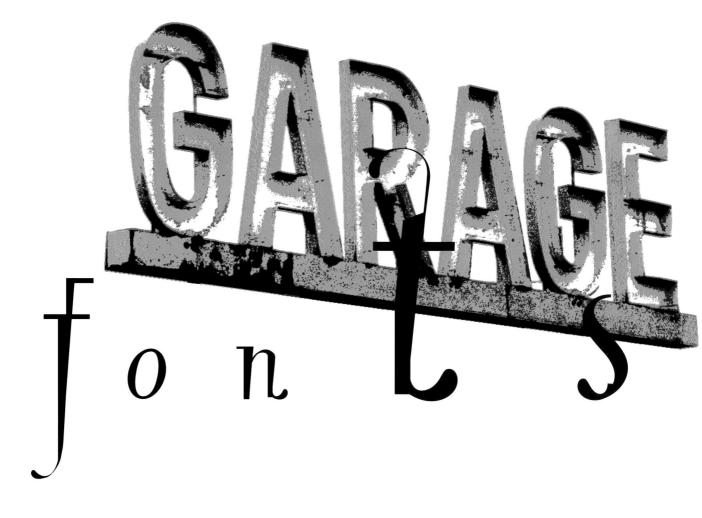

WHEN ITS LATE AND YOU NEED THE PERFECT FONTS

RIGHT NOW TO MAKE YOUR PROJECT WORK,

GO TO WWW.GARAGEFONTS.COM

See the winners of the first international font design contest sponsored by GarageFonts and Macromedia.

We're offering special deals on the Ray Gun Classics as we prepare to put them out to pasture. Get 'em while you can. electriclide transmission

WE DON'T KEEP YOU WAITING BY THE MODEM OR THE MAILBO BROWSE, ORDER, CHARGE IT (SECURELY) AND DOWNLOA THEN GO—CREATE—WIN AWARDS—MAKE MONEY—WHATEVE JUST COME BACK WHEN YOU HAVE MORE TIN

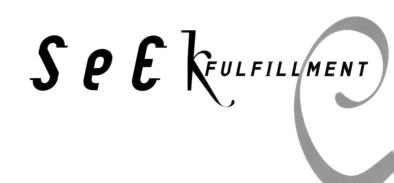

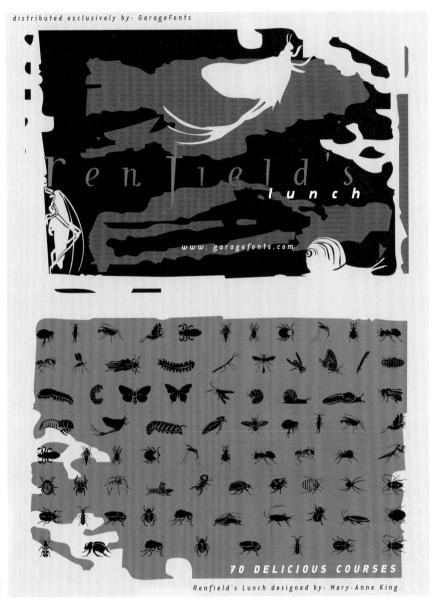

Flyer to promote Renfield's Lunch, spring 1998

Design: Betsy Kopshina Type Design: Mary Ann King _Renfield's Lunch Dingbats

Thomas Schnaebele _Café Retro Bold, Black

Timothy Glaser, Josh Darden _Index Italic

Christine Taylor _Hegemonic

Poster advertising on-line ordering system, 1998

Design: Betsy Kopshina
Type design: Christine Taylor _Hegemonic

Timothy Glaser, Josh Darden _Index Italic

Gustavo Ungarte _Conectdadots Interleave

Thomas Schnaebele _Café Retro Bold

_Dualis Italic

Interactive design for the multimedia piece In Search of the Next Big Whatever, about the Design Contest, spring 1998, organized by Garagefonts/Macromedia.

Design: Betsy Kopshina

Garagefonts and Macromedia joined forces to sponsor a major international font design contest. Entries were judged by internationally acclaimed graphic designers Neville Brody and David Carson and by authors Steven Heller and Robin Williams. Submissions were accepted in three categories: text, headline/experimental and dingbats. In addition to cash prizes and Macromedia software, winners were offered licensing agreements for worldwide distribution through Garagefonts.

Typo ruler (useless) 1994 5 x 20 cm Based on the measuring system garcia

> Design: Typerware Type design: Andreu Balius _Playtext

Typerware _Tiparracus

garcia fonts & co.

Location_Barcelona, Spain

Established 1993

Founders_Andreu Balius, Joan Carles P. Casasín

Type designers_Laudelino L.Q., Estudi Xarop Alex Gifreu, Pablo Cosgaya Peter Bil'ak, Agente Doble Malcolm Webb, David Molins Typerware, Andreu Balius

Distributors_garcia fonts & co., ITC, FontShop International (FSI)

Type is not sacred. Type is POPULAR!

garcia fonts & co. is a digital typeface project, founded in spring 1993 by Andreu Balius and Joan Carles P. Casasín in Barcelona. The fonts are obtained by exchange with a personally designed font. Everyone who sends in a font receives material from the library, but only the most interesting contributions are shown in the frequently published brochures. The fonts are exclusively distributed for experimental and personal use. If studios or agencies want to use fonts for commercial purposes, they can buy the ones designed by Andreu Balius and Joan Carles P. Casasín, which are published under the name Tw®Font Foundry, affiliated with their design studio Typerware (see p. 272).

Catalogue 1, Library #1-#6, 1995 Brochure, 40 pages

> Design: Typerware Type design: Andreu Balius _Playtext

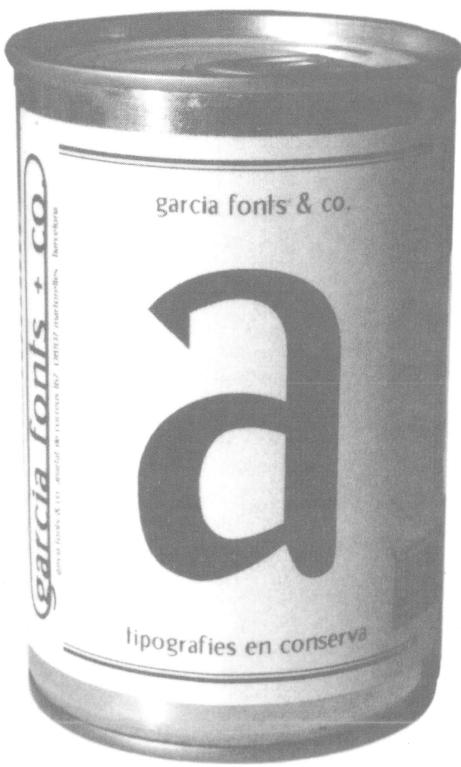

Invitation postcard for the exhibition garcia fonts & co. tipografies en conserva in Vic, 1995.

Design | Type design: Andreu Balius _Playtext

Tiparracus type specimen included in Library #5, 1994.

Design: Andreu Balius Type design:Andreu Balius _Playtext Typerware _Tiparracus

Earcia fonts & coal affair

Pages from Library #5, 1994 40 × 42 cm Matilde Script type specimen Design|Type design: Andreu Balius _Matilde Script

* Matilde Script *
Soa Bb Cc Çç Dd Ee
Ff Gg Kh Ii Fj Kk
Ll Mm Nn Nñ Oo
Pp 2g Rr Ys Et Uu
V~ Ww Kx Yy Zz

Library #4, 1994 10 x 21 cm Ozó type specimen

Design: Andreu Balius
Type design: Typerware _Ozó type
Andreu Balius _Playtext

Library #5, 1994 10 x 21 cm Matilde Script type specimen

Design | Type design: Andreu Balius _Playtext

Type specimen for FontSoup light, regular, boiled, extraboiled, vomited and Garcia Snacks, 1995 10 X 21 CM FontShop now exclusively distributes the redesigned

> Design: Andreu Balius Type design: Typerware _FontSoup _Garcia Snacks

Andreu Balius _Playtext

Type design: Typerware _Parkinson

Pages from Library #6, 1994

Parkinson type specimen Design: Andreu Balius

40 x 42 cm

Library #6, 1994 10 X 21 CM Parkinson type specimen

library

Design | Type design: Andreu Balius _Playtext

Pages from Library #7, 1995 40 x 42 cm Belter type specimen folder, now exclusively distributed by ITC.

Design: Andreu Balius

Type design: Typerware _Belter Regular, Outline, Extra Outline

) P

<u>aniversario</u>

CONCHITA BAUTISTA

JOSÉ GUARDIOLA

BETT

MISSIEGO

SALOMÉ

JOSÉ VÉLEZ

RAPHAEL

BNUBE

EVH SANTA MARIA

AZUCAR MORENO

MOCEDADES

ERES TÜ

JULIO IGLESIAS

LA. LA. LA

PALOMA SAN BASILIO

MICKY

CADILL AC

SERGIO Y

suan Castillo Script

The handwriting of an elder man from Albacete (spain)

AaBbCoCoDdEeF+Calt MisikkleMMNnNnO ofpoqRrSottleWwW

£= (1234567890)

AaBbCcCcDdEeffCgH Missittle MMN nNno of po a Rasott Mulve W W++4ytz (1234567890)

Marrier of tratementar

Pages from Library #8, 1995 40 x 42 cm

Juan Castillo Script type specimen. The typeface is based on the handwriting of an old man from Albacete

> Design: Andreu Balius Digitization: Typerware _Juan Castillo

Script Fina,Regular

VIVO CANTANDO

QUIEN MANEJA MI BARCA

enserame a cantar

Cover for Library #7, 1995 10 X 21 cm Belter type specimen

> Design: Andreu Balius Type design: Typerware _Belter Andreu Balius _Playtext

is for me

library

Cover for Library #8, 1995 10 x 21 cm Juan Castillo Script type specimen Design | Type design: Andreu Balius _Playtext TABLE COLDER OF THE RELIGIOUS OF THE SECOND SECOND

Page from I
Des

Page from Library #11, 1996 40 x 42 cm

Design | Type design:
Malcolm Webb _Network

Library #11, 1996 10 x 21 cm Network and Jam Jamie type specimen

Design: Malcolm Webb, Alex Gifreu
Type Design: Andreu Balius _Playtext

Library #12, 1998 10 x 21 cm Inmaculatta and Euroface type specimen

Design: Agente Doble, Peter Bil'ak Type design: Andreu Balius _Playtext

garcia for

Digitization: Typerware _Juan Castillo Script

Quicktime shows with music,
1996
The shows are distributed
with the fonts (on floppy disk).
They begin with a photograph of the brochures and
packaging and go on to
present pictures and illustrations to promote the fonts.

Design: Andreu Balius

Parta Por Mitterte The Marker

Digitization: Typerware _Vizente Fuster

Matilde Script Isa Bl Cc Dd Ee Ff Sg Fh Ii Ij Hh Bl Mm Nn Oo Pp 2g Fr Is Et Uu V ~ Xx Iy Zz

Type design: Andreu Balius _Matilde Script

Type design: Andreu Balius _Garcia Bitmap

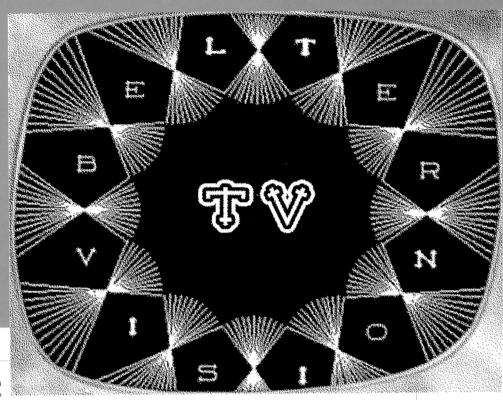

Promotional film for Belter, with music from the Sixties, 1996

Design: Andreu Balius Type design: Typerware _Belter

BELTER

ABCDEFGHI JKLMNOPQ RSTUVWXYZ Pictures from the Quicktime show, 1996

Design: Andreu Balius Type design: Typerware _Belter

House Industries

Location_Wilmington, Delaware, USA

Established_1993

Founders_Andy Cruz, Rich Roat

Type designers_Andy Cruz, Allen Mercer

Ken Barber, Jeremy Dean

Kristen Faulkner, Nicole Michels David Coulson, Tal Leming

Distributors_House Industries,
FontShop International (FSI), Atomictype

Slapping a reference book on the scanner and boosting images isn't our baa.

After a modest beginning in 1993, House Industries' reputation for dependability, integrity, stubbornness and overpackaging has grown to put them at the forefront of the display typographic trade.

All House Industries merchandise is unique and is created to the highest level of craftsmanship. The most popular font collections begin where display type should – as pencil sketches on paper. Only after diligent artists have finessed each complete character set in pen and ink does it enter the digital realm. There aren't any computer-enhanced filter fonts or overused designer clichés in the House Industries library, just revivals of all the cool old stuff that everyone else is too lazy to draw these days. The same work ethic goes into House Industries' commercial illustration projects, T-shirt collections and product packaging. All illustrations, paintings and type treatments are exhaustively refined by the overworked and underpaid House Industries staff.

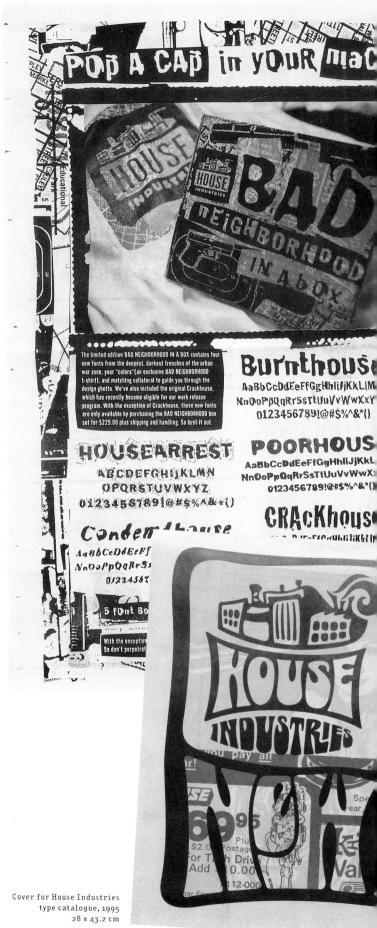

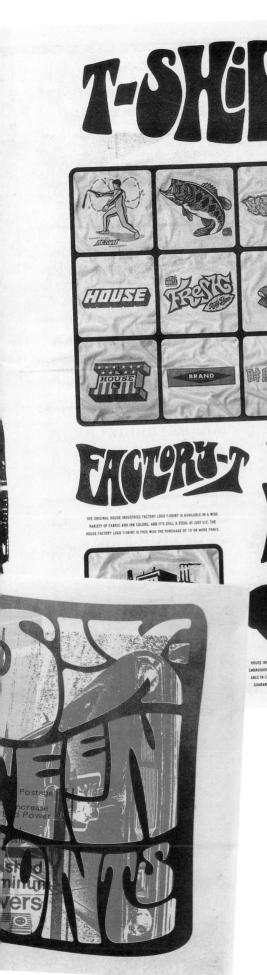

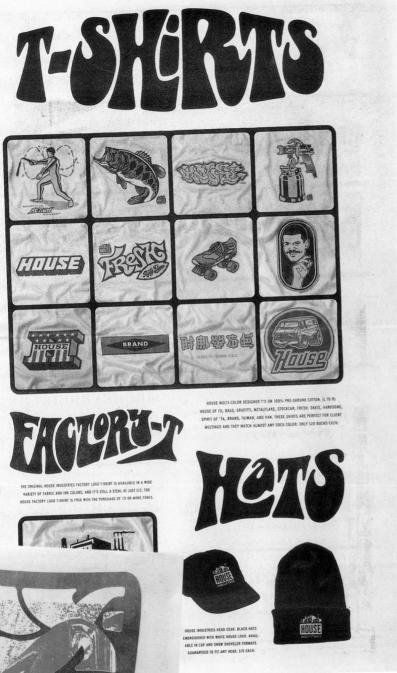

Logo for Paper Line (Custom Papers Group), 1995 Design | Hand lettering: Andy Cruz Allen Mercer _Custom type

House Industries type catalogue, 1995 28 x 43.2 cm

> Design: Andy Cruz Hand lettering: Andy Cruz Allen Mercer, Ken Barber _Custom type

Type design: Jeremy Dean _Burnthouse

- _Poorhouse
- _Crackhouse
- _Condemnedhouse
- _Housearrest

Super Riegel Custom shop manual paper promotion, 1995 14 x 21.6 cm Several of the headlines and type treatments in this piece and the Super Riegel Custom logo were the inspiration behind the House Street Van font collection.

Design: Andy Cruz, Rich Roat, Allen Mercer Hand lettering: Andy Cruz, Allen Mercer _Custom type

Type design: Allen Mercer _Horatio

Bad Neighbourhood catalogue, 1995 15.3 x 28 cm

Design: Andy Cruz, Jeremy Dean
Hand lettering: Jeremy Dean _Custom type

Dragster catalogue, 1996 15.3 x 28 cm

Design: Andy Cruz, Allen Mercer, Ken Barber Hand lettering: Andy Cruz, Allen Mercer _Custom type

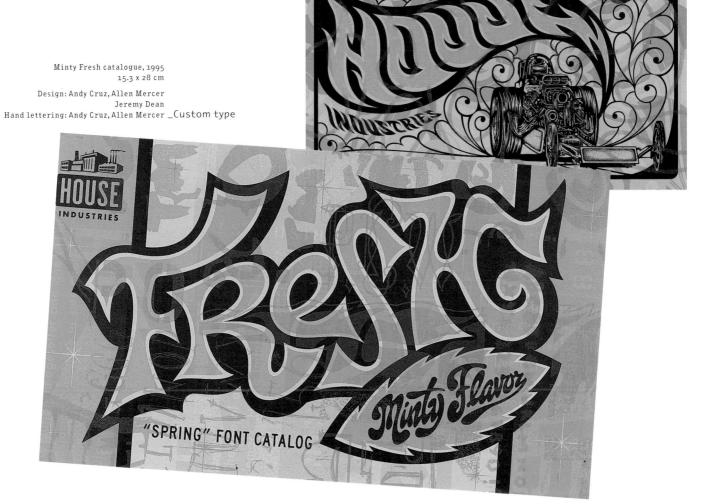

Black Leatherette catalogue cover, 1994 15.3 x 28 cm

Design: Andy Cruz Hand lettering: Andy Cruz, Allen Mercer _Custom type

FUNKHOUSE

ABCDEFGHIJ KLMNOPORST UVWXYZ 1234567890

KATHODSE

ABBCCDLEEFfGg Hhli J.Kk Ll Mm Nn Oo PPQqRrssTtDuVv WWXxYYZz 1234567890

SCUBYZHOUSE

Aabbccddeeffgghhii Jjkklimmnnooppaq Rrsstluuvvwxxxyzz 1234567890

Spread from black Leatherette catalogue, 1994

> Design: Andy Cruz Type design: Allen Mercer _Funkhouse

> > _Kathouse

Kristen Faulkner _Scübyzhouse

Jeremy Dean _Crackhouse

Andy Cruz _Warehouse

_Rougfhouse

CRACKhouse

AaBb Cc Dd Ee Ff Gg Hh liljKkllMm Na OoPp Qq RrSsTt Uu Vv Ww Xx Yy Zz 1234567890

WAREHOUSE

ABCDEFGHIJ KLMXOPQRST UVWXYZ 1234567890

Rougthouse

AaBic. Date FragHh IIJ: KKLIMm NaU. P.Q. RrS. T+U.V.W.XxY, Zz 1234567890

Wousemaje)

CrabbCoDd&oFfggkh lidjKkLlMmlinOofpQq RrSsT fridvldwxxfyZz 1234561890

CHOPHOUSE

AaBbCcDdEeFfGgHhli JjKkLlMmNnOoPpQqRr SsTtUuVvWwXxYyZz 1234567890

\$66200066 6020560006 60206000000 52006000000 500061006

Spread from black Leatherette catalogue, 1994 15.3 x 28 cm

Design: Andy Cruz Type design: Kristen Faulkner _Housemaid

Ken Barber _Heads of the Household

Allen Mercer _Chophouse

_Treehouse

_Funhouse

Nicole Michels _Doghouse

3605H33NJ

AaBbCcPd==FGgHhli SJKkllmmnnooPpQqKr S=TtuuVvWWXXYyZz 1234567890

FUNHOUSE

ABCDEFGHIJ KLMNOPARST UVWXYZ 1234567890

Doghouse

OlaBbCoDdEeFfGgHh
IiJjKKllMmNnOoPpQq
RrSsTlUuVvWwXxYyZz
1234567890

ITC

Location_New York, USA

Established_1973

Founders_Herb Lubalin, Aaron Burns

Type designers_Herb Lubalin, Ed Benguiat, Aldo Novarese
Mark Jamra, David Farey, Robert Slimbach
Hermann Zapf, Matthew Carter, Sumner Stone
David Quay, José Mendoza and many more

Distributors_Adobe, Agfa, Bitstream, Elsner+Flake
FontShop International (FSI), FontWorks
Linotype Library, Monotype Typography
Precision Type, Treacyfaces

Inform and inspire the design community

An international leader in typeface design and marketing for over twenty-five years, ITC collaborates with world-class designers to provide a library of over 1200 classic typefaces and innovative new designs, as well as complementary products for digital design. ITC licenses its typeface library to more than 130 companies in the graphic design, computer and printing technology fields throughout the world. As part of its commitment to informing and inspiring the design community, ITC publishes the award-winning quarterly publication U&lc (Upper & Lower Case: The International Journal of Graphic Design and Digital Media), where new ITC typefaces are introduced and shown in use. The on-line edition of the journal can be found at www.uandlc.com. ITC's website, located at www.itcfonts.com, provides typographic information, resources and tools, as well as an on-line type shop.

U&1c cover, volume 25 number 2, Fall 1998 21.2 x 27.5 cm Design: Mark van Bronkhorst

ASE: THE INTERNATIONAL JOURNAL OF GRAPHIC DESIGN AND DIGITAL MEDIA PEFACE CORPORATION: VOL.25 NO.2: FALL 1998: \$5 US \$9.90 AUD £4.95 田田日内 山 SOLD TO: \$989689888 مر مر مر مر مر د

ITCTYPEFACE

U&lc back cover, volume 25 number 2, Fall 1998 21.2 x 27.5 cm

Design: Mark van Bronkhorst MvB Design

<u>U&lc</u> inside pages, volume 25 number 2, Fall 1998 21.2 x 27.5 cm Essay about the type designer Phill Grimshaw.

Design: Mark van Bronkhorst MvB Design Type design: Phill Grimshaw

U&lc cover, volume 25 number 1, Summer 1998 21.2 X 27.5 cm

Design: Mark van Bronkhorst MyB Design

newfromitc

ITC Officina Sans & Serif

When ITC Officina was first released in 1990, as a paired family of serif and sans-serif faces in two weights with italics, it was intended as a workhorse typeface for business correspondence. Its robust structure was meant to work when printed on 300-dpi office printers, and it had the no-frills legibility of a typewriter face, although much subtler in its design. But the typeface proved popular in many more areas than correspondence. It's been used as a corporate typeface, especially by high-tech companies and car manufacturers. Erik Spiekermann, the founder of MetaDesign in Berlin, who designed the original version, says, "Once Officina got picked up by the trendsetters to denote 'coolness', it had lost its innocence. No pretending anymore that it only needed two weights for office correspondence. As a face used in magazines and advertising, it needed proper headline

Pages from U&lc, volume 25 number 1, Summer 1998 21.2 x 27.5 cm

Design: Mark van Bronkhorst MvB Design Type design: Erik Spiekermann _Officina Sans & Serif

textbyjohndberry

weights and one more weight in between the original Book and Bold. And they would all have to be available in Sans and Savif. Roman and Italics, with Samali Caps, and Odd Sylvefiguers. To add the new weights and small caps, Spiekermann collaborated with Ole Schler, who is Director of Pyogogaphy and Type Deelign at Netabesign in Berlin. "We started wowning that the Sans and Savif. We started working at momental between Giberra, which is the started working at Metabesign, no continued working on the Offician of FICINA Officina of Sans and John Caps. The original concept which was a started working at the characters, talk about it, and put in the corrections. The digital is doe is mostly my part."

Spiekermann observes: "The original concept meant that Offician strued dut to be a very rugged typeface, which is now proving its worth in the newest medium, online communication. I've long had the theory that faces designed to address one problem end up becoming classics—and not just these days, when the trend towards fudurital faces is a trend against verve-designing, against decorre

is a trend against over-designing, against decora-tion and all sorts of other social implications. Look at the present hits: Bell Gothic, DIN, OCK-B, Letter Gothic, Frutlger (designed for one signage project), Interstate, Officina... Even Times New Koman was Interstate, Officina... Even Times New Koman was designed for one project originally: rough paper, worn type, platen printing. All those faces have survived and are being used again."

Officina Officina Officina

Officina OFFICINA Officina

Officina OFFICINA Officina

Officina OFFICINA Officina

aaaaaaaaaaaaaaaaaaaaaaaaa

Try before you buy 🕞 Set your own text sam

U&lc cover, volume 21 number 4, Spring 1995 27.5 x 37.3 cm

Design: Rhonda Rubinstein

Pages from U&lc, volume 25 number 1, Summer 1998 21.2 x 27.5 cm

Design: Mark van Bronkhorst MvB Design

Type design: Slobodan Miladinov _Coconio

_Beorama

Teri Kahan _Holistics

Phill Grimshaw _Stoclet

newfromITC

ABCDEFGHIJKLMNOPQRSTUVWXYZ 12345678904bcdefghijklmnopgrsturWxyz FONTEK

AAABCDEFGHIJJKLMNNOPQ RSTUVWXYZ&1234567890 abccdeefghijklmnopqrsstuvwxyz AAABCDEFGHIJJKLMNNOPQ RSTUVWXYZ&1234567890

<u>U&lc</u> covers volume 22, 1995 number 1, Summer 27.5 x 37.3 cm

Design: Rhonda Rubinstein

number 2, Fall 27.5 x 37.3 cm Design: Michael Ian Kaye number 3, Winter 27.5 x 37.3 cm

Design: Rhonda Rubinstein

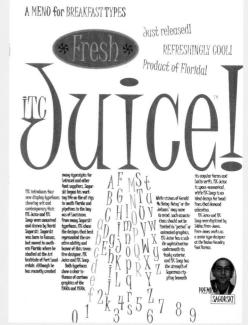

Page from <u>U&lc</u>, volume 21 number 4, Spring 1995 27.5 x 37.3 cm

Design: Rhonda Rubinstein Type design: David Sagorski _Juice

Pages from U&lc volume 22, number 2, Fall 1995 27.5 x 37.3 cm

Design: Michael Ian Kaye

Book design is an act of pure seduction.

volume 22, number 1, Summer 1995 27.5 x 37.3 cm

Design: Rhonda Rubinstein

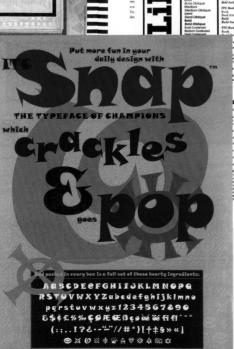

Volume 21, number 4, Spring 1995

Pages from <u>U&lc</u>, volume 21 number 4, Spring 1995 27.5 x 37.3 cm Illustration showing an album cover of the band Underworld designed by John Warwicker/Tomato.

Design: Rhonda Rubinstein

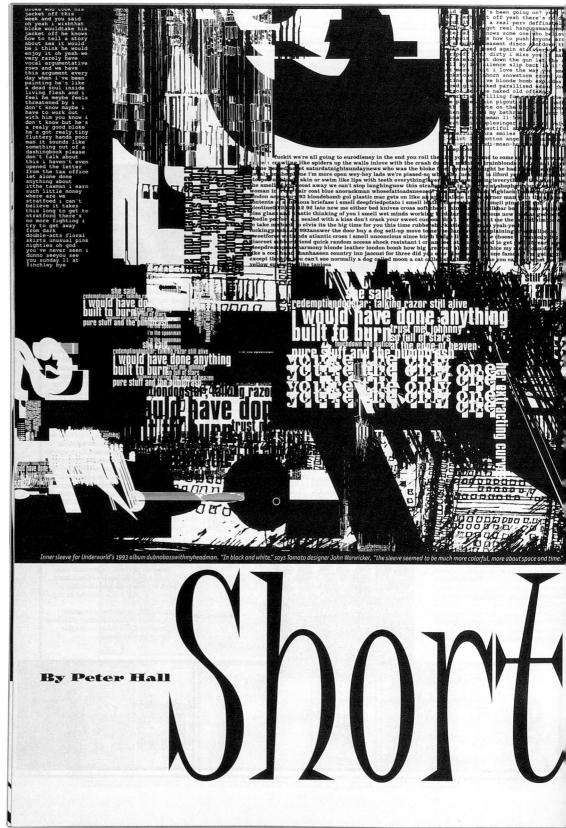

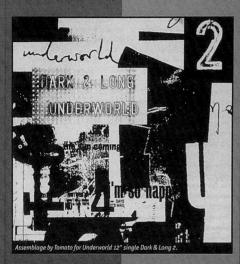

t's a wonder there's anything good to look at on the shelves at Tower Records. For starters, there's little money in it. The general consensus from designers is that sleeve art budgets are generally set by record companies at the lowest practical level, in case the release or the band flops miserably. If a sizeable budget is allocated, high design and production costs will often be viewed as penalty points against the band the sleeve is promoting, and offset against sales, a further disincentive against lavish packaging. Then there's the disappointing format of the CD sleeve. The old 12" record sleeve was the tactile face of rock 'n' roll, coveted by fans, as former A&M Records art director John Warwicker puts it, like "a flag of allegiance." In comparison, the CD package sometimes seems little better than a postage stamp behind scratched plexiglass. The final slap in the face is that if a piece of music sells millions, rarely will a penny in royalties go to the creator of the sleeve.

and yet for some reason, the spirit of cover design is as alive as it ever was. A sampling of recent sleeves produced in Britain reveals a startling array of innovations and styles: deeply textured, painterly images of spaceships and dolls, assemblages of digital detritus,

A fresh approach to

designing the incredible shrinking album cover,

imported from Britain.

SIAAN AS

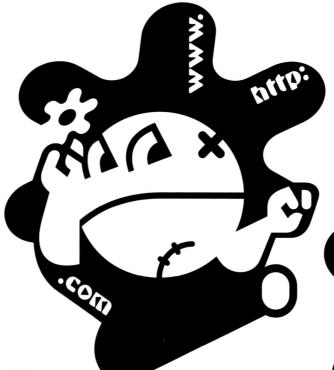

kametype

Location_San Francisco, California, USA

Established_1993

Founder | Type designer_Joachim Müller-Lancé Distributors_Adobe Systems, FontShop International (FSI)

Hissatsu kozo-ken! This is the Shuriken Boy's battle cry ...

> Joachim Müller-Lancé underwent a four-year training period in traditional type design with Christian Mengelt and André Gürtler at School of Design Basel, Switzerland before starting to work on Macintosh in 1987. His first digital font family (Lancé Condensed) received the Gold Prize in the 1993 Morisawa Awards, Japan. He has published three fonts with Adobe so far (Shuriken Boy, Ouch!, Flood) and one family with FontShop International (FSI) (Lancé Condensed). Kametype concentrates mainly on sans-serif display types in order to offer fonts that are definitely modern and sometimes experimental.

The mascot for the font Shuriken Boy, available under the key command shift-option-2, was used for the release of Shuriken Boy on Adobe's website, winter 1996. The Shuriken Boy and his sis are harsh pups. In their fight against legibility they've received a couple of punches in the (type)face, but they keep going.

> Type design: Joachim Müller-Lancé _Shuriken Boy

Sample art used for the release of Ouch! on Adobe's website, winter 1996. Ouch! was inspired by a sprained ankle during AtypI 95 in Barcelona. It hopes to help patients and medical professionals accept their suffering and their work with humour.

> Design | Type design: Joachim Müller-Lancé _Ouch!

> > (3)

of Shuriken Boy on Adobe's website, winter 1996. Shuriken's shapes can be used in many ways, for example, as Triangulito, a new cyberstyle construction toy for the young engineer.

> Design | Type design: Joachim Müller-Lancé _Shuriken Boy

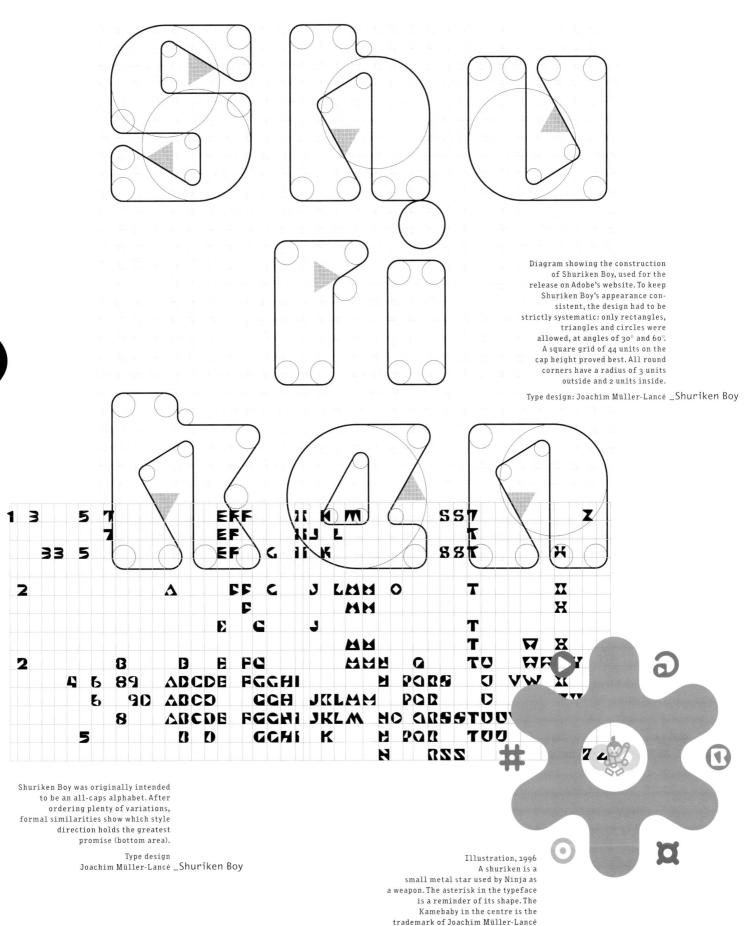

Design|Type design: Joachim Müller-Lancé _Shuriken Boy, Girl

- a portrait of the artist as a karate baby splitting a brick.

__A Word from the Laboratory of the Visual

Rian Hughes

Design is about making maps. First, maps using signs and symbols from the cultural background the designer finds her/himself in.

Second, maps using colour, shape and composition for their raw aesthetic impact. The first comes from the outside in, the second from the inside out. The first is informed by observation, the second by intuition. The first can be taught, the second, well...

A successful piece marries these two sides together, like lyrics and song, into a satisfying whole. A lot has been written about the first, because it has as its source history, culture and politics and it is easy for the journalist to draw out influences and structure a critique. The second is only made understandable and concrete by carrying it out. It's the difference between reading about a song in a music review, and the experience of the hairs on the back of your neck rising at that certain chord change. If everything that made design important could be written down, there would be nothing left for design to do.

If design is about making maps, it's obvious what kind of mapmaking we are doing in the first instance. We are using familiar signs, whether they be words, type styles, logos or even national flags to communicate something about the outside world, for example, to sell a product, campaign for a cause or to rally for an ideology. Communication has to be direct and powerful – there is little room for anything but the familiar, the iconic.

The maps that we produce in the second instance are an altogether more subtle and, I feel, more interesting affair. The process of making a piece of new design or the process of creating any art form, is the mapping of uncharted territories. These lands are, on the obvious level, geometrical or mathematical; they certainly have an internal logic, but it does not derive from the cultural, social world. They lie beyond that – they are places of elemental form and shape, harmony, beauty and proportion, law and number.

However, in the making, the maps become physical and, to those with the eyes to see them, serve as windows in the real world that look out on to these unknown lands. Once brought into actuality, however, any piece becomes part of the culture, another reference point that informs the next round of creation. A feedback loop exists wherein ideas or discoveries are commodified and become recognized symbols, surviving until, like last year's fashions, the deeper ideas that informed them become discredited or transformed into something new. All of a sudden, what seemed like a work of genius will seem facile and hollow; but it's time will come around again, and as an icon with a culturally acknowledged meaning it will have power once more.

This is a macrocosm of the process that goes on when an individual piece of work is produced: various avenues are explored, colour combinations are tried out and layouts are changed around to see what happens. Some arrangements will say what you set out to say, some will say something else, or something confused, or even nothing at all. The process of sketching, changing and refining happens in a much shorter space of time, but is still reflected in the aesthetic evolution of the world at large.

Like all maps of the more familiar kind, any piece of design has to be self-consistent. It also has to define what it is trying to achieve (whatever that may be) and be rigorous in its assessment of the success or failure of individual elements to carry, expand upon and elucidate the whole. This applies to both the threads mentioned above but, of course, judging how you are doing on the first count is easier than judging how you are doing on the second.

An example: red can mean several things by connection to its historical use or by analogy. It can mean blood, it can mean Communism, it can mean anger. But put red next to orange or lilac, or within an amorphous blob, and its symbolism is less obvious. At some stage, we move beyond implied meaning and into new territory where our only guide is a gut feeling that is impossible to break down into a series of set rules (the ones so loved by marketing types), where x inevitably leads to y. At this point, you are writing in the ur-language, the meta-language of nature in the raw. Even at this stage, it is impossible to discard completely all the baggage the first approach brings. The challenge is to use this constructively, to make it work for you.

I see no distinct division between typography and illustration or illustration and graphic design; the same universal aesthetic concerns underlie them all. However, type design seems the sharpest tool of all with which to probe this subatomic realm of form and shape, like a physicist in the laboratory of the visual. The essentials of curve and line, vertical and horizontal are immediate concerns that, on larger real-life scales, can still convey a specific atmosphere, ranging from a futuristic twenty-year-old TV optimism to yesterday's cracked Paris Métro vinyl warning sign.

Typography illustrates both sides in a pure manner, and the historical and cultural connotations are merely a starting point. A font is available to other designers and the use (and abuse) it gets after leaving its creator will shape its perceived future meaning in ways that are impossible to foresee. Type evolves after escaping the design laboratory and the most virulent strains that end up articulating the Zeitgeist have a life of their own.

Postcard for FF Graffio, 1995 Graffio means scratching: it seems to go deep into the flesh, leaving behind marks, inciting aggression and fear. But in the end it is only the scratching of a nice little cat that needs a little sleep. There is also a pictogram series for non-verbal communication that matches the font.

Design | Type design: Alessio Leonardi _Graffio

Alessio Leonardi

Location_Berlin, Germany

Established 1990

Distributors_FontShop International (FSI) Linotype Library, Fontology

The important thing is to travel. Even if one finally ends up in familiar towns again, one sees them through different eyes.

> For Alessio Leonardi, the teachings of the old masters are the starting points for new journeys and discoveries: one should first question the typographical inheritance of the past in order to use it. Instead of merely imitating it, one must really understand this geneology in order to create design innovations that build on it.

> Catholic priests and nuns guided his upbringing during the first eighteen years of his life. He learned from them that one should not believe in an ideology without being able to discuss it. The religious way of thinking has since taken a place in his life similar to that of a counterpunch of a letter.

After studying visual communications at the ISIA in Urbino. Alessio Leonardi went to MetaDesign in Berlin in 1990 where he was introduced to many new aspects of typography. This brought structure to the ideas and impulses that he brought from Italy.

Alessio Leonardi has been working as a self-employed designer and font-maker since 1994. With Priska Wollein, he founded the design studio Leonardi. Wollein in 1997. The intensive analysis of the interplay of form and content and their respective functions within communication stand at the centre of his commercial and experimental work.

FF Handwriter

The REAL & ONLY Portable

Handwriter Machine How it works:

- → looks very nice!
 → use it for loveletters: success guaranteed!
- perfect for all officials forms!

iots of useful signs for office and interpersonal communication
 it's a real monospaced, but it's not perfect*

Postcard for FF Handwriter, 1998 Handwriter is a hand-written monospace font: the perfection of the digital is questioned in an ironic way through the imperfection of the characters. The Handwriter pictograms are useful for communication between people and love letters.

Design | Type design: Alessio Leonardi _Handwriter

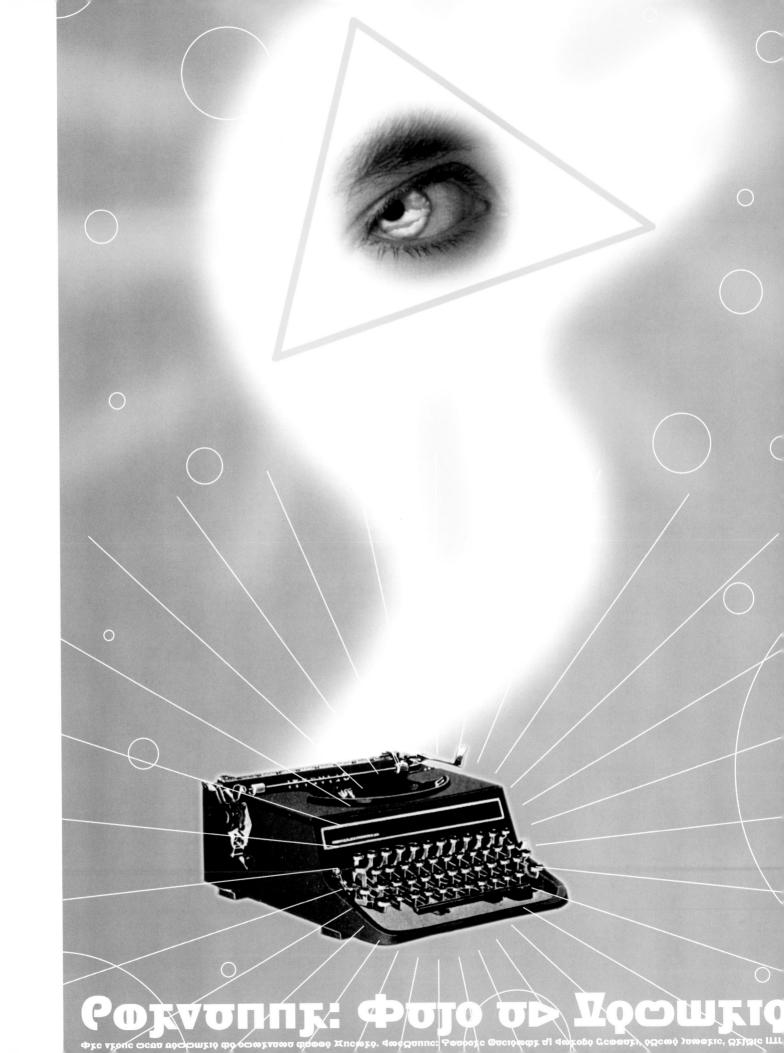

Alessio Leonardi developed the fictitious poster Deus ex machina for Olivetti as an experiment for the 13th Forum Typografie in 1996. He used a font from the series Alternativo Fonts: variations on Omnia, Bodoni, Franklin Gothic and Frutiger, among others. The series was developed in a single afternoon by reconstructing and changing Latin script. This shows that our alphabet would look quite different if the Phoenicians had used other characters.

Design | Type design: Alessio Leonardi _Alternativo Franklin Gothic

Page from the magazine

Climax no. 2, 1997

The picture serves as the lead for an article by Alessio Leonardi on the relationship between typography and religion. What his experiment shows is not only a formal exercise, but also the result of looking critically at our beliefs on readability and the untouchable Holy Scriptures allegedly given by God.

Design/Type design: Alessio Leonardi _Cratilo Sans

Postcard for FF Matto, 1997
Matto actually means crazy, but this
name stands for a completely normal
font with four serif, four sans serif
and four Porco cuts. Medieval numbers and a genuine italic make it
suitable for all corporate-design uses
- as long as there is no objection to
the Porco cuts making the pages a bit
dirty.

Design | Type design: Alessio Leonardi _Matto, Matto Sans, Matto Porco

d'un Matto

Website, 1997-98.

www.leowol.de/alessio

Apart from the homepage and the
typepage, the example for the
Baukasten font clearly shows
how the fonts are presented.

Design | Type design:
Alessio Leonardi _Matto

_Baukasten

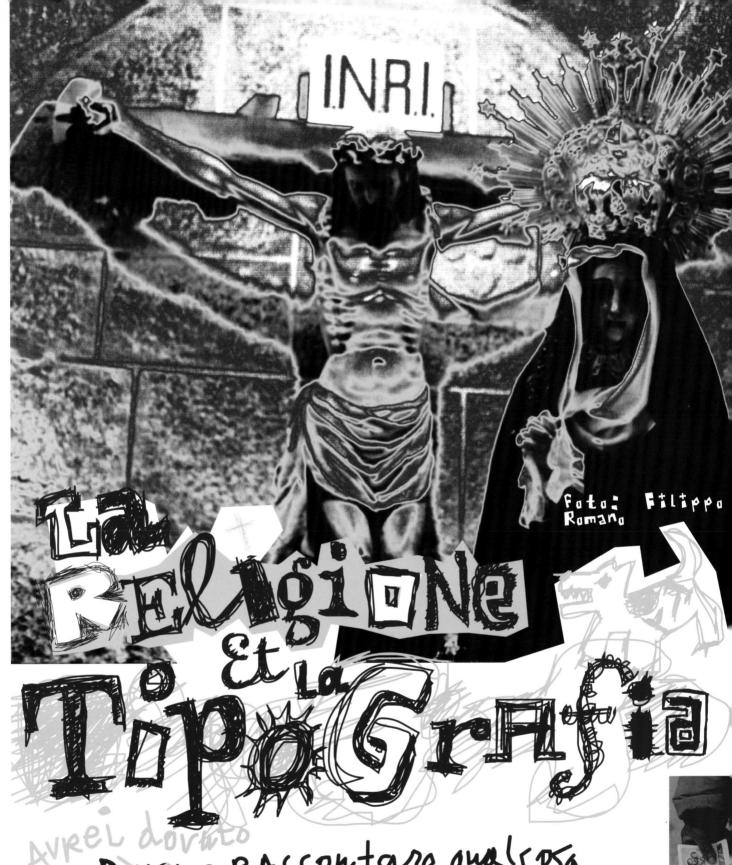

Dovero RACCONtare qualitésa sul Rapporto tra l'épografia e RERIGIONE E Questo e quanto (ed e quello) che mi e venuto in mente.

Commemorative medal, Italy, 1441
Garrett Boge and Paul Shaw used the medal as an illustration in the reprinted monograph, Sans Serif and Other Experimental Inscribed Lettering of the Early Renaissance by Nicolete Gray, which they published in 1997. The monograph, designed by Paul Shaw, documents the historical background for the Florentine font set and accompanies the release of the Collector's Edition.

LetterPerfect

Location_Seattle, Washington, USA

Established_1986

Founder_Garrett Boge

Type designers_Garrett Boge, Paul Shaw

Distributors_Adobe, Agfa, Creative Alliance

FontShop International (FSI), Precision Type
FontHaus, ITF

LetterPerfect is committed to the vision of making historical lettering styles accessible to today's graphic designers

Garrett Boge and Paul Shaw have more than forty years of combined professional lettering and type design experience. Boge worked first at Hallmark cards, then as a contract designer for companies such as Monotype Typography, Apple Computer and Microsoft Corporation. Paul Shaw worked as a lettering artist for such clients as NBC, Campbell's Soup, Revlon and Rolex. When Shaw and Boge met at an industry forum in New York City in 1987, they realized that their work shared many influences. After a few years of collaborating on freelance lettering projects and type commissions, they became partners in Letter-Perfect, founded in 1986 by Garrett Boge originally in Kansas City, and since 1988 in Seattle.

Since 1988, LetterPerfect has been supplying original display fonts to designers and desktop publishers after a process of careful research, thoughtful design and meticulous font craftsmanship. The company now offers over fifty unique designs in two distinctive lines: Vive la Fonts, a collection of lively, contemporary display designs and Legacy of Letters, a series of interpretations of historical designs. Their affiliated tour programme, Legacy of Letters Tour of Italy, now in its third year, introduces other designers and lettering professionals to the original lettering sources that have inspired LetterPerfect's historical type programme.

PONTIF

A TYPE DESIGN INSPIRED BY ROMAN BAROQUE INSCRIPTIONS

BAROQUE INSCRIPTIONS STILL ABOUND IN ROME AS TESTIMONY TO THE INFLUENCE OF THE RENAISSANCE POPES.

PAVLVS · QVINTVS · PONTIFEX · MAXIMVS
AQVAMIN · AGRO · BRACCIANENSI
SALVBERRIMISE · FONTIBVS · COLLECTAM
VETERIBVS · AQVAE · ALSIFTINAE · DVCTIBVS · RESTITVTIS
NOVISQYE · ADDITIS
XXXV · AB · MILLIARIO · DVXIT

"PONTIF" WAS DESIGNED AFTER CAREFUL STUDY OF SOURCE MATERIAL IN ROME
AND AT THE VATICAN. ITS USE AS A TYPEFACE CAN MODEL THIS HISTORICAL PERIOD,
OR IMBUE ANY DESIGN WITH ITS QUALITIES OF REFINEMENT & AUTHORITY.

SENATVS POPVLVS QVE ROMANVS

le, WA 98104 (800) 929-1951 | ETTE

The photo by James Mosley of the St Bride Printing Library in London shows the mosaic lettering surrounding the base of the cupola of St Peter's in Rome, which was the inspiration for the design of the Pietra typeface. It was used to accompany his essay, 'The Baroque Inscriptional Letter in Rome', designed by Paul Shaw, which documents the historical background of the Baroque font set. The essay was published by LetterPerfect in 1996 and accompanies the release of the Collector's Edition.

Single-sheet type specimens, used to publicize the Baroque font set, 1996
21.6 x 27.9 cm
The sheets were initially published in poster format (45.7 x 61 cm) to announce the release of the Baroque font set at the Boston Seybold Publishing Conference in 1996.

Design: Garrett Boge
Type design: Garrett Boge, Paul Shaw _Pontif

_Cresci

_Pietra

CRESCI!

BASED ON THE LETTERING OF GIOVANNI FRANCESCO CRESCI

ABCDEFGHIJ KLMNOPQ RSTUVWXYZ

-...()!?

CRESCI WAS THE PRE-EMINENT VATICAN SCRIBE OF THE LATE FIFTEENTH CENTURY

HIS LETTERS EPITOMIZE THE REFINED AESTHETIC OF THE RENAISSANCE. PRESAGING

THE EXHUBERANCE OF THE BAROQUE.

ECAC
© 1996 Garrett Boge & Paul Shaw. All rights reserved. Cresci is a trademark of LetterPerfect - 526 First Ave. S. #227, Seattle, WA 98104 - (800) 929-1951

+PIETRA+

MODELED ON THE BAROQUE LETTERING IN ST. PETER'S BASILICA

ABCDEFGHIJKLMNOPQRSTUVWXYZ&OI23456789
ABCDEFGHIJKLMNOPQRSTUVWXYZ& %®#\$¢
@£¥f%°©™^^-!?¿i*-,;;,,,,,,o«»""(-)[-]{_}¶†\$ "'++=-/^~\|/
ÁÂÀÄÂÅÆÇÉÊÈËÍÎÌĬÑÓÔÒÖŌØÚÛÙÜŸIŒ'^'
ÁÂÀÄÃÅÆCÉÊÈËÍÎÌĬÑÓÔÒÖŌØŒÚÛÙÜŸ

THE MASSIVE 5-FOOT TALL

THE PIETRA TYPEFACE, BASED ON THIS SOURCE, CONSISTS OF BOTH

MOSAIC LETTERS IN THE

FULL-SIZE CAPITALS & SMALL CAPITALS WITH A SLIGHTLY WIDER

INTERIOR OF SAN PIETRO PROFILE. PIETRA JOINS THE OTHER LEGACY OF LETTERS

IN ROME ARE ONE OF THE

MOST COMPELLING USES

PROVIDING DESIGNERS A RICH TYPOGRAPHIC TITLING PALETTE.

OF BAROQUE LETTERING.

+TV ES PETRVS ET SVPER HANC PETRAM AEDIFICABO+ ECCLESIAM MEAM ET TIBI DABO CLAVES REGNI CAELORVM

Text from the inscription around the base of St. Peter's Dome — as seen in background photograph, 18 pt caps

Graphics from the covers of the specimen sheets and order forms for the Baroque and Florentine font sets, 1996-97.

Design: Garrett Boge Type design: Garrett Boge, Paul Shaw _Pontif

- _Pietra
- _Cresci
- _Beata
- _Donatello
- _Ghiberti

ANNOUNCING

3 BAROQUE FACES

PONTIF+PIETRA+CRESCI

The first in the new LEGACY OF LETTERS series of historically-informed typefaces from LETTERPERFECT

Announcing

THE FLORENTINE SET

BEATA · DONATELLO · GHIBERTI

The second set in the LEGACY OF LETTERS series of historically-inspired typefaces from LetterPerfect

A rubbing of the inscription on the tomb of Beata Villana by the sculptor Bernardo Rossellino, dated 1451, in the church of Santa Maria Novella in Florence. The rubbing was made by Garrett Boge in 1995 and was used as an illustration in the Nicolete Gray monograph. The rubbing was also reprinted in a duotone offset limited edition to accompany the release of the Collector's Edition of this font set.

©1997 LETTERPERFECT

LettError

Location_The Hague, The Netherlands
Established_1989

Founders | Type designers_Erik van Blokland, Just van Rossum
Distributor_FontShop International (FSI)

Programming = Design

LettError started when Just van Rossum and Erik van Blokland discovered a way to make letters move inside the printer and needed a magazine to tell people about it.

They work independently, in separate offices and each has his own clients. But they develop new projects together, write code, create tools, animations, clickable design and, of course, fonts

LettError's typefaces range from utterly silly experiments with scanners, where they inadvertently invent grunge type via BitPull and RobotFonts, to large corporate typeface families (GAK) and fonts made for television (MTV).

RobotFonts & EPSmachines, 1998 The collage was created using all LettError fonts and faked advertising copy.

Design | Type design: Just van Rossum Erik van Blokland, Python

RobotFonts & EPSmachines, 1998
The fonts are generated from bitmaps by creating
various filters and then the illustrations are
generated by another program. These examples
are selected from hundreds of iterations.

Design | Type design: Just van Rossum, Erik van Blokland, Python

RobotFonts & EPSmachines, 1998 Typography made with a game console.

RobotFonts & EPSmachines, 1998
Instead of making one single item, Just van Rossum
and Erik van Blokland define a set of rules and
write a program to generate a series of variations.
They evaluate the results, modify the program
and the rules, then generate the next step.

Design | Type design: Just van Rossum Erik van Blokland, Python

<Sign s of Troubl e>

lineto

Location_Zürich, Switzerland Berlin, Germany Established_1994 Founders_Stephan Müller, Cornel Windlin

Type designers_Stephan Müller (a.k.a Pronto)

Cornel Windlin

Distributors_www.lineto.com, FontShop International (FSI)

'When was the deadline?'

Cornel Windlin and Stephan Müller work independently as designers and art directors in Zürich and Berlin. Their typeface designs are mostly by-products of design projects, brought to the appropriate standards for public use. The lineto label, named after a PostScript™ code, was formed as a loose partnership to release their typefaces.

Windlin and Müller have always been fascinated by applied typography in public spaces – shopping centres, airport terminals, traffic signage, massage parlours, corporate identity – and a big part of their type design focuses on making such designs available. They publish various fonts based on LCD displays, dot-matrix technology, thermal printers and car registration plates. However, many of their type designs are more refined and quite a few have not been released, some are now available on the lineto website: www.lineto.com.

Selection of lineto typefaces, 1998

Design: lineto
Type design: Stephan Müller
Cornel Windlin

Page from the
FontExplorer catalogue, 1998
21 x 28 cm

Design: Leonardi.Wollein Type design: Adrian Frutiger Linotype Designstudio _Linotype Univers

Linotype Library

Location_Bad Homburg, Germany
Established 1886

Founder_Ottmar Mergenthaler

Type designers_Adrian Frutiger, Hermann Zapf, Gerard Unger Peter Matthias Noordzij, Reinhard Haus Franco Luin, Marco Ganz, Hans Eduard Meier Gary Munch

Distributors_Linotype Library, Heidelberg, FontShop
International (FSI), fundicioń tipográfica
Bauer, Type Associates Esselte Letraset and
many more

Extending and expanding the consistent reworking of original and innovative font design

Linotype fonts have been an established name for over one hundred years. During this time, typesetters the world over have benefited from both the technical innovations of Linotype typesetting machines and the numerous quality types developed for professional applications. The Linotype Library - a Heidelberg Group company - now includes more than 3600 types by over 350 well-known international type designers. Typefaces like Times and Helvetica, Hermann Zapf's Palatino or Adrian Frutiger's Univers are milestones in type creation and have become bestsellers worldwide. And, there is no shortage of new material either: the International Type Design Contest, initiated by Linotype Library, attracts type designers from all over the world, coming to make their mark and knowing that the winning entries will enter the Linotype Library. The company is also the initiator of the international specialist congress typo[media] which takes place in Frankfurt/Main.

CD-ROM packaging
and booklet for Univers, 1997
The Linotype Univers has been
completely redesigned by Adrian
Frutiger and the Linotype Library team
to become a full type family with fiftynine weights. The thickness of the
strokes has been configured so that the
various widths can be mixed effortlessly in a single weight.

Design: Leonardi.Wollein Type design: Adrian Frutiger Linotype Designstudio _Linotype Univers

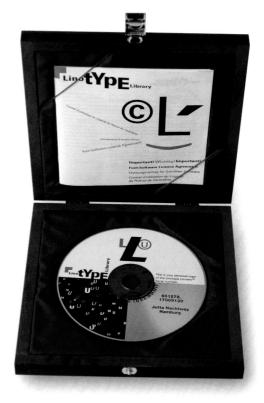

the new face: Linotype Univers®

Website, 1998 www.LinotypeLibrary.com Design: PointUp, Nürnberg Type design: Gary Munch _Ergo Cover of the FontExplorer catalogue, 1998
168 pages
21 x 28 cm
The catalogue includes a CD-ROM
containing the software FontExplorer, a
navigation system that helps to locate types
of all classes and specifications in an
interactive database. After selecting and
combining from a whole range of parameters, FontExplorer provides the user
with a list of suitable fonts in real time.

Design: Leonardi.Wollein Type design: Adrian Frutiger Linotype Designstudio _Linotype Univers

Page from the FontExplorer catalogue, 1998

Design: Leonardi.Wollein Type design: Linotype Designstudio Max Miedinger _Neue Helvetica

tion He velic **a** Helvetic Helvetic Helvetic cuca Her Helvetic a Helvetid 🗗 Heh *ca* Helv€ **Vyetica** ica He re vetica Helvetica elvetica Helvetica Helvetica Helve Helvetic A Helvetica Helvetica Helve A Helvetic **nelvetica** *Helvetica* **Helvetica** *Helica* **Helvetic** Helvetica : ca Helvetic Helvetic ca Helvetica F *lelvetic* a Helveti **Helvetic** a Helvet N etica **Vetica** elvetica .Helvetic Helvetic Helvetic vetica Helvetica Helvetica Helvetica Helvetica Helvetica vetica Helvetica Helvetica Helvetica Helvetica Helvetica etica Helvetica Helvetica

Yp Library Helvetica Helvetica Helvetica Helvetica Helve

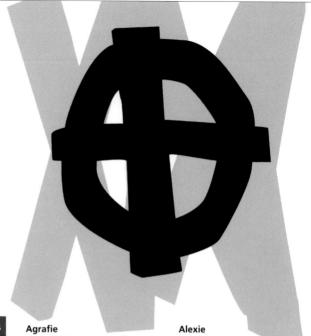

abcd=fghij KINOParst uvWxz aBCDFFGHIJ **** ZaBC KLMHOPOR STUVWXYZ äöü B !?"\&/() :/5/()

DEFGHIJK LMNOPOR STUVWXYZ #\$%\$,,",;.

Linotype Li37Δ7Υ

Cover of the Take Type 1 catalogue, 1995

31 pages 10.7 X 21 CM

Design: xplicit ffm Type design: Dieter Kurz _Matthia

Alessio Leonardi _HaManga

Dariusz Nowak-Nova _NoveAteny

Adrian Frutiger _Frutiger

Lutz Baar _Balder

Sine Bergmann _Giacometti

Svenja Voss _Schwennel lila + nearo

Design: xplicit ffm Type design: Roland John Goulsbra _Agrafie

_Alexie

Alessio Leonardi _Ale Ornaments Rotato, Spirato

CD-ROM included in the Take Type 2 catalogue, 1998

Design: Christoph Burkardt Albrecht Hotz, Büro für Gestaltung (Offenbach am Main)

Type design:Thomas Leif _Traffity

Andreas Karl _Mail Box Heavy

Thorsten Weisheit _Irish Text

Svenja Voss _Schwennel lila + negro

Thomas Hoffmann _Ho Tom

Dan-André Niemeyer _Vision regular

Alexej Chekoulaev _Bariton

Hans Jürgen Ellenberger _Beluga

__Make it yourself, sell it yourself

Gerard Unger

Have we gone so far that fonts make and sell themselves? Is it possible for fonts to mutate on their own in computers? Whatever the answers, many of my colleagues, when looking at their font collection, ask themselves, 'How did I get this font?'.

Developments since the mid-1980s have brought font designers certain advantages. In the pre-digital era, there were settingmachine manufacturers who faced us font designers with strict selection committees. This meant that many designs stayed on the shelves gathering dust because each new font required heavy investments. Fonts can now be brought into the world for less money and the committees no longer exist. Or do they? We could say that all potential customers now make up the committee. Actually, even the investments have only been transferred: font designers who produce and sell their own fonts must now convince the selection committee they themselves have created.

I use the advantage obtained from the much faster and easier design and production of fonts to experiment more, to follow each experiment to its limits. I have not won time, but rather room for thought. On average, I still need two years to bring a font to maturity – about as long as in the pre-digital era.

Many believe that the computer is causing inflation in font quality, or even the fall of type culture. Personally, I see everything quite differently. The earlier, mostly conservative, evaluation committees let many experiments die, and the limits remained invisible. These

have become clearer after almost fifteen years of digital experimentation with fonts and typography. New typographical continents have risen out of the fog, and typographical cartography has been partially redefined. In addition, font designers have more potential customers than ever before: customers who have grown up with the new richness in fonts, who have become more and more critical, who can formulate their desires better and know how to separate the wheat from the chaff.

But how do we reach this huge evaluation committee? There have already been many attempts: different designers have joined together to share costs and work the market together. Not a bad idea, but I believe that appearing on the market independently offers the most advantages: direct contact with the customer, interaction, cross-pollination, a drive to undertake new projects, improvements and extensions and a more precise knowledge of the market. What remains true is that we first need the customers before we can exchange thoughts with them.

Offering extras or gifts are proven means to win customers: a carrot in front of the nose. Fabulous! That is what this book is about. If you have a good font, you can include good documentation, an enchanting font sample book, fantastic explanations, inspiring application examples or simply humorous items. These things are often too expensive to give away. Perhaps an additional sale at a discount with the purchase of fonts? Again, a good idea that benefits both designers and customers, and is fun.

Another way to reach customers is by cutting prices. This is probably the worst idea of the century, since quality suffers. There will then be no money to make carrots or beautiful font documentation, unless we finance font production through other activities, such as graphic design. Font design as a hobby? Font designers certainly do not want their work to be on the same level as the do-it-yourself construction of a rabbit hutch!

Fonts certainly do not sell themselves. Marketing them is damn hard work, requiring much stamina: you are not just the artist, but also the merchant. You stand in the marketplace and have to yell to be heard. Just as with selling bananas and watches, this certainly works better with humour.

The prejudice still remains that font design and commerce do not readily mix. It would, however, be very stupid to work on a font for two years and never think about the market. You can, of course, make money with pure beauty (Claudia Schiffer), but it sells better when you offer several advantages.

From the start of the digital era, font sellers have had their eyes on mass markets. The concept of exclusivity remains completely ignored. However, it is still not possible to please every customer with a font design. Therefore, it is probably easier to reach a small group of customers with a common interest - this works best with specialized fonts. You then can write to customers directly or communicate with them through appropriate specialist publications. I have had mixed results with advertising – sometimes there was much interest, sometimes none at all. Best of all is when you develop such a good or original font that the specialist publication writes about it on its own. You can also work as an author for specialist publications, which creates quite a bit of publicity the fonts virtually sell themselves.

There are not yet any fonts that can mutate without the intrusion of designers. There should not be any fonts that get into a computer by themselves, but there are. Maybe publications like this one can contribute to increasing the honesty of font buyers or font users. At any rate, those who contributed to this book will certainly reach an interested audience. Hopefully it will inspire others to think up new variations of the carrot. I wish all my colleagues many sold fonts.

abCdefgHIJklMNOPqRSTUVWXYZ

&PACTER LINK I WNO PARSIVMX A S

Type design: Jeroen Barendse, 1994-95 _LUSTBlockbuster Blockbuster bold

ABCDEFGHIJKLMNOP@RSTUVWXYZabcdefghijklmnopgrstuvwxyz

Type design: Thomas Castro, 1995 _LUSTBlowout One, Blowout Two BlowoutThree, Blowout Four Blowout Five

LUST

Location_The Hague, The Netherlands $Established_1996$

Founders | Type designers_Jeroen Barendse, Thomas Castro Distributors_LUST, FontWorks and soon [T-26]

LUST, in a nutshell, is the missing piece of the puzzle.

> LUST is a small design studio in The Hague. started in August 1996 by Thomas Castro and Jeroen Barendse. On the one hand, they realize commissioned projects (such as books, posters, business correspondence, websites and CD-ROMs) for architects, art groups, designers and publishers. On the other hand, they work on self-initiated, independent projects, which also include type design. LUST concentrates on the difference between ratio and coincidence. between vision and urge. Examination of these terms has resulted in designs that often have an autonomous character, but are related to previous LUST designs.

> LUST's designs and philosophies do not follow a set style, but come from interpretation and conceptualization of an assignment. Castro and Barendse are mainly interested in context and association, which means that their typefaces can only be made within this framework. The fonts are a part of their work as graphic designers in the same way that their design work is a part of their typeface design. Everything comes together to serve their ideology.

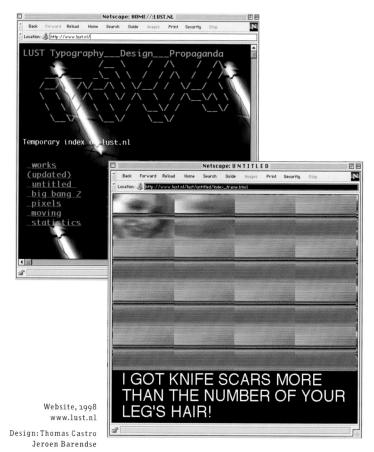

Type design: Thomas Castro _LUSTBlowout Jeroen Barendse _LUSTIncidenz

Jeroen Barendse

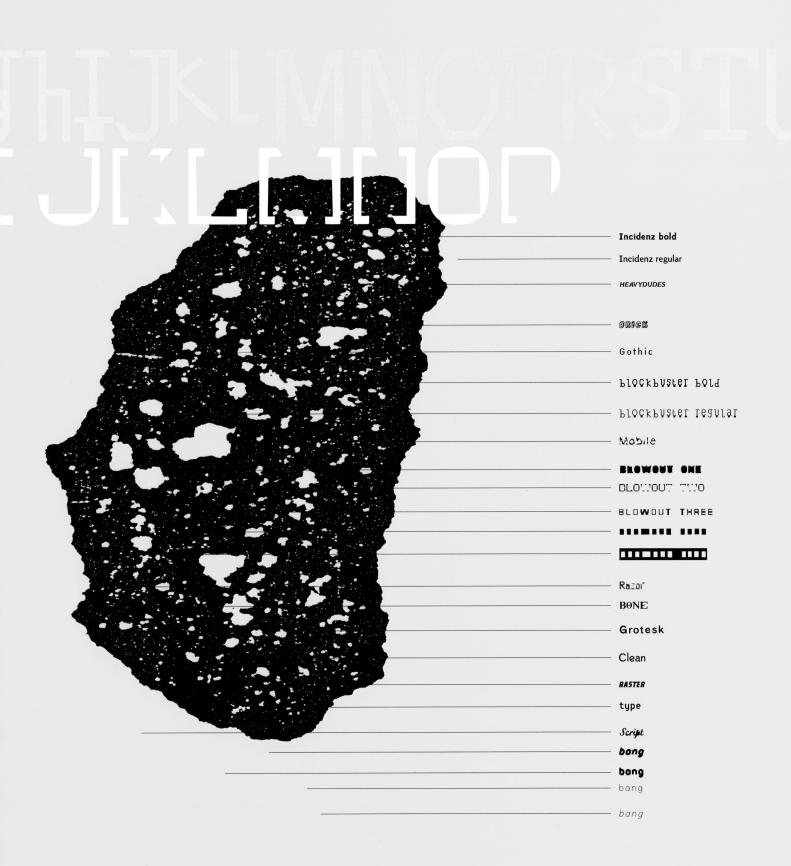

Alternative type specimen sheet published in TXT ONLY magazine July 1998
21 x 29.7 cm

LUST designed the type specimen called The Page 3 Girl for this magazine, which has no images and includes contributions from various type designers.

Design | Type design: Thomas Castro Jeroen Barendse _LUSTPure

LUST Map, 1996
70 x 85 cm
A foldable map giving an insight
into the LUST philosophy.

Design: Thomas Castro, Jeroen Barendse
Type design: Jeroen Barendse _LUSTIncidenz
Thomas Castro _LUSTGrotesk
_LUSTBlowout

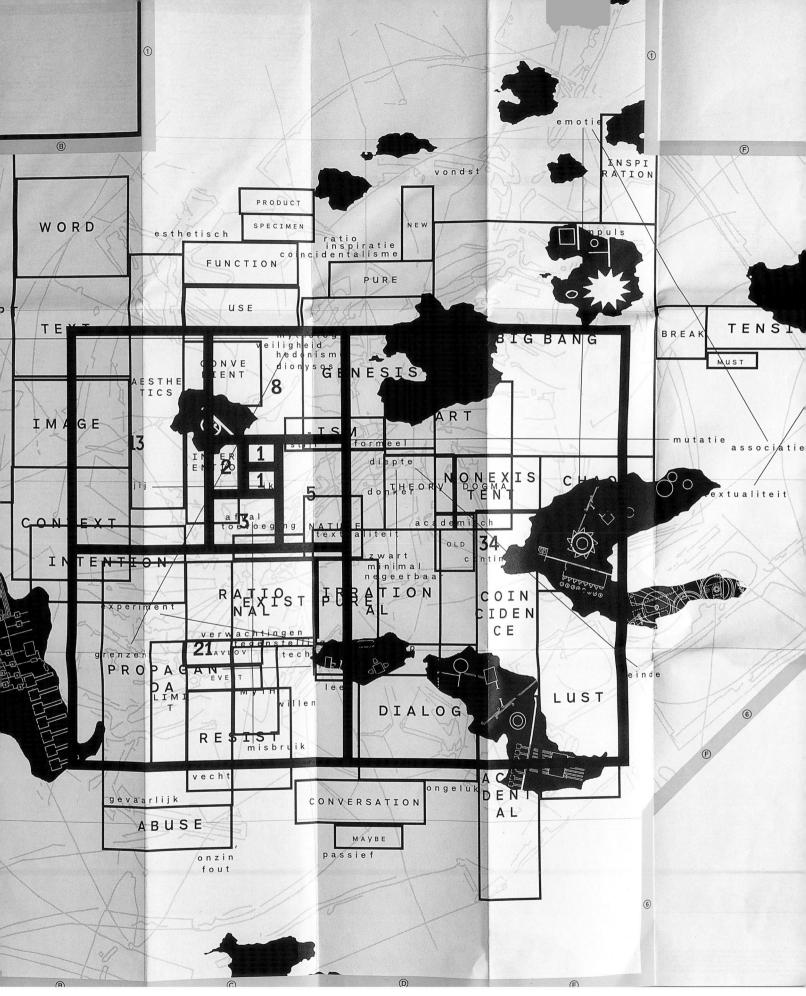

Poster, 1995
43 x 56 cm
Design: Steve Mahallo

Monotype Typography

Location_Redhill, Surrey, UK

Established_1887

Founder_Tolbert Lanston

Type designers_Albert Boton, Matthew Carter, Ong Chong Wah
Vincent Connare, Carolyn Gibbs, Michael Harvey
Jean Lochu, Luiz Da Lomba, Brian Lucid
Steve Matteson, Robin Nicholas, Joe Nicholson
Ian Patterson, Rosemary Sassoon
Patricia Saunders and many more

Distributor_Monotype Typography

Monotype Typography is one of the oldest and most respected companies in the typographical field. It made history as the inventor of the Monotype hot-metal typesetting machine and for more than one hundred years, the company has continued to develop high-quality typographical products for the graphics industry. Today, the company develops and sells fonts and software for computer systems and peripheral equipment. Monotype is considered to be the market leader in multilingual font solutions and Unicode implementations, and has extensive know-how in non-Latin and expanded Latin alphabets.

The Agfa-Gevaert Group took over Monotype Typography in 1998 after the two firms had cooperated closely for five years. In 1997 they worked together to produce and distribute the font collection Creative Alliance 8.0 (see p. 42), which contains more than 6500 fonts from their combined font libraries.

Type design: DS Design, Jake
Scott, Jane Scarano _Kid Type Paint
Frederic Goudy, Steve Matteson _Truesdell
Luiz Da Lomba _Pierre Bonnard
Chank Diesel _Mr. Frisky

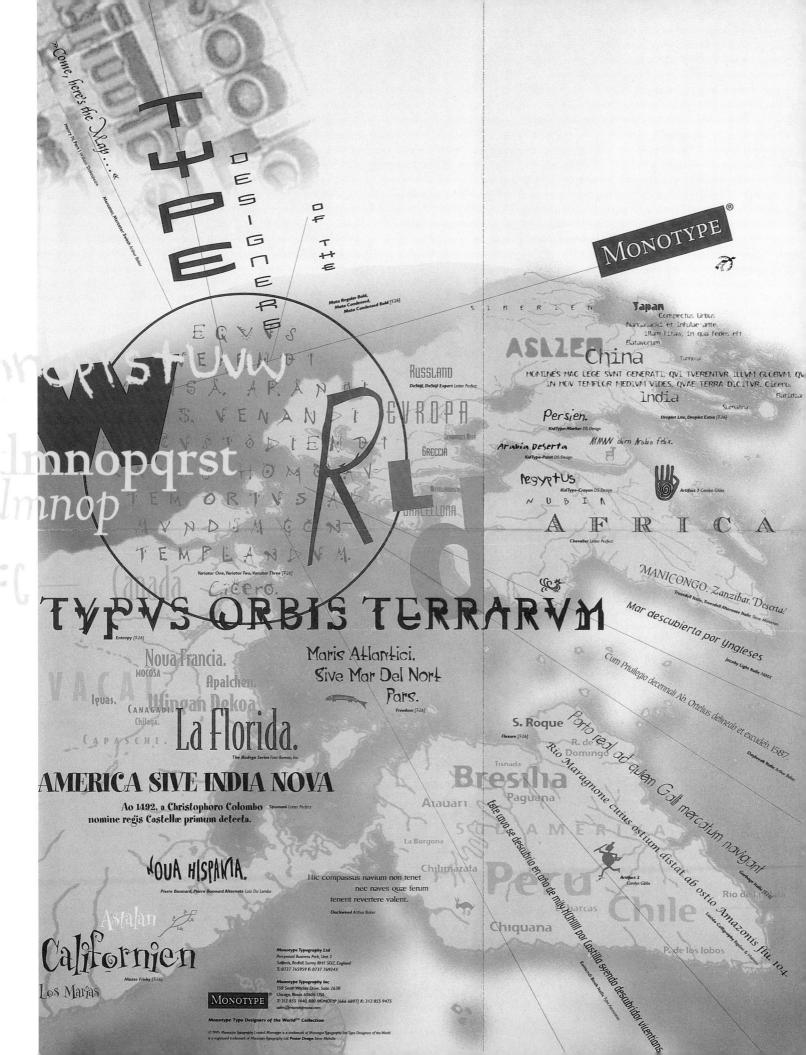

Leaflet Design: Robin Nicholas Digitization: Monotype Typography _Monotype Bulmer

The chase I Sing, hounds, and their various breed, And no less various use. O thou, great Prince! Whom Cambria's towering hills proclaim their lord, Deign thou to hear my bold, instructive song. While grateful citizens, with pompous show, Rear the triumphal arch, rich with the exploits Of thy illustrious house; while virgins pave Thy way with flowers, and as the royal youth Passing they view, admire, and sigh in vain; While crowded theatres, too fondly proud Of their exotick minstrels, and shrill pipes, The price of manhood, hail thee with a song.

From The Chase by William Somerville Printed by WILLIAM BULMER, 1796 Wood-engraving by THOMAS BEWICK

Monotype Bulmer [PACKAGE 1247]

ABCDEFGHIJKLMNOPQRSTUVWXYZ abcdefghijklmnopqrstuvwxyz 1234567890

ABCDEFGHI7KLMNOPQRSTUVWXYZ abcdefghijklmnopqrstuvwxyz 1234567890

ABCDEFGHIJKLMNOPQRSTUVWXYZ Semi bold abcdefghijklmnopqrstuvwxyz 1234567890

Semi bold italic

Display italic

ABCDEFGHI7KLMNOPQRSTUVWXYZ abcdefghijklmnopqrstuvwxyz 1234567890

ABCDEFGHIJKLMNOPQRSTUVWXYZ

abcdefghijklmnopqrstuvwxyz 1234567890 **ABCDEFGHIJKLMNOPQRSTUVWXYZ** Bold italic abcdefghijklmnopqrstuvwxyz 1234567890

ABCDEFGHIJKLMNOPQRSTUVWXYZ Display roman

abcdefghijklmnopqrstuvwxyz 1234567890 *ABCDEFGHI7KLMNOPQRSTUVWXYZ*

abcdefghijklmnopqrstuvwxyz 1234567890

ABCDEFGHIJKLMNOPQRSTUVWXYZ Display bold abcdefghijklmnopqrstuvwxyz 1234567890

ABCDEFGHI7KLMNOPQRSTUVWXYZ Display bold italic

abcdefghijklmnopqrstuvwxyz 1234567890

TRUESDELI

This release of F.W. Goudy's Truesdell typeface by Monotype Typography marks the 55th year since the tragic fire that consumed Goudy's studio early on the morning of 26 January 1939. C After the fire at Marlboro-on-Hudson, it was impossible for Goudy to fill any more orders for the Truesdell font which he had completed in 1931. Monotype's new PostScript version of Truesdell was digitized by Steve Matteson in 1993 from letterpress proofs of the 16-point fonts which reside at the ROCHESTER INSTITUTE OF TECHNOLOGY. To increase the versatility of the Truesdell family, a bold and bold italic have been designed. Original swash letters, leaves & paragraph marks are also included in the family to offer the designer a full range of typographic effects.

AÆBCDEFGHIJKLMNOŒPQRSTUVWXY&Z aæbcdefghijklmnoæpqrsßtuvwxyz fi fl ff ffi ffl et st ([{/}]) ABCDEFGHIJKLMNOPQRSTUVWXYZ • 0123456789 · 0123456789 *\pmu\#\\$\$¢f£\@@\RTM;;!?"":;;\\«>

AÆBCDEFGHIJKLMNOŒPQRSTUVWXY&Z aæbcdefghijklmnoæpqrsßtuvwxyz • fi fl ff ffi ffl & st ([{/}]) 0123456789 0123456789

AÆBCDEFGHIJKLMNOŒPQRSTUVWXY&Z aæbcdefghijklmnoæpqrsßtuvwxyz • fi fl ff ffi ffl et st h ABCDEFGMPRTThUadebmnv 0123456789 * 0123456789

AÆBCDEFGHIJKLMNOŒPQRSTUVWXY&Z aæbcdefghijklmnoæpqrsßtuvwxyz • fi fl ff ffi ffl ct st h 0123456789·0123456789· () ((())) ((())) (())

THE TRUESDELL FAMILY INCLUDES NINE fonts - regular, bold, italic, bold italic, alternate fonts for each style, and sorts Truesdell's friendly design quirks add to its charm & interest without limiting its legibility or functionality. Truesdell makes an excellent choice as the principal text type for a wide variety of uses, and it looks quite handsome in display sizes too. [11/13]

Truesdell was Goudy's 47th type design and carries his mother's maiden name. He cut the 16-point size in February 1931. Goudy completed Truesdell to compose a two-page prefatory he wrote for The Colophon No. 5 after discovering that his 18-point Kaatskill design overran his allotted space. [11]

The Truesdell family includes nine fonts regular, bold, italic, bold italic, alternate fonts for each style, and sorts. Truesdell's friendly design quirks add to its charm & interest without limiting its legibility or functionality. Truesdell makes an excellent choice as the principal text type for a wide variety of uses, and it looks quite handsome in display sizes too. [11/13]

Truesdell was Goudy's 47th type design and carries bis mother's maiden name. He cut the 16-point size in February 1931. Goudy completed Truesdell to compose a two-page prefatory he wrote for The Colophon No. 5 after discovering that his 18-point Kaatskill design overran his allotted space. [11/13]

Copyright © 1994, Monotype Typography Ltd. Truesdell and Artifact are trademarks of The Mo ABCDEFGHL

Semi bold expert

ABCDEFGHIJ

J 12345678

ABCDEFG

ABCDEFGHIJ

ff fi fl ffi ffl 12

JJKNOQTY

alternative

sc osf

Roman expert

alternative

Italic expert

scosf

J 1234567890£\$ * "

ABCDEFGHIJKLMNOPORSTUVWXYZ abcdefghijklmnopqrstuvwxyz 1234567890

Semi bold italic expert fffifffffff 1234567890

alternative

Monotype Buln

JJKNOQTY 1234567890£S ***

Bold expert alternative

ff fi ff ffl 1234567890 J 1234567890£\$ * "

Bold italic expert

ff fi fl ffi ffl 1234567890

alternative

JJKNOQTY 1234567890£\$ * **

Display Roman all Display Italic alt

J fffiflffifl 1234567890 1234567890£\$ "" JJKNOQTY ff fi fl ffi ffl 567890 123456£\$ * "

Display Bold alt

J fffiffiffl 1234567890 1234567890£\$ ' "

Display Bold italic alt

JJKNOQTY fffifffffff567890 123456£\$ ""

Leaflet for Truesdell, 1994 14.3 X 21 cm

Design: Steve Matteson Type design: Frederic Goudy

Steve Matteson _Truesdell

Optimo

Location_Lausanne, Switzerland
Established_1997
Founders | Type designers_Stéphane Delgado, Gilles Gavillet
David Rust
Distributor_www.optimo.ch

Keep in circulation the rumour that typography is alive.

After finishing his studies at the École Cantonale d'Art de Lausanne, David Rust was invited by Peter Scott-Makela, director of the Cranbrook Academy of Art, to complete a post-graduate programme. Stéphane Delgado and Gilles Gavillet also participated in the programme, although they were still students at the École Cantonale d'Art de Lausanne. Whilst at Cranbrook, they created the multiple master font Detroit, inspired by American neon advertisements, which led to the decision to found Optimo. In the future, it will not only be a type label, but also a forum where photographers, musicians and students can present their work.

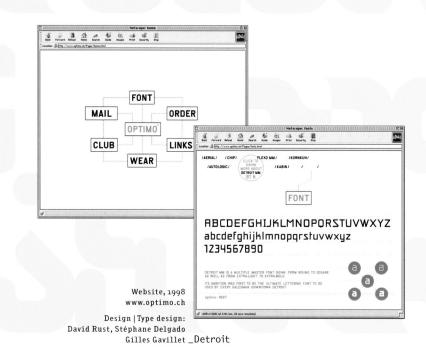

صحدالم

The font Autologic enables the user to quickly and automatically generate logos. Spring, 1998

Type design: Gilles Gavillet $_$ Autologic

Type design: Gilles Gavillet
Stéphane Delgado _Kabin

Type design: Stéphane Delgado Gilles Gavillet _Kornkuh

Type design: Gilles Gavillet _Chip

Design: Disco Volante Type design: Stéphane Delgado Gilles Gavillet _Kornkuh

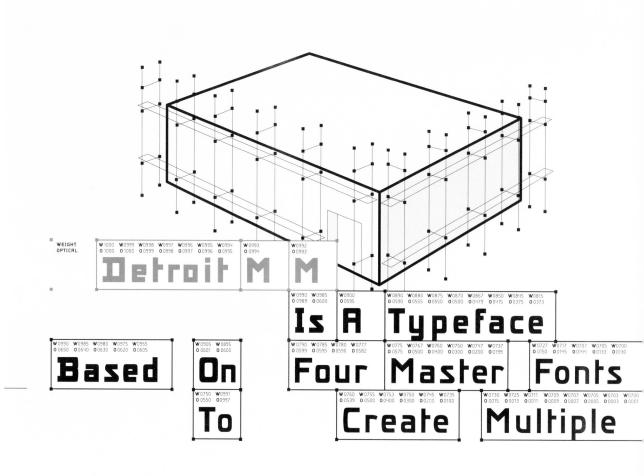

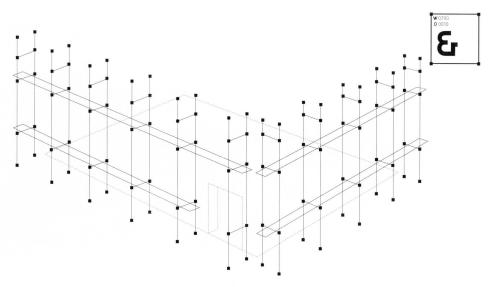

Detroit multiple master font
was created during a visit to Cranbrook
Academy of Art, Michigan in 1997. The designers
wanted it to be the ultimate font used
by every salesman in downtown Detroit,
and to then become a very flexible
universal type.
Type design: Stéphane Delgado
Gilles Gavillet, David Rust _Detroit

Dennis Ortiz-Lopez

Location_New York, USA
Established_1981
Distributors_FontHaus, Phil's Fonts
International Typefounders ITF

I specialize in revivals of old masters and try to be faithful to the original designs

Dennis Ortiz-Lopez completed a course in typography and font design at California State University in Long Beach, where he became aware of the importance of typography for visual communication. After working from 1979 to 1981 as a hand-letterer for Rolling Stone magazine, he founded his own studio with an emphasis on editorial design. He mostly uses his own fonts and his goal is to develop solutions that transmit their message with the least amount of internal conflict. In addition, Ortiz-Lopez offers typographic services for advertising agencies.

In designing fonts, he specializes in revivals of old masters. He selects as models fonts that can be used in display sizes, and always places great value in creating an exact translation of the model (mostly phototypositor versions) into the Postscript format.

ACME Creative Group logo, shown in the catalogue of services, 1997. The logo was produced for Nickelodeon Television.

> Design | Type design: Dennis Ortiz-Lopez

Pages from the catalogue
of services, 1997
14 x 21.6 cm
Design | Type design:
Dennis Ortiz-Lopez

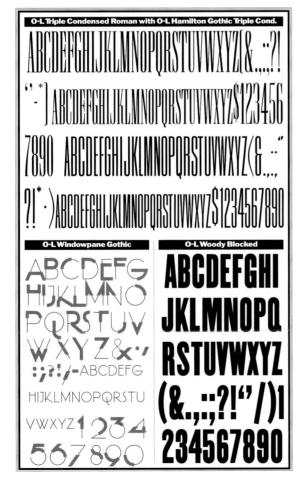

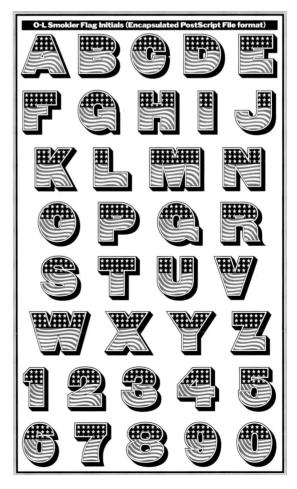

ABCDEFGHIJKL

ABCDEFGHIJKL

MNOPQRSTUVW

XYZ(8.,:,""?!/
-*#•)abcdefghij

klmnopqrstuvw

xyz\$1234567890

O-L Maria Bold Text Italic

ABCDEFGHIJKL

MNOPQRSTUVW

XYZ(8.,:,""?!/
-*#•)abcdefghij

klmnopqrstuvw

xyz\$1234567890

ABCDEFGHIJKL

MNOPQRSTUV

XYZ\$1234567890

ABCDEFGHIJKL

MNOPQRSTUV

WXYZ(8.,:,""?!/-*#)abcdefghijkl

mnopqrstuvwxyz1234567890

ABCDEFGHIJKL

MNOPQRSTUV

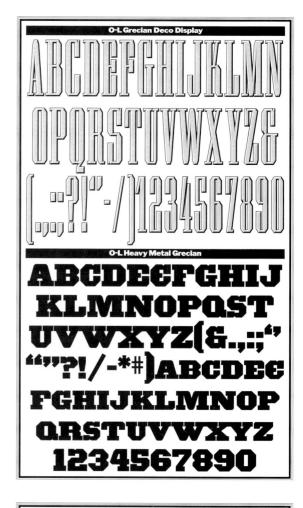

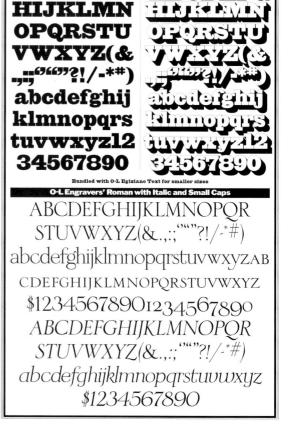

ABCDEFG

הבי-אור

These few signs form the basis of most of the hebrew alphabet as shown at right.

*/.BQ.D.B BURELLET. KIMIND PORST TYNYX Y 557390 ZEMI ZONPENZEP ZMENZA-ŁINĘ PECO HAZDELOHI NELNANXA PINTWUOLU 34567850

Pages from the catalogue of services, 1997 14 x 21.6 cm

Design | Type design: Dennis Ortiz-Lopez

ICHPAINTER ROMAN, DESIGNED FOR THE CREATIVE TEAM OF WALTER BERNARD AND MILITON GLASER, IS TO MY KNOWLEDGE, THE MOST COMPLEX FONT OF ITS KIND, CREATED TO SOLVE THE PROBLEM OF HAVING TO RENDER VARIOUS ORNAMENTAL TITLES, ON DEADLINE ALL THE WAILE RETAINING THE HAND-LETTERED LOOK OF THE SAMPLE THEY HAD PROVIDED ME TO MATCH, SIGNAMITER, EACH WITH ITS OWN COLOR AND ALL SARING THE SAME KERNING, IT IS NOT FOR SALE.

S 5 5 5 5 TYPE

O-L HEBREW ORIGINAL DESIGNS אבגדהווחטיכלמנסעפצקרשתךםןק אבגדהוזחטיכלמנסעפצקרשתךםזףץ: אבגרהוזחטיכלמנסעפצקרשתרסזין אבגרהוזחטיכלמנסעפצקרשתרסזיו ן אבגרהווחטיבלפוסעפעקרשתךםןץ:

ABCDEFGH ABCDEFGHIJKL IJKLMDOP MNOPQRSTUVW ORSTUVW XYZ(&&.,;;"" XYZ(&.,;;"9""?!/-"?!*-/)abcde *)abcdefghijkl fghijklmnopg rstuywxyz \$ 1234567890 yz1234567890

ABCDEFGHIJKLM NOPQRSTUVWX YZ(&.,;;?!""*/)abc defghijklmnopqrst **UVWXYZABCDEFGHI JKLMNOPORSTUVWX** YZ123456789012 34567890

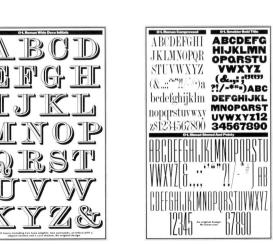

RABCDEEFFGHHIJKKL MNOPPORASTUVW X99Z[&.,:;"""?!/--*] AABCDEEFFGHHIJKKLM **NOPPORASTUVWX99Z** \$1234567890% ABCDEFG HIJKLMN OPORST UVWXYZ (&.,;;''"'?! /-**-)ABCDE FGHIJKLMN OPORSTUV WXYZ123 4567890

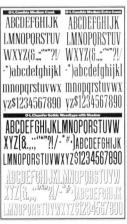

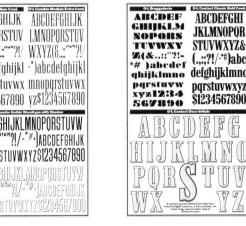

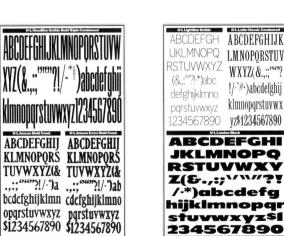

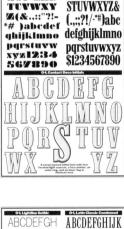

ParaType

Location_Moscow, Russia Established_1989 Founder_ParaGraph

Type designers_Vladimir Yefimov, Tagir Safaev
Lyubov Kuznetsova, Manvel Shmavonyan
Alexander Tarbeer and many others
Distributors_FontShop International (FSI)
FontWorks, FontHaus

Welcome to the world of One Hundred Language Fonts

In 1989 ParaType was established by ParaGraph to unite the best Russian type designers and to license practically all type-faces existing at that time in Russia – about twenty families. The 1998 ParaType font catalogue consists of about five hundred fonts and presents the best work of Russian type designers within the last fifty years. In 1998 ParaType became independent and continued as a private company, registered in the USA and in Russia. ParaType font library is now the world's largest library of Cyrillic fonts.

ParaType font library also typesets the languages of Eastern and Western Europe, Asia and the former USSR. The more popular fonts have an expanded character set with special diacritics, phonetic spelling and unusual characters, including Old Russian (pre-1917) letters. ParaType aims to act as a catalyst in the formation of typographic culture in modern Russia and in presenting the Russian typographic tradition to the world. At the same time, its interest in multilingual fonts contributes to intercultural communications. People are becoming closer and ParaType serves these changes.

Catalogue with invitation card for the Five Year Anniversary of ParaType exhibition at IMA art gallery in Moscow, 1994. 22 x 29 cm

Design | Type design: Alexander Tarbeev _ITC Garamond Cyrillic

Poster for PT Rodchenko typeface, 1995
60 x 90 cm
The font is inspired by works of
Russian Constructivists Alexander
Rodchenko, Varvara Stepanova Stenberg
brothers, in 1920s and 1930s.

Design | Type design: Tagir Safaev _Rodchenko

POATENK

₩ŮŬĬĠĔĦĸ

1234567890

ABCDEFGHIJ

ABCDEFCHIJK

АБВГДЕЁЖЗИ

АБВГДЕЁЖЗИЙ

@#\$&†() § Nº!?

Poster for PT Pollock typeface, 1995 60 x 90 cm The poster was created after the international conference FUSE 95 in Berlin.

Design | Type design: Alexander Tarbeev _Pollock

Poster for ParaType Arabic project, 1995 60 x 90 cm Design: Tagir Safaev

هرسبزه که برکنار جوئی بودست گوئی که خط فرشته خوئی بودست تا بر سر سبزه پا به خواری ننهی کان سبزه زخاک لاله روئی بودست

RUBAYAT by Omar Hayam

Typefaces: PT Mariam, PT Naskh Ahmad

Type designer: Lyubov Kuznetsova

Design: Tagir Safayev

© ParaGraph 1995

abcdefghijklmno

Type design: Jean-François Porchez _Apolline Regular

Porchez Typofonderie

Location_Malakoff, France

Established 1994

Founder | Type designer_Jean-François Porchez

Distributors_Agfa, FontBureau

FontShop International (FSI)

High-quality typefaces for adventurous digital typographers

After training at the Atelier Nationale de Recherche Typographique (ANRT), Jean-François Porchez worked as a typeface designer and consultant at Dragon Rouge. His first two type designs, Angie and Apolline, were prize-winning entries at the international Morisawa typeface competition. By 1994 he had created the new typeface for Le Monde and, in 1996, he created Parisine (intended for the corporate identity of the Paris Métro) and Anisette (designed with reference to the French poster designers of the 1930s). He has since finished the Le Monde family, which is made up of four basic styles.

Porchez Typofonderie is the biggest independent type foundry in France and is devoted to continuing the French tradition of typography. It specializes in the production of custom typefaces and digitizing work. Jean-François Porchez teaches typography at École Nationale Superieure des Arts Décoratifs (ENSAD) and École de Communication Visuelle (ECV), in Paris. He is typographic correspondent for the magazine Étapes Graphiques, a member of the Rencontres Internationales de Lure and the French representative of the Association Typographique Internationale and the Typographic Circle.

Jeune créateur de caractères, Jean-François Porchez, 30 ans, a été formé dans une école d'arts graphiques & à l'Atelier National de Création Typographique. Il a travaillé comme créateur & conseiller typographique chez Dragon Rouge. Ses deux premières créations, le FF Angie & l'Apolline ont été primées au concours international de création de caractères Morisawa awards.

créé par Jean-François Porchez

Mais sa plus belle réussite est le caractère Le Monde créé pour la nouvelle formule du quotidien du même nom. Depuis il exerce en indépendant, une activité de créateur de caractères & enseigne la typographie:

JVWXYZ&ABCDEFGHIJKLMNOPQRSTUVWXYZ0123456789

₹ 7/9pt REGULAR L'Apolline, un caractère de texte qui allie sensibilité & rythme a déjà recu le prix d'honneu au concours international de création de caractères Morisawa Awards 1993 au Japon. La famille a été dessinée en 3 graisses, romain & italique. Des petites capitales ainsi que des jeux de chiffres bas-de-casse, capitales et de nombreuses ligatures complètent les séries. Le bas-de-casse romain marque l'horizontale, il tire sa dynamique de l'écriture. Par ses différences deproportions, l'asymétrie de ses empattements, le texte est plus rythmé. Il fait référence aux caractères

€ 9/11pt Regular humanistiques. Les capitales sont lapidaires par leurs proportions, écrites par la forme de leurs empattements. L'italique est lui, plus contemporain dans son dessin. Il peut rappeler les italiques d'eric GILL, de JAN VAN KRIMPEN. L'Apolline, un caractère de texte qui allie

€ 12/14pt REGULAR La famille a été dessinée en 3 graisses, romain & italique. Des petites capitales ainsi que des jeux de chiffres bas-de-casse, capitales & de nombreuses ligatures

€ 12/14pt Semi-Bold La famille a été dessinée en 3 graisses, romain & italique. Des petites capitales ainsi que des jeux de chiffres bas-de-casse, capitales & de nombreuses

La famille a été dessinée en 3 graisses, romain & italique. Des petites capitales ainsi que des jeux de chiffres bas-de-casse, capitales & de nombreuses

ortzEstbffhfififififlfltQQ

fffiffiffi1/21/31/41/82/33/45/87/80123456789

ABCDEFGHIJKLMNOPQRSTUVWXYZ&fffiflffiffl¹/2¹/3¹/4¹/8²/3³/4⁵/8⁷/80123456789

2RSTUVWXYZ01234567890123456789

IIJKLMNOPQRSTUVWXYZ01234567890123456789

abcdefghijklmnopqrstuvwxyz&ABCDEFGHIJKLMNOPQRSTUVWXYZ01234567890123456789

opgrstuvwxyz&ABCDEFGHIJKLMNOPQRSTUVWXYZ01234567890123456789

BCDEFGHIJKLMNOPQRSTUVWXYZ01234567890123456789

abcdefghijklmnopqrstuvwxyzABCDEFGHIJKLMNOPQRSTUVWXYZ ƌ&æœfifl\$01234567890123456789%%\$\$£¥f áâàäãåçéêèëfîìïiñóôòöőúûùüÿÁÂÀÃÄÅÇÉÊÈËÍÎÌÏÓÔÒÖŐÑÚÛÙÜŸ

E 16/18pt RECULAR L'Apolline, un caractère de texte qui allie sensibilité & rythme a déjà reçu le prix d'honneur au concours international de création de caractères morisawa awards 1993 au Japon. La famille a été dessinée en 3 graisses, romain & italique. Des petites capitales ainsi que des jeux de chiffres bas-de-

de caractères de texte et de titrage ont été ajoutées à la collection Agfatype. Ces nouveautés portent la collection à un total de 1300 polices de caractères.

 $\mathsf{AgfaType}$

Postcard/specimen, 1995 38 x 23 cm

Design | Type design: Jean-François Porchez _Apolline

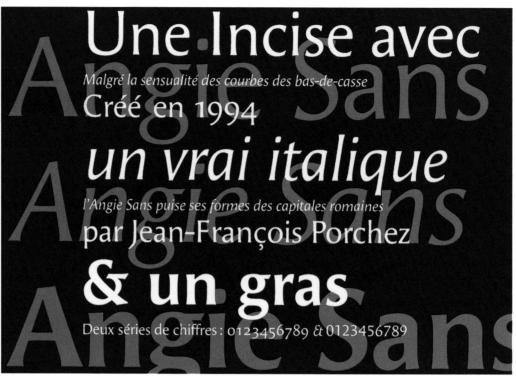

Postcard/specimen, 1994 15 x 10.5 cm

Design | Type design: Jean-François Porchez _Angie Sans Roman, Italic, Bold

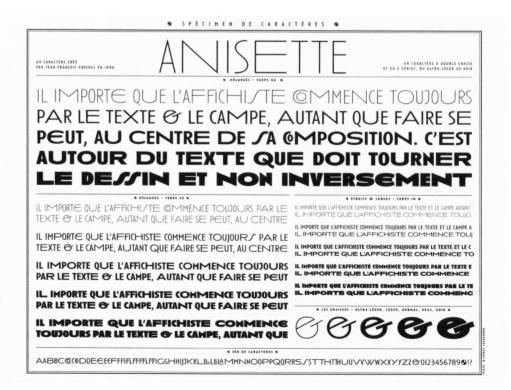

Postcard/specimen, 1997 15 x 10.5 cm

Design | Type design:

Jean-François Porchez _Anisette Thin, Light, Medium, Bold, Black

FFAngie
Angie Sans
ANISETTE
Apolline
Le Monde Journal
Le Monde Sans
Le Monde Livre
Le Monde Courrier

Type design: Jean-François Porchez Parisine

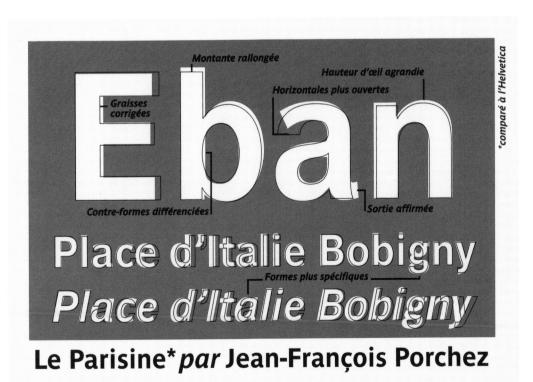

Postcard/specimen, 1997 15 x 10.5 cm The postcard compares Helvetica condensed at 90% and Parisine, the new face for the Paris Métro.

> Design | Type design: Jean-François Porchez _Parisine Bold, Bold Italic

abcdefghijklmnopqrstuvwxyz abcdefghijklmnopqrstuvwxyz ABCDEFGHIJKLMNOPQRSTUVWXYZ ABCDEFGHIIKLMNOPORSTUVWXYZ ABCDEFGHIJKLMNOPQRSTUVWXYZ ABCDEFGHIJKLMNOPQRSTUVWXYZ 0123456789 && 0123456789 ßfifl,;;!? 0123456789 && 0123456789 ßfifl,;:!?

Il y a bien évidemment des rapp ORTS ENTRE LE MONDE & LE TIM es New Roman précédemment uti LISÉ PAR LE JOURNAL. LE TIMES ES

Il v a bien évidemment d ES RAPPORTS ENTRE LE M onde & le Times New Rom AN PRÉCÉDEMMENT UTILISÉ

Le Monde Journal

abcdefghijklmnopqrstuvwxyz abcdefghijklmnopqrstuvwxyz ABCDEFGHIJKLMNOPQRSTUVWXYZ ABCDEFGHIJKLMNOPQRSTUVWXYZ ABCDEFGHIJKLMNOPQRSTUVWXYZ ABCDEFGHIIKLMNOPORSTUVWXYZ. 0123456789 && 0123456789 Bfiff,,;:!? 0123456789 && 0123456789 ßfifl,.;:!?

abcdefghijklmnopqrstuvwxyz abcdefghijklmnopqrstuvwxyz ABCDEFGHIJKLMNOPQRSTUVWXYZ ABCDEFGHIJKLMNOPQRSTUVWXYZ ABCDEFGHIJKLMNOPORSTUVWXYZ ABCDEFGHIJKLMNOPORSTUVWXYZ 0123456789 && 0123456789 Bfifl,.;:!? 0123456789 && 0123456789 Bfifl,.;:!?

If the temporary to the control of t

Il y a bien évidemment des rapports entre Le Mond e & le Times New Roman précédemment utilisé pa R LE JOURNAL LE TIMES EST DEVENU PAR SON USAG e l'équivalent d'un véritable cliché culturel. Il est donn é comme premier caractère, par défaut, à presque tou S LES MICRO-ORDINATEURS EN MÊME TEMPS QUE L'HELV

Il y a bien évidemment les rapports entre L E MONDE & LE TIMES NEW ROMAN PRÉCÉD emment utilisé par le journal. Le Times est d EVENU PAR SON USAGE L'ÉQUIVALENT D'UN VÉ

abcdefghijklmnopqrstuvwxyz ABCDEFGHIJKLMNOPQRSTUVWXYZ ABCDEFGHIJKLMNOPQRSTUVWXYZ 0123456789 & 0123456789 Bfifl,;;!? 0123456789 & 0123456789 Bfifl,;:!?

abcdefghijklmnopqrstuvwxyz abcdefghijklmnopqrstuvwxyz ABCDEFGHIJKLMNOPQRSTUVWXYZ ABCDEFGHIJKLMNOPQRSTUVWXYZ 0123456789 & 0123456789 & Bfifl...:!? 0123456789 & 0123456789 ßfifl, ;:!?

abcdefghijklmnopqrstuvwxyz abcdefghijklmnopqrstuvwxyz ABCDEFGHIJKLMNOPQRSTUVWXYZ ABCDEFGHIJKLMNOPQRSTUVWXYZ ABCDEFGHIJKLMNOPQRSTUVWXYZ ABCDEFGHIJKLMNOPQRSTUVWXYZ 0123456789 && 0123456789 &fiff, ;;!? 0123456789 && 0123456789 Bfiff, .::!?

abcdefghijklmnopqrstuvwxyz abcdefghijklmnopqrstuvwxyz ABCDEFGHIJKLMNOPQRSTUVWXYZ ABCDEFGHIJKLMNOPQRSTUVWXYZ ABCDEFGHIJKLMNOPQRSTUVWXYZ ABCDEFGHIJKLMNOPQRSTUVWXYZ 0123456789 && 0123456789 Bfifl,,;:!? 0123456789 && 0123456789 Bfifl,,;:!?

abcdefghijklmnopqrstuvwxyz abcdefghijklmnopqrstuvwxyz ABCDEFGHIJKLMNOPQRSTUVWXYZ ABCDEFGHIJKLMNOPQRSTUVWXYZ ABCDEFGHIJKLMNOPQRSTUVWXYZ **ABCDEFGHIJKLMNOPQRSTUVWXYZ** 0123456789 && 0123456789 Bfifl, ;:!? 0123456789 && 0123456789 ßfifl,.;:!?

abcdefghijklmnopqrstuvwxyz abcdefghijklmnopqrstuvwxyz ABCDEFGHIJKLMNOPQRSTUVWXYZ **ABCDEFGHIIKLMNOPORSTUVWXYZ** ABCDEFGHIJKLMNOPQRSTUVW; ABCDEFGHIJKLMNOPQRSTUVWXYZ 0123456789 & 0123456789 & fiff, ;;!? 0123456789 & o123456789 & fiff, ;:!?

abcdefghijklmnopqrstuvwxyz abcdeignijkimnopqistuvwxyz abcdefghijkimnopqistuvwxyz ABCDEFGHIJKLMNOPQRSTUVWXYZ ABCDEFGHIJKLMNOPQRSTUVWXYZ ABCDEEGHIIKI MNOPORSTUVW ABCDEFGHIJKLMNOPQRSTUVWXY. 0123456789 && 0123456789 Bfifl, ::!? 0123456789 & 0123456789 ßfifl, ;:!?

abcdefghijklmnopqrstuvwxyz abcdefghijklmnopqrstuvwxyz ABCDEFGHIJKLMNOPQRSTUVWXYZ ABCDEFGHIJKLMNOPQRSTUVWXYZ 0123456789 & 0123456789 Bfifl,;;!? 0123456789 & 0123456789 Bfifl,;;!?

ABCDEFGHIJKLMNOPQRSTUVWXYZ 0123456789 & 0123456789 Bfiff, ;:!? 0123456789 & 0123456789 Bfiff, ;:!?

abcdefghijkimnopqrstuvwxyz abcdefghijkimnopqrstuvwxyz ABCDEFGHIJKLMNOPQRSTUVWXYZ

DEVEN Il y a ORTS es Ne ILISÉ lly

memn

ES R ond AN F

abcdefghijklmnopqrstuvwxyz ABCDEFGHIJKLMNOPQRSTUVWXYZ ABCDEFGHIJKLMNOPQRSTUVWXYZ ææðfifllþßææÆŒÐŁÞ 0123456789&0123456789&0123456789
\$\$¢¢¢£Y¥€€f¹²³/½¼¾%%%!¡?¿()[]{}|\/_
•**†\$\$#@®©@TM®OµV<+x-=>^-|áâàããáçéêèēminóôòöōøúûùūÿ

ÁÂÀÄÄÁÇÉÊÈĒÍĬĬĬŇÓÔÒÖÖØÚÛÜŸ ÁÂÀÄÄÁÇÉÊÈĒÍĬĬŇÓÔÒÖÖØÚÛÙŨŸ

Le Monde Sans

Specimen for Le Monde family, 1997 29.7 x 41.8 cm The specimen includes texts from Laurent Greilsamer, Gérard Blanchard Sumner Stone and Allan Haley. Le Monde family consists of thirty-two weights in four different styles: Le Monde Journal, Le Monde Sans Le Monde Livre, Le Monde Courrier.

Design | Type design: Jean-François Porchez _Le Monde

e Monde Livre

Le Monde Grande Grande

Parcourt Lire neuf, grand & beau A type family story

Echoing old style faces

La Totale typographie

apports entre Le Mond Écédemment utilisé par VENU PAR SON USAGE L culturel. Il est donné co aut, à presque tous les mi MPS QUE L'HELVETICA. LE

des rapports entre IEW ROMAN PRÉCÉ rnal. Le Times est de UIVALENT D'UN VÉRIT

ment des rapp NDE & LE TIM édemment utili LE TIMES EST D

lemment de TRE LE MO New Roman T UTILISÉ PA

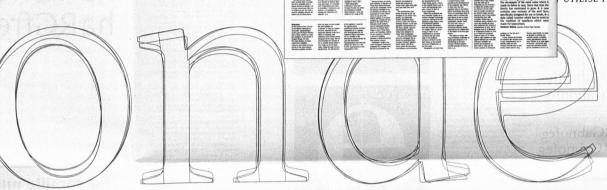

nt des rapports entre New Roman précéd journal. Le Times est L'ÉQUIVALENT D'UN VÉRI

mment des rapp MONDE & LE TIM récédemment ut IAL. LE TIMES EST

idemment d ENTRE LE M nes New Rom MENT UTILISÉ P

Le Monde Courrier

The control of the co

AND THE CONTROL OF TH

Il y a bien évidemment les rapports entre LE MONDE & LE TIMES NEW ROMAN PRÉCÉDE mment utilisé par le journal. Le Times est de VENU PAR SON USAGE L'ÉQUIVALENT D'UN VÉRITA Il y a bien évidemment les rapp ORTS ENTRE LE MONDE & LE TIMES New Roman précédemment utilis É PAR LE JOURNAL. LE TIMES EST DE

Il v a bien évidemment d ES RAPPORTS ENTRE LE MO nde & le Times New Roma AN PRÉCÉDEMMENT UTILISÉ

abcdefghijklmnopqrstuvwxyz abcdefghijklmnopqrstuvwxyz ABCDEFGHIJKLMNOPQRSTUVWXYZ ABCDEFGHIIKLMNOPORSTUVWXYZ ABCDEFGHIJKLMNOPQRSTUVWXYZ **ABCDFFGHIKLMNOPORSTUVWXYZ** 0123456789 & 0123456789 Bfifl, ;:!? 0123456789 && 0123456789 \$fifl, ;:!?

abcdefghijklmnopgrstuvwxyz abcdefghijklmnopqrstuvwxyz ABCDEFGHIJKLMNOPQRSTUVWXYZ ABCDEFGHIJKLMNOPQRSTUVWXYZ
ABCDEFGHIJKLMNOPQRSTUVWXYZ ABCDEFGHIJKLMNOPQRSTUVWXYZ 0123456789 && 0123456789 Bfifl,.;!? 0123456789 && 0123456789 ßfifl,.;:!?

abcdefghijklmnopqrstuvwxyz abcdefghijklmnopqrstuvwxyz ABCDEFGHIJKLMNOPQRSTUVWXYZ ABCDEFGHIJKLMNOPQRSTUVWXYZ ABCDEFGHIJKLMNOPQRSTUVWXYZ ABCDEFGHIJKLMNOPQRSTUVWXYZ 0123456789 && 0123456789 Bfifl,;;!? 0123456789 && 0123456789 Bfifl,;;!?

la fua ruota

Fabrizio Schiavi Design

Location_Piacenza, Italy
Established_1998
Founder|Type designer_Fabrizio Schiavi
Distributors_[T-26], FontShop International (FSI),
Fontology

Post-design

Fabrizio Schiavi has worked as a self-employed designer and font maker since 1994. He places conceptual work in the foreground of developing projects and does not believe that innovation exists in aesthetic aspects. Instead he feels that it results from removing familiar elements from their usual context and integrating them into a new context so they receive an unfamiliar, new meaning. Schiavi rejects the idea that a font only serves as the bearer of a specific message; he believes a font communicates its own information as a result of its visual qualities.

Schiavi devotes more and more time to Web design. His goal is not only to translate the contents of print media, but also to create a truly interactive experience so users can obtain information in an entertaining way and experience new contexts.

Fabrizio Schiavi is also one of the founders of the Fontology font project which began in 1995 in collaboration with Happy Books in Modena (see p. 120).

typelace name: Post style name: Regular

GARAGE
Ken ishi
displayed
stop->post
post-Bahaus
auantearde
no more erunge
intelligent techno

Specimen, 1997 The font was exclusively designed for the record company Expanded Music Srl.

Website, 1998
www.agonet.it/fabrizioschiavi/
On his own website Fabrizio Schiavi
pays homage to the people responsible
for his career development.
He also demonstrates his ideas about
interactive communication and
presents information in a playful way by,
for example, using a type quiz.

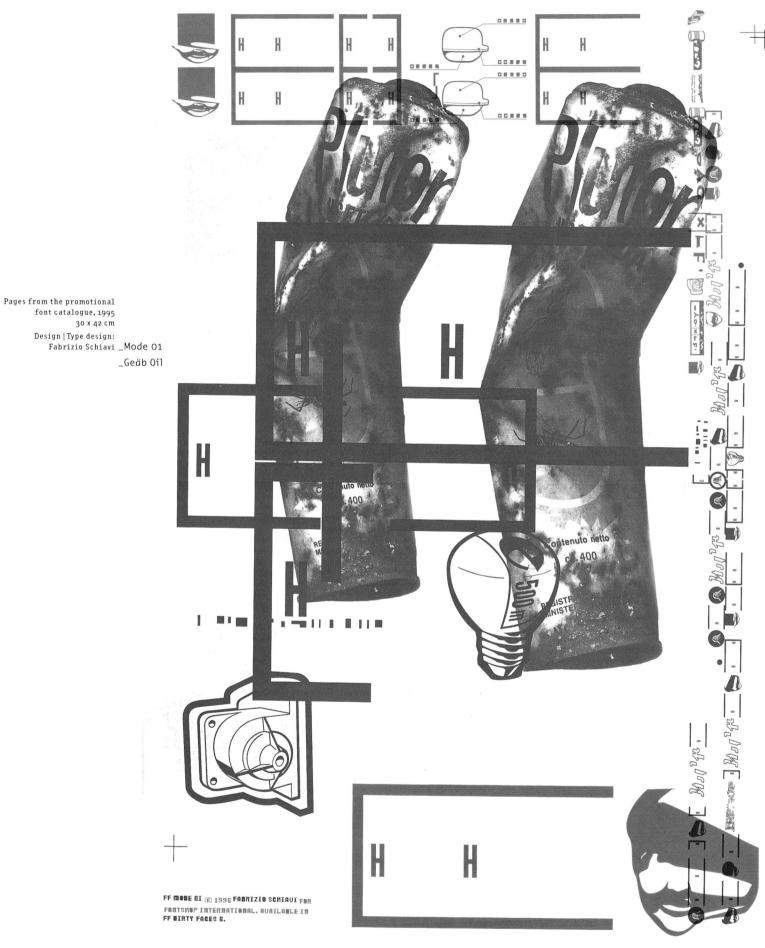

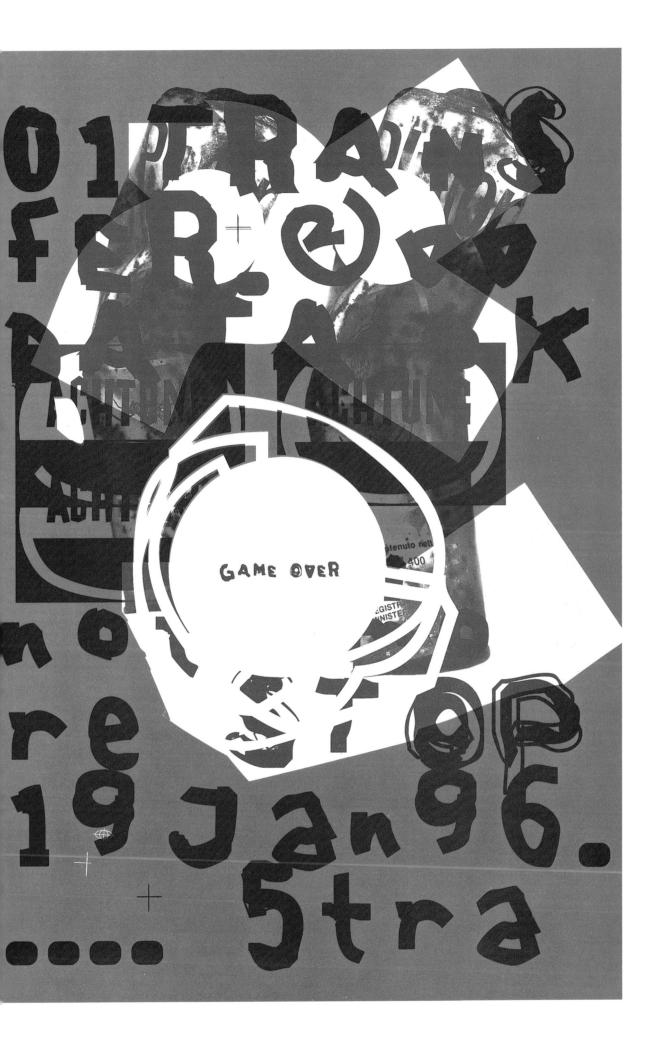

___Dot Gain or The Endless Repetition of Dot

Michael Horsham

I can't remember when I stopped watching the soap opera 'Eastenders'. I only know that I did. The reasons for deserting what had become something of a ritual for a couple of evenings a week were complex. The show hadn't become worse. If anything, it was in the process of becoming a more concentrated version of itself. Story lines were tight and compelling. The characters, if not completely believable, were sufficiently strong to induce care or hissing fits depending or their perceived capacity for good or evil.

It was pantomime, but good pantomime. Wilmott-Brown, for example, our Kaff's rapist/nemesis was quite the Victorian villain. He was posh and a landlord to boot, and was only missing the moustache to twirl and a convenient railway track on which to strap the heroine. Sympathetically, or maybe just pathetically, I cared what happened next. But, if I can't remember when I stopped watching, I can remember why – it was Dot.

Dot Cotton, with her infernal internally rhyming name, had long begun to take the pleasure out of watching for me. It wasn't just her appearance – the haggard face and the cigarette held aloft, the receded gums and the long teeth – it was her role. Even though I had dreamed of having sex with Dot (surely a turning point), it was her functional omnipresence that began to put me off the show. Dot was like the Greek chorus; she commented on the action all the time. Preceding her pronouncement with the absurd, 'Well, yes, you know me, I'm

not one to gossip, but...', she goes on to assassinate the traits of one of her fellow characters. It was comic at first, of course it was, but the endless and repeated use of Dot as a device for moralizing or mediation grew wearisome. The grotesqueness of her appearance coupled with her role as a mediatrix who never actually produced anything by way of plot or development, was ultimately alienating. She just reproduced the action and that act of reproduction held an implicit criticism of what had occurred. There was little in the way of good or originality within her; a secondary character with a secondary function. She was no Hilda Ogden.

Now, I'm told, she is back in the show (I hadn't realized she'd been away) and I can only surmise that 'Eastenders' will continue to churn out its depressing mixture of low drama and government-inspired 'issue-based' stories. Stories featuring single parents, illiteracy, AIDS awareness, etc., all without swearwords and all tinged with the all-knowing, utter fake functionality of Dot's two-dimensional character.

The issues are dimensionality and filtering; an idea of truth, or authenticity and an idea of the real. The link between 'Eastenders' and the real subject of this piece is tenuous, and I am the first to admit that I would be stuck for an opening if Dot were named otherwise. It's lucky she isn't and it's equally lucky that she is so crap. But still, I think there is a point here.

To illustrate the case of the dot a little further. Around 1966 Rover cars launched their replacement for the highly regarded P5 model. For those of you that need a reference point, the P5 was a ministerial barge, which also doubled as a gangster wagon. For instance, James Fox's chemically unbalanced character was driven about in a P5 in Cammel & Roeg's film Performance. The P5 is generally regarded by afficionados as the last real Rover. The replacement was the P6, the car I drive today; an altogether more modern and angularly aerodynamic design. The P6 has an atmosphere of Rover authenticity that stems not from the lavish use of walnut and leather as did its predecessor's, but from its mechanical excellence and reliability.

Unwilling to break completely with the traditions of the marque, the designers at Rover eschewed real wood in favour of a suggestion of the same. The result was the inclusion of some very nasty 'wood veneers' printed with a half-

tone colour image of rosewood grain. Look closely at the door trim or the dashboard and the whole thing is dots of different colours. The effect is kitsch and the P6 is consequently – at the moment at least – a very cool car, but then I would say that. You don't disrespect your own ride, after all.

The car's appeal lies partly in the fact that it comes from a tradition not of craftsmanship and coachbuilding as its predecessors did, but of modern reproduction. It is therefore modern in its self-reflexive reliance on technology for its identity. In that sense it's very 1970s. It's also curious to think that the P5s and the P4s before them all enjoyed a modicum of uniqueness, delivered by the minute inconsistencies and quality of grain and colour in the woods used in their construction. The Rover P6 was among the first British cars to be serially replicated both decoratively and mechanically - because the organic nature of the decoration was mechanically derived. On the Rover's dash and panelling, tone had become type. Culturally and technologically, the grain had become The Dot.

The same idea works with photography. Although a chemical and therefore modern method of reproduction, the grain of photographic emulsion and the grain of photographic papers (or indeed any medium that has been made photosensitive) is the element which adds – to some degree – the grain of authenticity, even the grain of truth, to the image as manufactured object. Reproduce a photograph using a dotscreen and print it in a newspaper and the act of publishing is a matter of documentary reproduction rather than one of individual authorship.

The dot - the unitary, mechanistically derived element of the whole image is therefore a signifier of the process of mass mediation.

See a dot, this theory goes, and see the sign of reproduction and not authorship. Ah! I hear you say, but what about those painters and artists for whom the dot is central to their work? Well, even when the dot is deployed as part of the method of authorship, say, in a Lichtenstein or at a push a Chuck Close, its presence unfailingly marks the product as modern, and in some way the product of a filtered or mediated aesthetic that is not so far removed from that formica coffee table or my dashboard.

We know that Lichtenstein's Benday-style dots, long the underpinning of cheap reproductive technology, mark those works as self-conciously robust reproductions of reproductions. So, at first glance the issue becomes one of scale and meaning rather than an obvious analysis of or reliance on painterly technique. Chuck Close is at the other end of the spectrum. The laborious accretion of colour and tone in the manufacture of his seemingly 'photo-real' heads of the 1970s was achieved by using the airbrush, pastels, oils and seemingly a whole raft of traditional artists' materials to replicate and enlarge the characteristics of his sitters originally captured on polaroid. In much of Close's work the dot is there as evidence of a modern pointillist modus operandi: technique is everything, albeit mind-numbingly repetitious. The presence of the artist, not the machine, is the filter which turns the act of reproduction into what has been identified as a relationship between units and unity, the parts and the whole. The point is this: within the world of painting and made marks we end up with work that is modern. filtered and distanced and, as in 'Eastenders', we recognize it as such by the presence of the Dot.

It's our ability to break the close tonal range of the grain of the world into the specifics of unit and unity (and in the process highlight the relationship of the parts to the whole) that makes the presence of the dot in the culture of reproduction worthy of note. And, at the heart of the issue is the transference of

the qualities of tone and grain to those of typology and unit. It's a mechanistically simple process. Dot screening works by dividing any image or complex tonal field into a field of typological units: the dots. These units are then given colour and tonal values, but the dominant values are always the conditions and qualities of the dots.

Until recently one of the printer's greatest enemies to quality was the occurrence of 'dot gain', the phenomenon whereby ink would leach into the print medium and smudge the dots, so altering the supposedly stable typology and lending the image tonal values that were outside the printer's controllable parameters. That is, the quality of the dots would change by accident and there would be a tonally complex, but shitty image. Newer techniques, such as stochastic screening, recognize the ludicrous inflexibility of the traditional dot and use a more complex interwoven geometry. It seems that the dot may have run its course as a visible component of reproductive technology.

However, the humble dot is far from dead largely because it has the capacity to deliver both power and beauty. Thomas Ruff's giant composite portraits of seemingly perfectly featured people are presented on gallery walls in all their lilac-hued dotty magnificence. As products of modern photographic techniques involving – I am told – police Photofit cameras, the presence of the dot is utterly subservient to the effect of the picture's ethereal

otherness. But, the dot is a crucial part the notion that the images have been manufactured. The artifice of reproduction is almost the whole point. Jenny Holzer's dot matrixes are also worthy of note, in that they are perhaps the purest expression of the power of the dot when effectively deployed at the art end of the spectrum. The clarity and luminosity of the dot matrix as an information carrier is not compromised by the task it is being asked to perform.

And, there is the rub and the power. Wherever the dot is identifiable as evidence of filtering, wherever the dot-as-type replaces the grain-as-tone, wherever the dot is simply the identifiable mark of reproduction technology, the result is arguably removed from the authentic or the real experience.

Quite where this takes us in terms of value is difficult to determine. The experience of my car is no less enjoyable because the wood effects are cheesy, but for some reason a bad reproduction of a painting, say in a 1970s art anthology, wherein the dots are visible, unarguably destroys the quality of the image and in turn the experience of the image. Unless used as a pure form and not as a way of approximating complex tonal qualities, the dot is doomed to the cultural nether world of cheese repro. At the moment this has its own currency, but just how long that lasts is anyone's guess...

TYPEFACES

Stone Type Foundry Inc.

Stone Type Foundry

Location_Palo Alto, California, USA
Established_1990
Founder|Type designer_Sumner Stone
Distributors Aafa, Stone Type Foundry

The design of letter forms is both practical and magical

Stone Type Foundry creates, produces and markets designs for the professional typographer. The company also offers custom-made typeface design and identity and signage programmes for public and private institutions. Mobil Corporation, General Motors, Stanford University, San Francisco Public Library and Scripps College are all customers.

Sumner Stone is fascinated by written forms because they do not exist in a vacuum. Instead, they occupy a position at the confluence of many different streams of human life such as language, visual perception, intellect, kinaesthesia, emotion and social structure. From his point of view, typeface design involves the knowledge and practice of many disciplines, the underpinnings of which are drawing and the history of letter forms. His practice and study of these disciplines for more than thirty years helps him to solve typeface design problems such as designing a text typeface at the limits of condensation (Print) or a humanistic slab serif drawn entirely on a computer screen (Silica). However, there are also many other influences. Each new project is a challenge to old aesthetics and received wisdom for Sumner Stone. It is a new window on some part of society, an active journey through his own eyes, mind, hands and spirit to unite the past and the future.

Specimen for Arepo, Cycles, Print, Silica and ITC Stone, 1995 21.6 x 27.9 cm

> Design: Jack Stauffacher Type design: Sumner Stone _Arepo Roman, Italic

Part of an advertisement for ITC Stone, version 2.0., that appeared several times in 'U&lc' in 1995. 8 x 24 cm

Design | Type design: Sumner Stone _ITC Stone, Version 2.0

The early Christian latin palindrome above was painted on a wall at Pompeii.

This broadside was printed at Stone Type Foundry, Palo Alto, California
as a keepsake for Sumner Stone's lecture

"The Future of Typeface Design"
given for The Associates of the Stanford University Libraries on January 11, 1996.

The typeface, Arepo, was designed by Mr. Stone.

Keepsake from a lecture given at Stanford University, 1996.

Design | Type design: Sumner Stone _Arepo

Judith Sutcliffe: The Electric Typographer

Location_Audubon, Iowa, USA
Established_1986
Founder|Type designer_Judith Sutcliffe

Distributors_FontShop International (FSI)

Agfa, Monotype, Type Founders

International, Daniel Will-Harris

Judith Sutcliffe founded The Electric Typographer in 1986 in Santa Barbara, California. She publishes and markets her own fonts exclusively under this name. When she began to work with Fontographer in 1985, she digitized various fonts by Frederic Goudy (Newstyle, Oldstyle, Italian), which are still included in The Electric Typographer's catalogue today. Since there were no scanners back then, she drew the fonts by hand - intensive training for eye and hand. Later, she began to draw her own fonts, which were mostly based on calligraphic ideas. She especially enjoys designing dingbats, particularly those based on petroglyphs. Judith Sutcliffe's best known fonts go back to manuscripts by Leonardo da Vinci and Giovanni Antonio Tagliente. Calligraphy, handwriting and hand-lettering remain her never-ending source of inspiration. In 1996 Judith Sutcliffe moved from Santa Barbara to Audubon, Iowa.

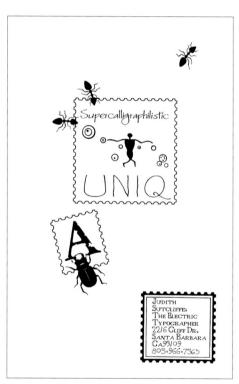

Catalogue cover, 1996

14 x 21.5 cm
The cover shows several dingbat fonts
and typefaces, for example, Daly Hand
(based on the casual handwriting of a
sculptor named Daly), Greene (based
on architectural lettering of the
Arts & Crafts architects Greene and
Greene), and Kiilani (based on
nineteenth-century letters carved into
Hawaii rocks).

 ${\tt Design} \ | \ {\tt Type} \ {\tt design: Judith \ Sutcliffe \ _Insecta}$

- _01dstyle Chewed
- _Petroglyph Hawaii
- _Electric Stamps
- _Daly Hand
- _Greene
- _Kiilani

Pages from the catalogue, 1996

Design | Type design: Judith Sutcliffe _Daly Hand

- _Insecta
- _01dstyle Chewed
- _Daylilies

It's a lively, elegant, farciful hand in small or large sizes. There are quite a few alternative characters, but they're not necessary for general composition. With a qualm, the jolly first mate expected a sorg about the grizzly viking. After I did this font. I created another, simplified, straighter, more regularized version:

Daly Text is a more regularized version.

This is what Daly Text looks like in smaller text size. This is a very pleasant sans serif fins 5 with Daily thand for littles and Dally Text for text. The quick brown for jumps over the lazy dog while the wicked peon quivered, gazing balefully skyward.

Single forts are \$45 cach Daly Sot Paly Hand and Daly Toxt) is \$79.95

INSECTA A font of 28 bugs lifelike enough to swat.

OLDSTYLE CHEWED the insects have eaten. Plus Goudy Oldstyle Bold/Italic Insecta Set includes Insecta, Oldstyle Chewed, Goudy Bold/Italic for \$45.00

Daylilies Initials uses Goudy Oldstyle capitals

₹00000 \$ ₹ 0 | x ‡ 0 0 LEAVES based on Goudy Oldstyle. Goudy Oldstyle included! Daylilies Set includes Daylilies, Leaves, Goudy Oldstyle & Italic for \$45.00 GARDEN VARIETY-Both Insecta & Daylilies Sets for \$79.95

Now you can write with a

For elegant Typesetting, for calligraphic display & titling. With cap and lower case flourishes, alternative letter forms, double and tied letters. And a bold version. Many calligraphers use this font for enver lope addressing. A handsome font with many uses. This is the bold version of Flourish.

AABBCEDDEEFFGGHHIJNCMMNN abcdefghijklmnopgrsturwyzyz th ti ll pp ss zz a r Küßchen

Hourish with Bold is \$70.05.

ENE AND GREENE DASED ON ARCHITECTURAL HAND LETTERING OF PASADENA ARCHITECTS IN EARLY 1900S CAPS AND SMALL CAPS Nº 123 TOR 45 AT 67890

THESE ARE TITLING FONTS AND WILL WORK BEST IN LARGER SIZES AS THEY ARE DELICATE PENCIL LINE SIMULATIONS. THIS IS THE BOLD AT 14 PT.

ARTS AND CRAFTS

CREENE AND ITS BOLD VERSION ARE \$45

Leonardo Hand Lennito da Vinci's calligraphic hand is just one of the unique of original typhaces available from the electric Typographer. Vigorous and discrinctive, with many alternative tharacters. ABCDE FGHJRLMNOPORSTUVW X Y 3 pocada (8 84 milker (MNO balestrom x A 315 14 2018 20) ente is based on the copybooks of a renowned 16th century Talsan writing master Many alternative characters. Quite a distinctive face. A B C CD F G H T LM M NN O P QR S T U W X T like apuck brown fox jumps over the lazy dogered 123,4567890 times \$\frac{1}{2}\$ Single foots 43 cmb or 129.95 for Leonardo Set (all three above) \(\frac{1}{2}\$

Schampel Black

Die geschwinde, braune Füchsin springt den fauler Hund über. Or something like that. Hy first Black Letter face, named for Grant Schampel, who thought my catalog was incomplete without one. There will be more.

Schampel Black is \$25.00

Design | Type design: Judith Sutcliffe _Flourish Greene

Design | Type design: Judith Sutcliffe _Leonardo Hand

_Tagliente

_Schampel Black

Website, 1998
www.t26font.com
Carlos Segura worked for a year to
develop a new look for the
[T-26] products. Viewers have been
able to see initial samples
since November 1998.

Design:[T-26]

ΓT-267

Location_Chicago, Illinois, USA

Established 1994

Founder_Carlos Segura

Type designers_Carlos Segura, Jim Marcus, Hat Nyugen
Stephen Farrell, Peter Bruhn, Alan Green
Darren Scott, Damien Mair, Chank, Greg Samata
Frank Heine, Rodrigo Cavazos, Margo Chase
John Wiese and many more

Distributors_[T-26], FontHaus, alt.Type, Atomic Type
Faces, FontWorks, Phil's Fonts, Precision Type
ITF, Agfa, Monotype, Creative Alliance
and many more

Change Your Face

When he was twelve years old, Cuban-born Carlos Segura already played the drums in a band in Miami. He stayed there until the age of nineteen working as a drummer and taking care of promotion for the band. He published a book presenting the material that he had designed during this time and was hired immediately as a production artist at an envelope company. His job was to design the return addresses for bank deposit envelopes. In 1980 he went to Chicago and worked for agencies such as Marsteller, Foote Cone & Belding, Young & Rubicam, Ketchum and DDB Needham, before founding the studio Segura Inc.in 1991. His intention was to merge fine and commercial art in his work.

Three years later he opened the foundry [T-26] to explore the typographical side of the business. The collection today contains eight hundred fonts. [T-26] also began the AIDing® project: a font released every quarter, consisting of a set of dingbats (each keystroke containing a design by a different contributor) to benefit AIDS research. Interested font designers send in their own contributions and the proceeds are donated to organizations that help and care for those afflicted by the disease.

In 1996 Carlos Segura also founded the experimental record label THICKFACE, which supports a mixed collection of art forms.

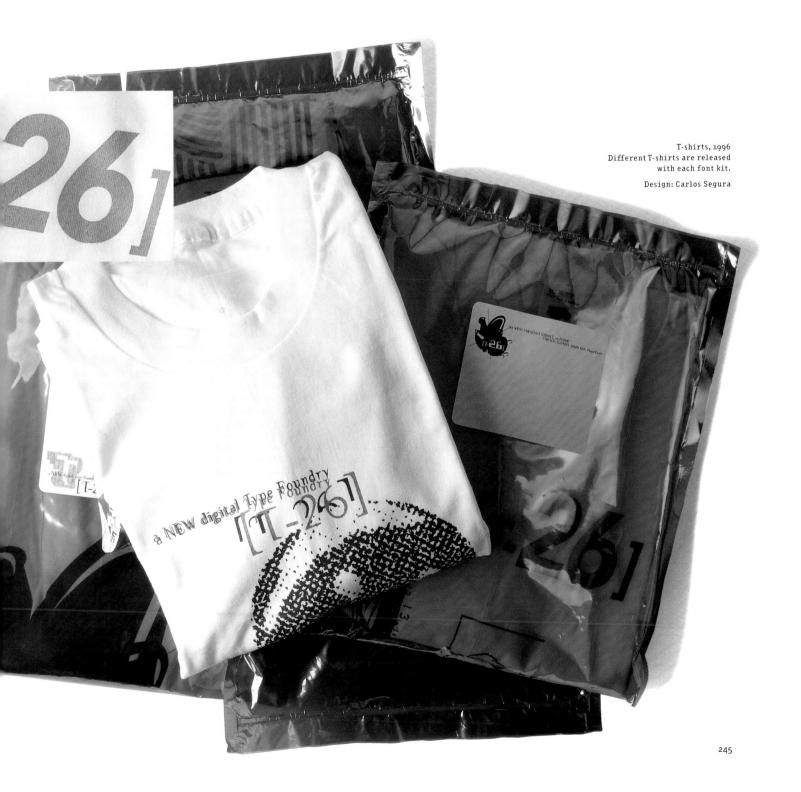

An exclusive

[T-26] release

trank Heine.

amplifier

 \square Tick here, and there \boxtimes .

Pages from the catalogue included in the Atypl box set, 1997 58 x 45 cm
It was produced to identify a shift in the corporate direction of [T-26], and was launched at the Atypl conference in Reading, 1997.

Design: Carlos Segura Susana DeTembleque John Rousseau Christine Hughes Type design: Frank Heine _Amplifier

Type design: Mauro Carichini _Babymine

Type design: Monib Mahdavi _Flux

Type design: Rodrigo Cavazos _Oculus regular, oblique

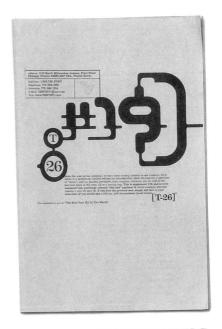

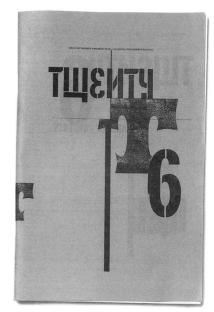

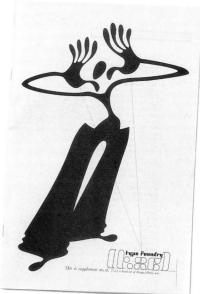

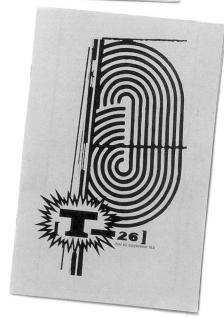

Catalogue supplements 1994-95 17.8 x 26.7 cm

Design: Carlos Segura Type design: Peter Bruhn _Pizzicato

_Unica

James Closs _Lunar Twits

Luiz Da Lomba _Lomba

Adam Roe _Dumpster

Dennis Dulude _Plastic Man

Marcus Burlile _Six Gun Shootout

_Telegraph Junction

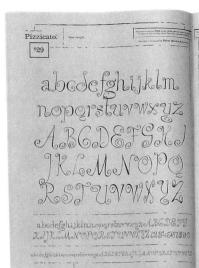

Pizzicato

1

krwwobok krwwobok

Agcgetehi Jktwhobók etanmana

αδεδεfghijkτωπορφεεταρωχήτ αδεδεfghijkτωπορφεεταρωχήτ

0123456789

Unica.

\$29

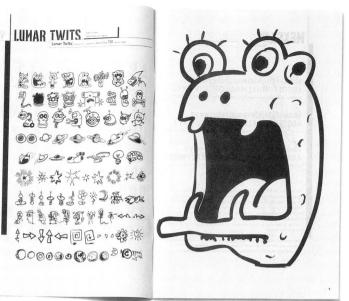

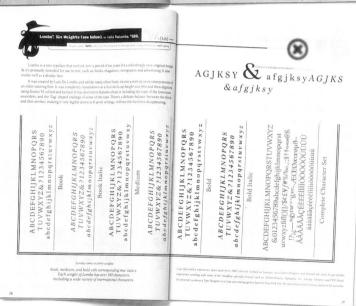

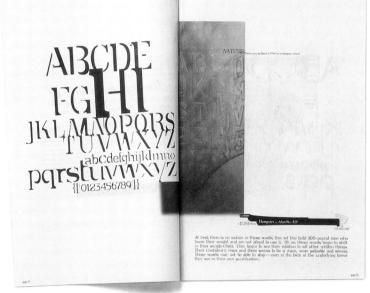

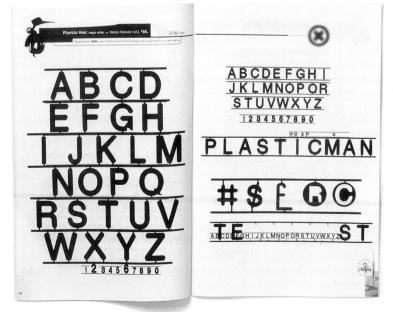

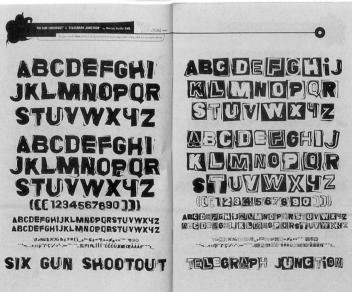

WAL-CHART™ CBW-01 REVISED 9/97

Chippies poster, 1997 61 x 45.8 cm

Design: Scott Stowell Type design: Chip Wass _Chippies E S^m

CREATURES -

A new dingbat font from

Brooklyn N.Y., U.S.A.
Ordering? Call:
(888) T26-FONT

	ANIMALS							
	R Offset: 47 Width: 966	Offset: 13 • Width: 1011	Offset: 64 Width: 890	B Offset: 50 Width: 1011	f Offset: 0 Width: 964	(}) Offset: 50 Width: 929		
	450					业		
	(R)	(.)	(option-g)	(B)	(f)	(@)		
	Offset: 70 Width: 803	Offset: 46 Width: 979	Offset: 24 Width: 862	Q Offset: 33 Width: 925	S Offset: 42 Width: 907	Offset: 66 Width: 954		
		N. T.				器		
	(,)	(K)	(")	(Q)	(S)	(5)		
	Offset: 57 Width: 969	Offset: 77 Width: 916	U Offset: 55 Width: 803	G Offset: 66 Width: 882	Z Offset: 21 Width: 801	Offset: 51 Width: 1012		
9			() So (C)					
2000000	(i)	(j)	(U)	(G)	(Z)	(1)		
	U Offset: 78 Width: 864	Offset: 59 Width: 895	Offset: 36 Width: 929	a Offset: 49 Width: 858	Offset: 75 Width: 1004	{ Offset: 79 Width: 1112		
					00			
louise.	(u)	(v)	· (/)	(a)	(1)	(1)		
)	Offset: 32 Width: 860	Offset: 88 Width: 1011	Offset: 0 Width: 713	Offset: 70 Width: 907	Offset: 48 Width: 1011	Ø Offset: 15 Width: 1055		
	***				0.0	*		

(shift-option-o)

Width 554

(option-3)

INSTRUCTIONS FOR USE: These 108 Chippies™ may be accessed by purchasing a copy of the Chippies by Wasseo™ font from T-26, 1110 North Milwaukee Avenue, Chicago, Illinois 60622, U.S.A. Orders may also be placed by telephone at (773) 862-1201, or by fax at (773) 862-1214. Orders received before 3:00 pm C.S.T. will be fulfilled the same day. Refer to this chart for keyboard placement of Chippies™. For external use only.

(option-7)

(option-8)

ALSO FROM WASSCO: Logotypes, character design, icons, book and compact disc jackets, posters, editorial and advertising illustration, as well as custom Chippies™ made to your exact specifications. For more information, or to obtain an estimate, contact your sales representative, Kirby "Chip" Wass, via telephone or fax at (718) 596-0864. Inquiries also accepted by electronic mail at chipwass@aol.com. Serious inquiries only, please.

11	6 Offset: 60 Width: 1011	Offset: 87 Width: 1011	> Offset: 80 Width: 914	♦ Offset: 47 Width: 947	Offset: 53 Width: 1011	Offset: 95 Width: 1001	? Offset: 79 Width: 857	2 Offset: 46 Width: 1011	3 Offset: 61 Width: 889	4 Offset: 95 Width: 1000
9	*		**				0	*	**	*
	(')	(=)	(>)	(*)	(+)	(-)	(?)	(2)	(3)	(4)
11	Offset: 75 Width: 1000	Offset: 75 Width: 997	Offset: 98 Width: 879	Offset: 27 Width: 1035	∞ Offset: 47 Width: 946	Offset: 78 Width: 1011	Offset: 42 Width: 935	9 Offset: 13 Width: 1066	Offset: 47 Width: 621	8 Offset: 55 Width: 754
7.7.7.		P. Li	0		攀					
	Ü	(')	(option-a)	(#)	(option-5)	(option-b)	(¡)	(9)	(/)	(8)

(option-9)

(w)

©1997 WASSCO, BROOKLYN, N.

Type design: Patric King, 1997 _Bad Excuse Solid, Outline

Front and back of poster, 1994 55.9 x 43.2 cm Design|Type design: Barry Deck _Cyberotica _Truth

Thirstype

Location_Barrington, Illinois, USA

Established_1993

Founder_Rick Valicenti

Type designers_Chester, Barry Deck, Frank Ford
Patrick Giasson, Patric King, Paul Sych
Greg Thompson, Rick Valicenti
Distributors_Thirstype, FontShop Germany
FontShop Norway

www.3st.com ... come on buy and see us

After working in Chicago as a graphic designer for The Design Partnership, Rick Valicenti founded his own company in 1981. In 1987 he set out to reinvent himself and the pursuits of his consultancy by creating Thirst, a firm devoted to art with function. His passion for design and the advent of new technology resulted in a dynamic marriage of imagery and inspiration. Thirst's creative versatility enables the exploration of elusive ideals of intelligence and beauty within today's world of commerce.

In 1993 Rick founded Thirstype, a foundry devoted to individual expression. Over the years, Valicenti has served as President of the Society of Typographic Art (American Center for Design), been a board member on the AIGA Chicago chapter and has jurored the President's Design Awards (Bush and Clinton). National Endowment for the Arts. He has also been nominated twice for the prestigious Chrysler Design Awards and was chosen to appear in the first list of top forty designers in I.D. magazine. The GGG and DDD Galleries in Osaka and Tokyo, respectively, have held one-man exhibitions of Valicenti's design and imagery. In 1997 the Canon Gallery in Tokyo exhibited Thirst's digital imagery, and selected Thirst works have also been included in the permanent collection of the Cooper-Hewitt National Design Museum. Most recently, Valicenti has formed 3st2, a firm devoted to design excellence in all digital media, with a focus on the Internet.

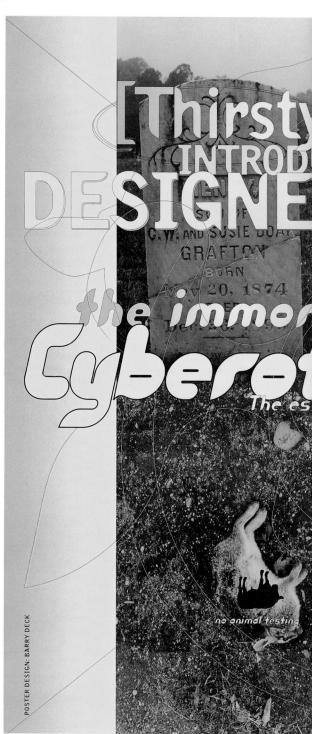

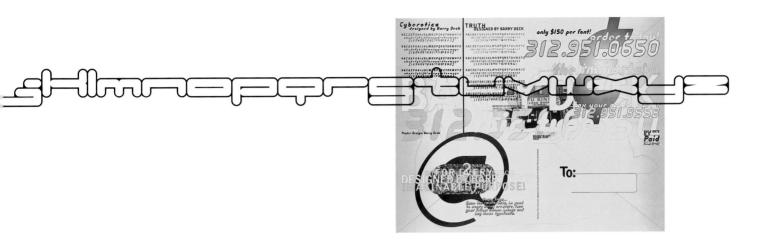

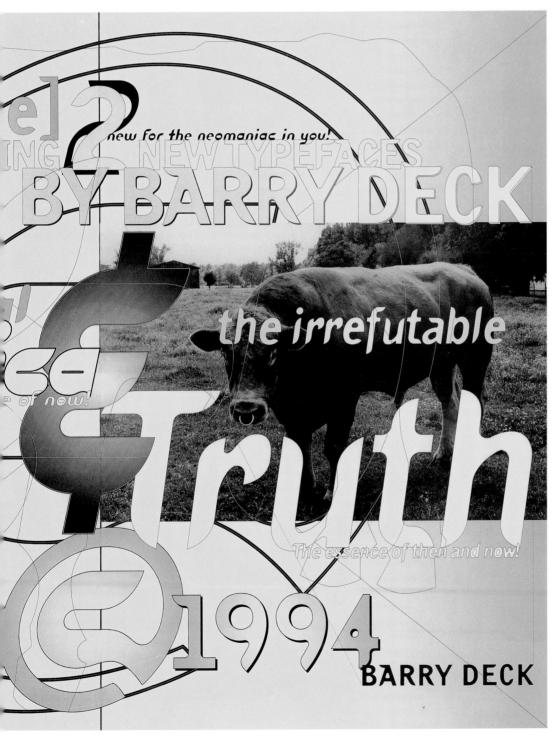

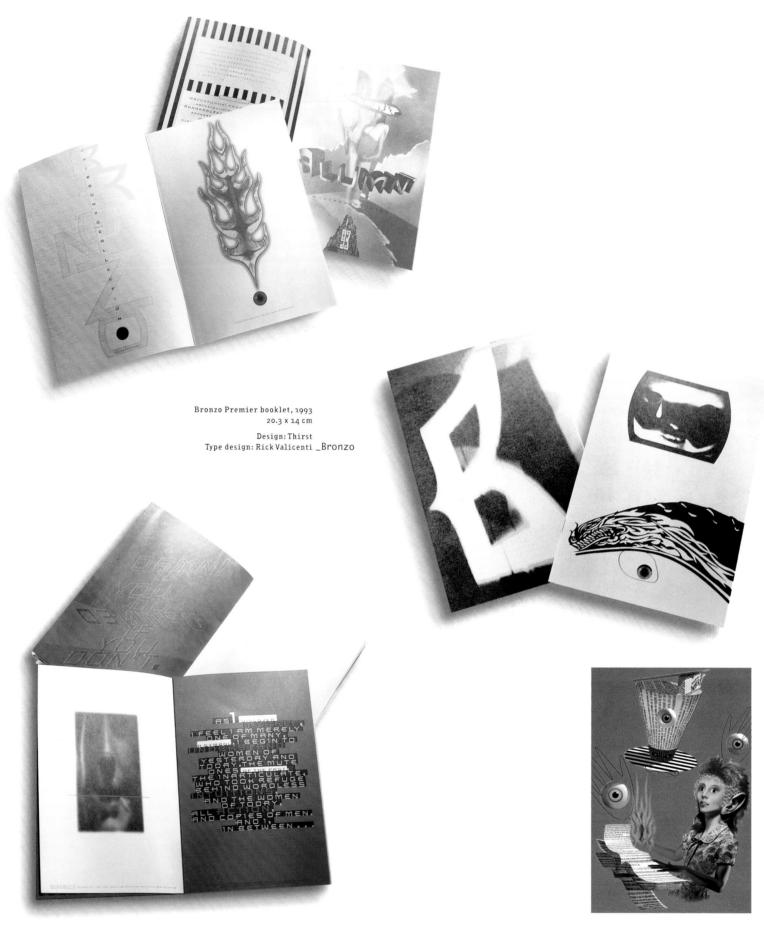

Card from Kulture Kit, 1996 20.3 x 14 cm Design: Rick Valicenti Type design: chester _Hate Note

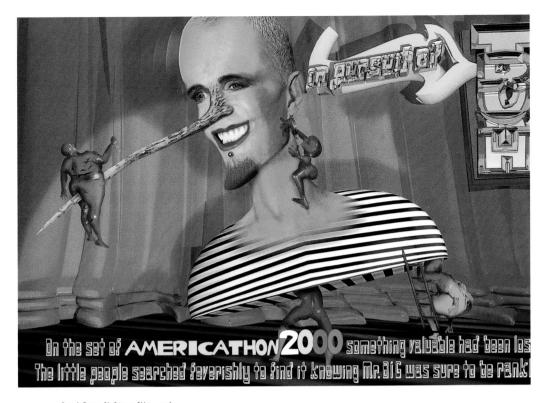

Card from Kulture Kit, 1996 20.3 x 14 cm Design: Rick Valicenti, Patric King

Type design: Rick Valicenti _Ooga Booga
Paul Sych _Fix

5 mile

Type design: Patric King, 1997_Smile

chester, 1997_Rheostat °Fahrenheit

_Rheostat °Celsius

Design: Rick Valicenti, Patric King

Design: Rick Valicenti Des Type design: Rick Valicenti _Bronzo Barry Deck _Cyberotica

Design | Type design: Paul Sych _Useh

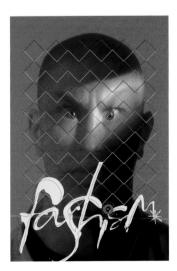

Design: Rick Valicenti, chester
Type design: Frank Ford _Stroke

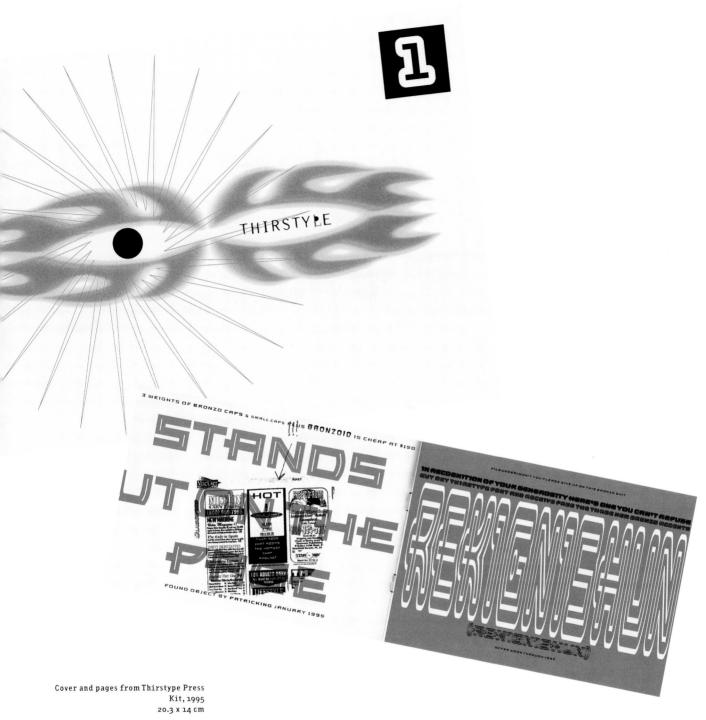

Design: Rick Valicenti, Patric King
Type design: Rick Valicenti_Love

_Bronzo

Barry Deck_Truth

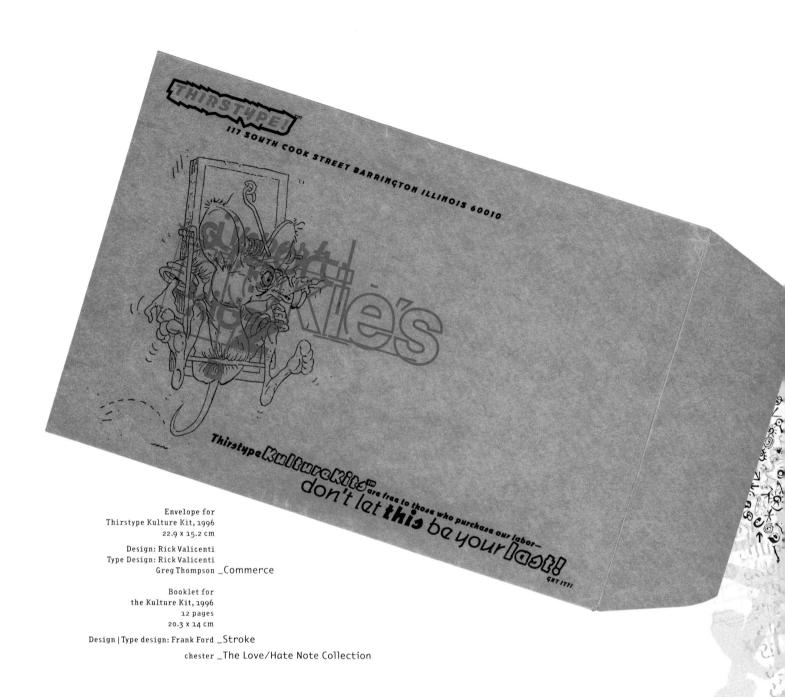

adore laurn crave desire ego favour poddess handa historial rate di Jacerale mg nuzzir poddess handa historiale desse post quiver room post quiver room sex tacit undulate vulneralile wants yearn zealous

Detail from the folder/poster

Welcome to Southern Europe

October 1996

Design | Type design: Type-Ø-Tones

Type-Ø-Tones

Location_Barcelona, Spain

Established 1990

Founders_Joan Barjau, Enric Jardí Laura Meseguer, José M. Urós

Type designers_Joan Barjau, Enric Jardí, Laura Meseguer José M. Urós, Juan Dávila, Adela de Bara Miguel Gallardo, Jaume Ros, Ivà, Mariscal Pere Torrent and many more

Distributors_Type-Ø-Tones for Spain, Andorra and Portugal FontShop International (FSI) for all other countries

Benelux and FontShop France to promote the library of Type-Ø-Tones. Design | Type design: Type-Ø-Tones

Poster Welcome to Southern Europe, October 1996

It was published by FontShop

43.5 x 59.4 cm

Our fonts correspond to a simple philosophy – the passion for typography

Type-Ø-Tones was founded by four graphic designers who shared the same passion for typography. Their fonts normally derive from individual ideas, but later become common projects.

Type-Ø-Tones offers display, script and picture fonts. As a service for clients with specific needs, José M. Urós also develops custom typefaces. Type-Ø-Tones generates the fonts with Fontographer and uses various software to scan and draw the characters, most of which have their origin in drawings on paper. The foundry is preparing its fonts to be available on PC.

Over the last years Type-Ø-Tones has had the chance to collaborate with other designers, artists and illustrators, all of whom have made fabulous contributions to the expansion of the typeface library. In several exhibitions in Spain and France, Type-Ø-Tones has presented its work to the public. John Barjau, Enric Jardí and Laura Meseguer are now running their own graphic design studios, while José M. Urós is working as a freelance desginer for Mariscal.

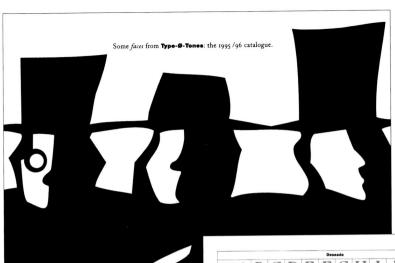

Cover of the Type-Ø-Tones catalogue 1995-96 48 pages 10 x 14 cm The cover shows a detail of the Type-Ø-Tones logo designed by Joan Colomer, Estudi Propaganda. The catalogue plays with the double signification of the word face, referring to typeface and to anatomy.

Design: Type-Ø-Tones

Regular A B C D E F G H I J K L M NOPQRabcde f j k l m n o p q r 1 2 3 4 5 Complete character set. DdE.ISiDb.Zs/9/4/4/20:1"#\$%&'()*.../0123466789;css?@ABC
DEFGHIJKLMNOPQRSTUVWXYZI)"_abclefgbiiklmopgratuswayz[]-Ā
ACENOUsaasascesteeninnoobasooogi"ess/\$\$\\$000^{\text{m}} \subseteq \si " Aa Aa © ENRIC JARDÍ, 1995

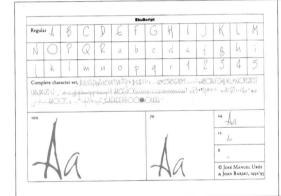

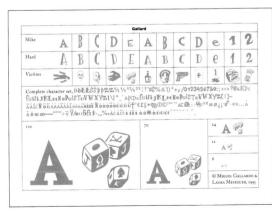

Pages from the Type-Ø-Tones catalogue, 1995-96

Design: Type-Ø-Tones Illustration: Leo Mariño Adela de Bara

Type design: Enric Jardí _Deseada José M. Urós _EbuScript

Miguel Gallardo _Gallard

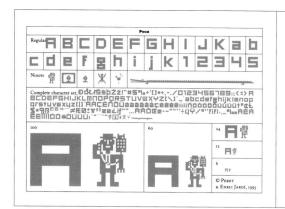

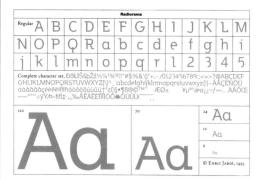

Pages from the
Type-Ø-Tones catalogue, 1995-96

Design: Type-Ø-Tones
Illustration: Leo Mariño
Adela de Bara
Type design: Pere Torrent _Poca
Enric Jardí _Radiorama
_Xiquets Forever

Samples from the Xiquets Primis, a series of dingbats or thematic drawings of an anthropological and historical nature, 1995.

Illustration to promote the font Frankie, used in the exhibition of Spanish typography at the Atypl conference in 1995, Barcelona. It's a caricature of the font designers Laura Meseguer and Juan Dávila generating the new typeface by making bad quality photocopies of sheets showing Franklin Gothic letters.

Design: Enric Jardí Type design: Laura Meseguer Juan Dávila _Frankie

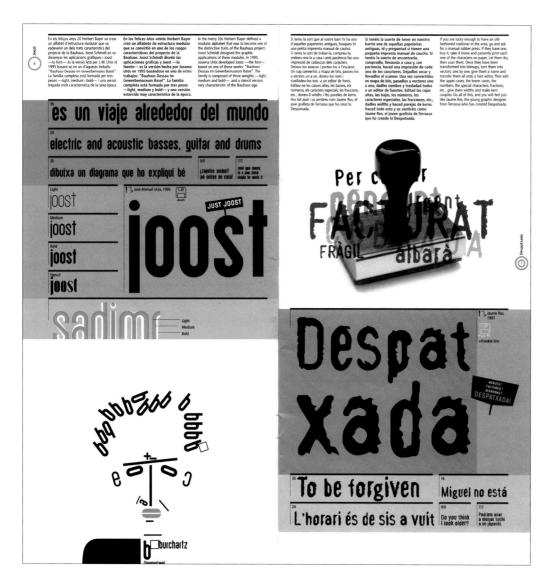

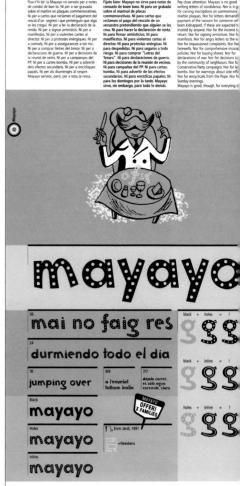

Pages from the Type-Ø-Tones catalogue, 1998 14.5 x 29.7 cm

Design | Illustration: Enric Jardí
Type design: José M. Urós _Joost

Jaume Ros _Despatxada

Enric Jardí _Mayayo

_Peter Sellers

Adela de Bara, Laura Meseguer _Adelita

Juan Dávila, Laura Meseguer _Frankie, Frankie Dos

Cada vez que los Type-G-Tones miramos con atención las formas de la Peter Sellers, nos sentimos transportados a los escenarios de aquellas películas de los años cincuenta y sesenta en las que Dean Martin pedia margaritas en un bar de Azapeloc, o Mario Moreno enseñaba a ballar cha-cha-cha a las turistas nortemericanas.

Each time Type-G-Tones take a close look at the Peter Sellers outlines, we are transported off to the settings made for those films of the 50s and 60s where Dean Martin asked for dassies in an Acaputco bar, or Mario Moreno taught American turists how to dance chacha-cha.

Charcha. Prize Sellers is our peculiar homage to the graphism of Saul Bass' time: The family is composed of two different parts conceived to be superimposed, thus creating a threedimensional effect. This front has an irregular aspect about it, as if hand made and with little geometrical structure. It is not a good typography to print proofs. You can compose and reduct hit as you like.

alking about the future. Just a minute!

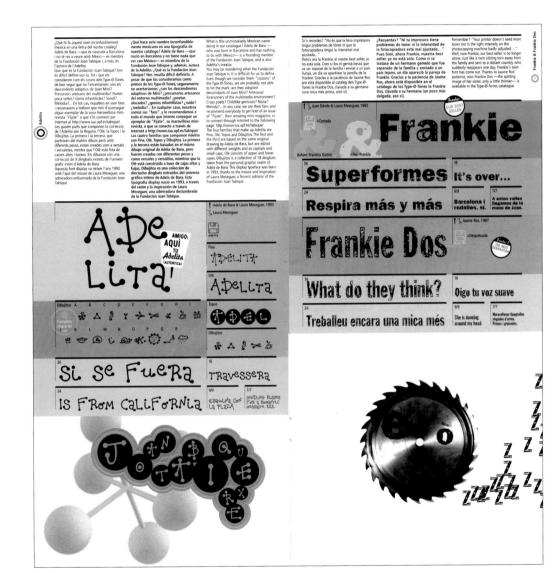

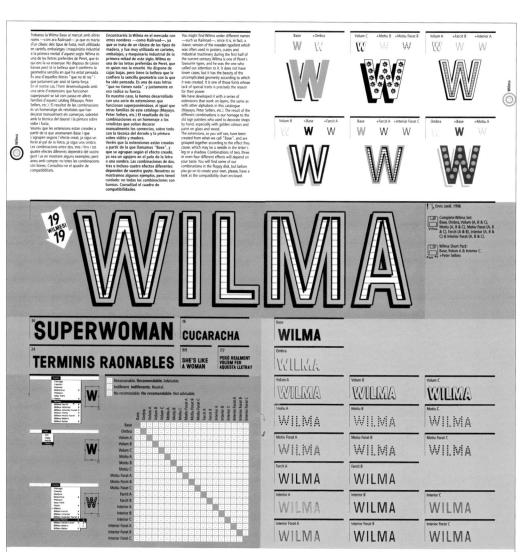

Pages from the Type-Ø-Tones catalogue, 1998 14.5 x 29.7 cm Design | Illustration | Type design: Enric Jardí _Wilma

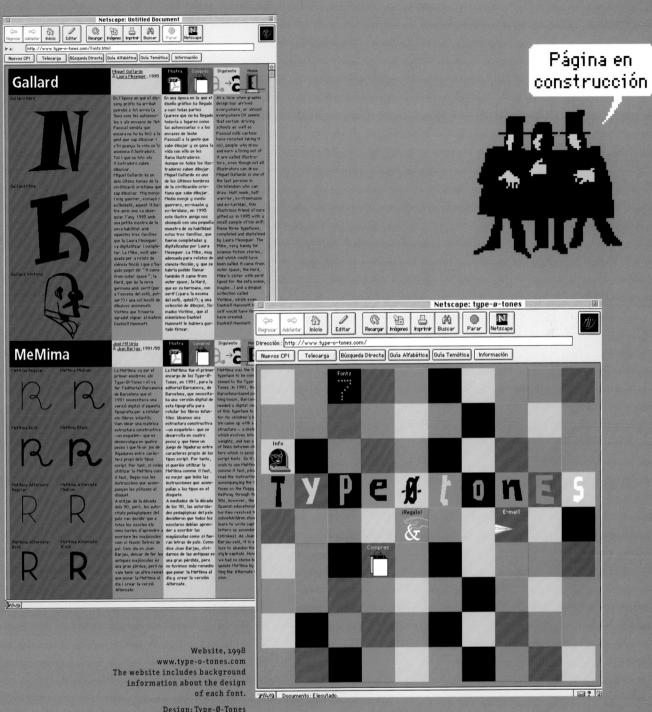

Design: Type-Ø-Tones Type design: Miguel Gallardo _Gallard José M. Urós, Joan Barjau _MeMima

269

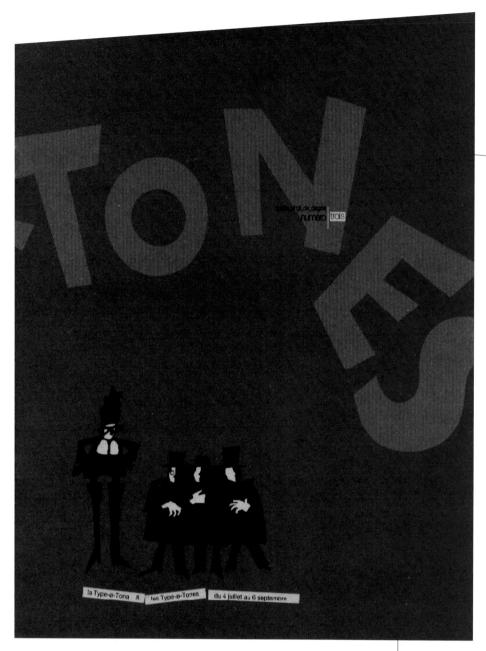

Exhibition catalogue La Type-Ø-Tona & les Type-Ø-Tones, 1996 12 pages 21.5 x 26.4 cm The exhibition took place in the gallery Association 90 degrés of the graphic studio art_est_net in Bordeaux, France, in summer 1996. The catalogue was printed and distributed by the gallery and worked as promotional material for both the gallery and Type-Ø-Tones.

> Design: art_est_net Logo design: Joan Colomer Estudi Propaganda Illustration: Enric Jardí Type design: Adela de Bara

Laura Meseguer _Adelita dibujitos

Enric Jardí _Deseada

_Escher

Laura Meseguer _Cortada

José M. Urós _EbuScript

Juan Dávila, Laura Meseguer _Frankie

Deseada: we desired Deseada making minor changes to a Casion Open Face

Deseada: Deseamos Deseada experimententando con pequeños cambios sobre una calson Open Face.

Cortada

ra, de la Type-Ø-Tones. amille Fina, tos, et

-from the -Ø-Tones. -a family, -ibujitos

-Ø-Tones sión Joan srrolló la as tres : Olé. Pop EbuScript: C'est la façon dont l'auteur écrivait en 1990-1991. Dessinée par José Manuel Urós et digitalisé avec l'aide de Joan Barjau. Premier projet original.

EbuScript: is the way its author used to write in 1990-1991. Designed by José Manuel Urós and digitalized with Joan Barjau's help. First original project.

Ebuscript: Es la manera en que su autor escribía en 1990-1991. Diseñada por josé Manuel Urós y digitalizada con la ayuda de Joan Barjau. Primer projecto original. Eacher: Mauritius Cornelius Escher füt un des plus grands créateurs de ce siècle. L'auteur des figures impossibles et des perspectives irréelles, était l'inspirateur de cette famille de trois épaisseurs.

Escher: Mauritius Cornelius Escher was one of the greatest creators of this century. Author of impossible figures and unreal perspectives, he was the inspirer of this family of three thicknesses.

Bacher, Mauritius Cornelius Escher fue uno de los grandes creadores de este siglo. Autor de figuras imposibles y perspectivas irreales, es al inspirador de este familia con tres ojos tipográficos diferentes. Escher alterada: Des variantes aux caractères transformés et une brève collection d'ornements.

Escher alterada: variants with altered characters and a brief collection of ornaments.

Escher Alterada: Variaciones con characteres alterados y una colección breve de ilustraciones.

Frankie: Votre imprimante n'a pas de problème de toner et l'intensité de lumière de la photocopieuse n'est pas non plus mal réglée. Frankie est né corrodé et effacé, malgré une encre fraiche.

Frankie: your printer does not have a toner problem nor is the light intensity on the photocopying machine badly adjusted. Frankie was born corroded and worn away, despite fresh ink.

Frankie: Ni tu impresora tiene un problema de toner, ni la intensidad de tu fotocopiadora està mal ajustada. Frankie nacio corroida y desgastada, a pesar de la tinta fresca.

Back of promotional postcard, 1996

10 x 15 cm

In this letter soup the reader can
find the word Typerware. Font Soup,
based on noodle forms from the
company El Pavo, is used by Typerware
as corporate typography.

Design | Type design: Andreu Balius
Joan Carles P. Casasín _Font Soup

Typerware Font Foundry

Location_Barcelona, Spain
Established_1993
Founders|Type designers_Andreu Balius, Joan Carles P. Casasín

Distributors_Typerware, Font Foundry

Type is a real living thing!

Andreu Balius studied Sociology at Barcelona University and Graphic Design at IDEP in Barcelona. Together with Joan Carles P. Casasín, who studied graphic design at Elisava and BAU in Barcelona, he founded Typerware in 1993. The studio has designed display type for magazines, improved type for screen, animated poems for a CD-ROM about contemporary Catalan poetry and created a typographic identity for a Spanish book publisher.

Apart from the non-commercial experimental type project garcia fonts & co. (see p. 148), Andreu Balius and Joan Carles P. Casasín set up their own label in 1998. The Tw® Font Foundry publishes and distributes the fonts they have developed for graphic projects or just for pleasure.

The illustration, representing
Andreu Balius and Joan Carles P. Casasin,
is part of the corporate design for
Typerware. It's used for informal
applications, for example on postcards
and on T-shirts for friends. The figure
is taken from a plaster package and is
used as a mascot. It also refers to the
use of thumbprints on Spanish passports and the corresponding digital
code in the computer system.

If the eye could see the devila the

qué nos explica Manes 7 N

El cigqueig (el text)

Personatges Separats per llengües comunes. Babel polifònic de

la incomunicació en què el text adquireix l'estatut de gest, més

que de discurs. És un cloqueig en què no importa el que es diu

sinó el que no es diu.

Manes no és una ideologia No hi ha una veritat per ser desgoberta.

Si no hi ha veritat primidènia, què ens expliga Manes? Res. Mames construeix i destrueix, bu§ca i no troba, fa preguntes le§ re§poste\$ de lEs quals

Plora de riure i riu desesperadament.

Manes són múltiples emocions que es comuniquen, vertiginoses, mitjançant diverses narracions que es creuen, es fleggen,

es freguen,
i que al seu torn generen més emocions.
Mames invoca els dimonièts del Caos que,
disfressats
de pollastre, juguen a la
desorganitació
per fer incomprensible allo que sembla lògic,
com en un somni.

Fem invisible el que se'ns fa inexplicable? Vet aquí una pregunta legítima, sense resposta:

una pregunta Mane una pregunta

Publication for the show MANES by the experimental theatre company La Fura dels Baus, 1996 21.2 x 28 cm Typerware developed the graphic design for this show and created a special font family for it.

Design | Type design: Andreu Balius

Joan Carles P. Casasín _FaxFont

_NotTypeWriterButPrinter-9 needles

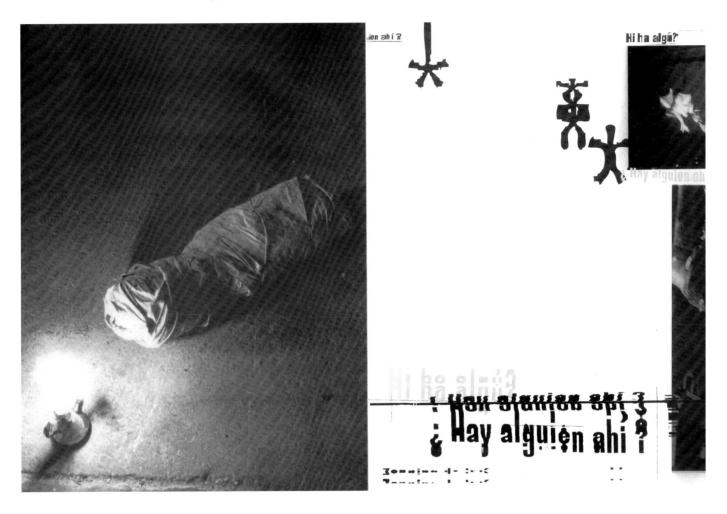

Examples from the information folder, 1997 21 X 29.7 cm Typerware developed this font at the request of Osoxile studio for the University of Salamanca's orientation system. Andreu Balius and Joan Carles P. Casasin first researched and analyzed the inscriptions on the walls of the university. Since its founding in the Renaissance, doctoral students have recorded their names and graduation dates for eternity. They used ox blood until the nineteenth century and natural earth pigments thereafter. Typerware photographed the inscriptions and developed a digital font that retains the handwritten characteristics of the different styles. Design | Type design: Andreu Balius

Joan Carles P. Casasín _Universitas Studii Salamantini

Una tipografía diseñada para la Universidad de Salamanca / por encargo de Osoxile

ABCDEFGHİJKLMN 00PQRSTVVWXYZ

35 © ÇÑNİii00000LVYW ®

MERCATVS

- 35 VNIVERSIDAD DE SALAMANGA
- ²⁰ CENTRO DE INVESTIGACIONES ALFONSO X EL SABIO
- 45 HOSPIFAL DEL ESTVDIO
- ²⁴ DEPARTAMENTO DE HISTORIA Y GEOGRAFIA

DERECHO

44 SALA DE LAS TORTVGAS

LIGADURAS

AIA ViTi NTV TOS CAS

Las ligaduras entre carácteres facilitan la creación de palabras más compactas.

La letra «a» dispone de un "rabillo" más largo respecto la letra «A», para unirla al caràcter que le antecede.

___Typotheses

Günter Gerhard Lange

- 1. The carrier of visual information is the typeface, and with it typography. When writing informs, characters are largely static. When writing animates, form and expression are dynamic. When writing declares, bold demands come forward.
- 2. The printed textbook needs clear organization and appropriate proportions to achieve comprehensibility. The designer can use conservative type criteria that have existed for a long time.
- 3. Font selection depends on the competitive environment and the target audience. Together with picture choice, font selection ensures acceptance of the communicated contents.
- 4. As a source of pleasure and beauty fonts are always based on personal handwriting. They are, in fact, a form of self-expression. But the greater the personal statement, the less likely the fact is to be accepted. While it may receive applause from the like-minded, it prevents access by the general public, since it is too élitist.
- 5. In the visual communications of large institutions and companies, categorical font requirements as part of the CI program are necessary to ensure that they can be recognized; individual initiative must be excluded. Despite the need for standardization, however, a certain amount of freedom for individual applications should remain.

- 6. Just as in music, theatre and literature, there will continue to be different interpretations when adapting the classics. The modern stands in contrast to the classical and is driven by the demand for individuality, drawing its form from the programs and capabilities of the latest digital technology. Its freedom of design leads to the boundaries of understanding.
- 7. For today's younger generation, action and visual animation are what count. They stimulate initiative and access to the text. The permanent desire is for something new, even if it is only the old viewed from a new perspective and in a different form. The conflict between generations does not begin with the declining power of sight alone (characters that are too small remain unread by older people), but rather with emotional, expressive design.
- 8. The ever-growing share of pictures reduces the volume of text. This apparently meets the needs of the majority, but requires a rhythmic change in form and size and a dynamic, free design, up to and including collage. Both younger and older readers react to visual wasteland in text and conventional picture-making with disinterest.
- 9. The mission of the designer and conceiver must not be restricted to the aesthetic alone. Assignments and requirements must be carried out and designed in a manner appropriate to the subject and the target group. We are first and foremost service providers and have a human, economic mission to carry out. Still, profit maximization and practical work are not everything.
- 10. We must continually exceed ourselves in our creativity. We may, should, even must, leave the well-trodden paths and open ourselves to experimentation. In brief, we should be innovative, provocative when necessary, to adequately express our beliefs new and different and/or better than before.

 Note: Change is the only constant.

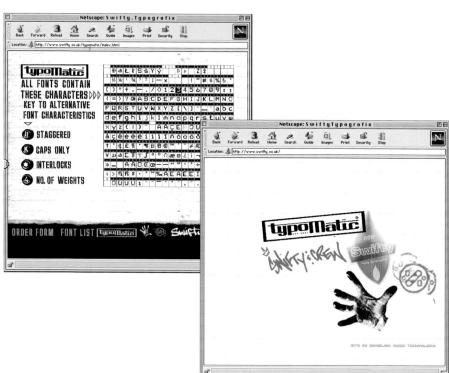

Typomatic

Location_London, UK

Established_1998

Founder_Ian Swift (Swifty)

Type designers_Ian Swift, Mitch, Robbie Bear, Fred

Distributor_WWW.Swifty.co.uk

Website, 1998 www.swifty.co.uk Design: Swifty

Funky, eclectic, dope, distressed, interlocked, outerlocked, staggered, flim-flammed and plain groovy! With a touch of cooool man ... yes Daddio.

Swifty was trained as a graphic artist from 1981-86 and later worked at Face and Arena magazines. He joined Neville Brody Studios as designer from 1988 to 1990 before establishing his own studio Swifty Typografix in London, where he has become a major force in British type design. Since 1994 he has been publishing Command Z, a project which includes Swifty Fanzine and Postscript Fontz (see p. 36). In 1997 he founded Typomatic, a font foundry launched on the Internet by a new generation of type designers (www.swifty.co.uk). The site also acts as a showcase for Swifty's work and features font designs from up-andcoming type designers from various imagemaking backgrounds - from graffiti to illustration and back again.

Samples of ongoing type designs, 1997-98
These visuals for stickers and posters were originally developed for an exhibition in France. They were published on the Typomatic website and as small bubblegum cards for the press release, 1998. Some of the fonts are still unfinished.

Design|Type design:Swifty _License Plate _Cut It Out _Skrawl _Slice of Cake

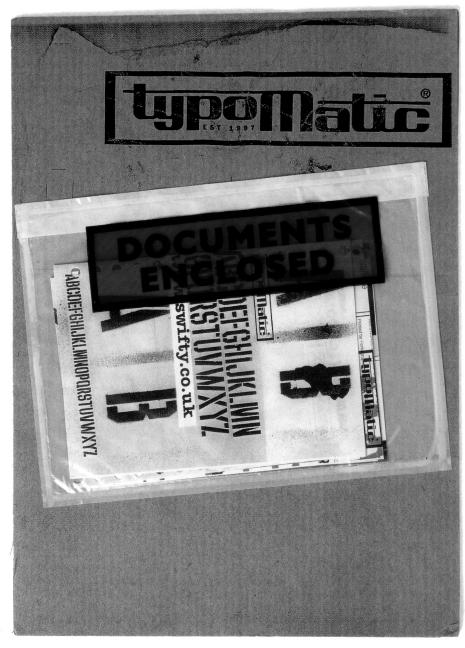

Press release, 1998
A4 tracing paper folded to A6 size,
mounted on to A5 corrugated cardboard with small bubblegum cards
showing screen grabs from the Internet site.

Design|Type design:Swifty _Slice of Cake

281

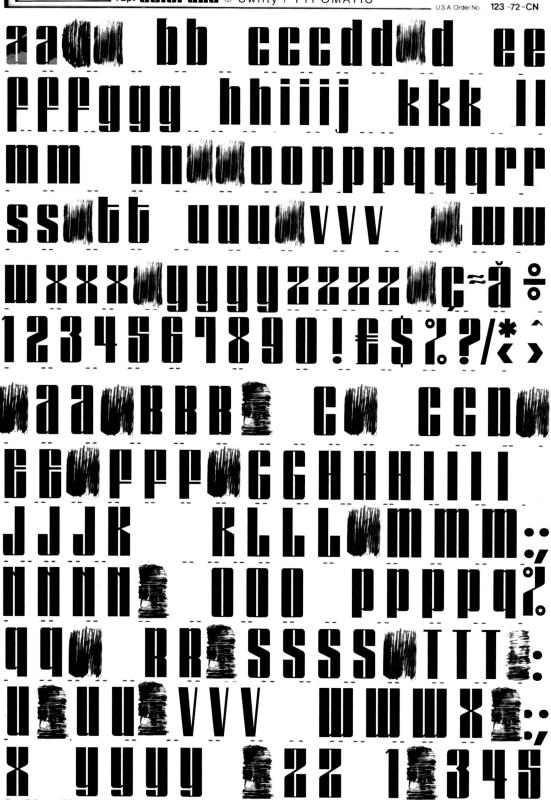

heat resistant

PRINTED IN ENGLAND U.S.A. Order No. 123-72-CN

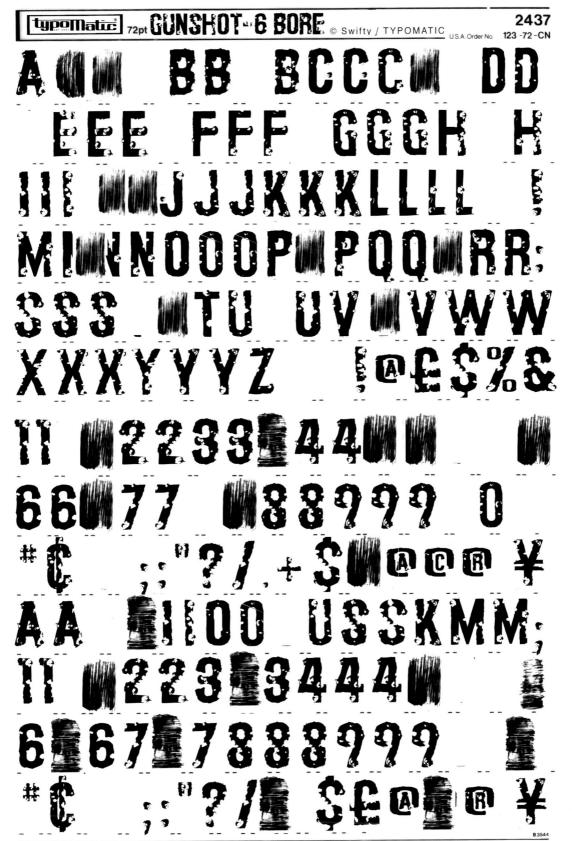

heat resistant

©TYPOMATIC INTERNATIONAL LTD. 1998

PRINTED IN ENGLAND U.S.A. Order No. 123-72-CN

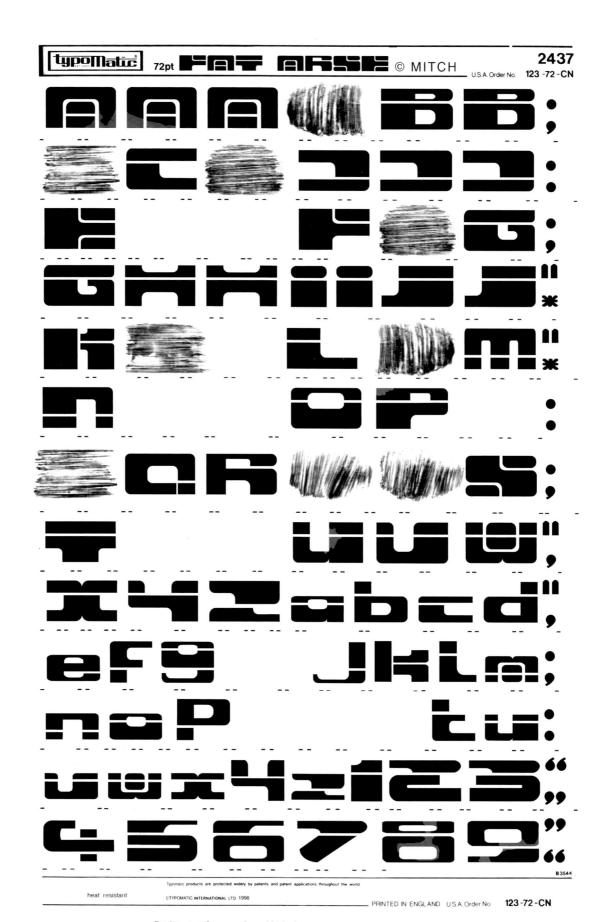

Fat Arse typeface sample, published on the Typomatic website, 1998. The typeface grid is based around the plan of an old leather sofa from the Seventies (see capital A).

Design: Swifty
Type design: Mitch _Fat Arse

RR

heat resistant

PRINTED IN ENGLAND U.S.A Order No. 123-72-CN

Gerard Unger

Location_Bussum, The Netherlands

Established_1972

Distributors_Gerard Unger, Elsner+Flake, Linotype Library ITC, Bistream, (URW)++, Dutch Type Library

Small font manufacturers of the world, unite!

Gerard Unger initially worked for fifteen years as a font designer with the Hell company. In the mid-1970s, he was among the first designers to develop digital fonts, along with Hermann Zapf, Adrian Frutiger and Matthew Carter. Unger has repeatedly adapted to technological changes and requirements when designing fonts – from lead type-setting to photosetting, digital CRT-setting, laser-setting and now to the monitor and 300-dpi printer. Today he uses the computer's potential, but places value on determining the forms of letters not from digital tools, but from his feel for form and the reading process. Gerard Unger not only works as a font designer, but as an independent graphic designer and author. Ideas for new fonts often result from going between his several activities. He has published various books that present his own fonts in their applications and simultaneously deal with readability.

Unger has been marketing his own fonts since 1993. He is currently working on the Paradox font, but also has plans for a new sans serif. In addition, he wants to expand the Capitolium family, developed for the 2000-year celebration of the city of Rome.

Gulliver's Travels, 1995
4.2 x 6.5 cm
(shown here in original size)
The publication, designed and
produced by Unger, shows that the
font Gulliver is easy to read even in
a very small point size.

Design | Type design: Gerard Unger _Gulliver

Gulliver Gulliver Gulliver Gulliver Gulliver Gulliver Gulliver Gulliver

Pages from <u>Gulliver's Travels</u>, 1995
4.2 x 6.5 cm
Through numerous experiments, Unger has
increased the readability of this font.
According to Unger, Gulliver is like a
Volkswagen for cross-country driving,
a kind of car for reading, almost a type
of techno font.

Design | Type design: Gerard Unger _Gulliver

Terwijl je leest (While You Read), 1997 17.5 x 24.5 cm In this book, Unger deals with the readability of letter forms.

Design | Type design: Gerard Unger _Paradox

ABCDEFGIIJKIMNOPORSTUVVXYZSSÆŒØFIELABCDEFG TUVWXYZÆŒØ1234567890,.;;?!()"/|-|\$%%5& ÁAĀĀĀĀÇÉÈĒĒĪĪĪNŎŎŌŌŪŪŪŪĀĀĀĀĀĀĒĒĒĒĪĪĪN abcdefghijklmnopqrstuvvxyz&ææsfiflABCDEFGHIJKLM TUVWXYZƌ01234567890...:?!()"/|-|\$%‰&@†f\$EV ÁÀĀĀĀĢĒĒĒĒĪĬĪŇÓŌŌŌŮŪŪŪāāāāāaēeēeēfiīnoōoōo TUVWXYZÆŒ ÁÀÄÄÄÄÇÉÈÉÉÎÎĨĨÑ

mee: een hang naar orde en perfectie, waardoor het instand-houden van een typografisch systeem het doel kan worden evenals verlangen van vormgevers daaraan te omstappen om hun eigen ei kuijt te kunnen en om leeses meer variatie te bie-den. Dezeglijke belangen reiken van de ideologie van volledige dienst bestjaat de in de de in

den. Dezeglijke belangen redem van de ideologie van volledige dientsbaarheit out der van complete ongebondenheid, van terveren naar optimale. Uijdlore en gestandaardiseerde typografie tot vormgeving die verschilt per medium, per onderwerp, per publiekssegment, per vormgever en per moment. Geen van de voorgaande voorbeelden bestrijk het hele typografies te riteriën. Novinoin's kelst betreft boskryopografie en is in boeksom verscheinen. Teichichold's meningen uit 1988 zijntsamengebracht in een boek en gaan over brieftbooffen van verscheinen. Teichichold's meningen uit 1988 zijntsamengebracht in een boek en gaan over brieftbooffen verscheinskartjes, brochures, catalogi, alfiches, advertenties, tijdschriften, kranten en tenslotte het nieuwe boek! Onder mere beinvoled door film voorzig skichichol in literatuur een verschuitving van lange teksten naar korte verhalen. Carnovi boek is een ving van lange telseten naar korte verhalen. Caroon's boek is een paperbask, maar toom typografie voor tijdschriften geweijd aan sport en muziek. Schwitten was kunstenaar, die veel letterowe men en delen van telseten in collages heeft voewelst. Ea Meez 82.1.1 is een tijdschrift mer als thema reclame, waarin bondige boodschappen gemengd met beeld essentied zijn. Dusdanijg werstellindende somen was ny topografie gaan samen met uiterenlopende wujzen van lezen, zoak gerumer tijd achterie lezen of brijnengen van telst tot telset, van kop naar fillustratie of bijschrift, waarbij gelezen en gekeken wordt, zowel naar de

Sounds and early Bee Goes with barrogue psychedia and folk-savant Bowie. The sound of Cardinal is so unaffected, so

teksten als de beelden. Zeer globaal bezien is er een tegenstelling tussen lange, gelijkmatige teksten in kleine copisen energigle en korte seksten od variatie anderrigle. Daarin worlt dikwijk een tegenstelling van vijlen gezien, waarzaan eone chiese verbonden worden, die eine soort typografie is did en de andree levendig, ben je voor de een, daa hen je behoudend, trewijl voorstanders van de andere bij de tijd zijn. De ene is voor oude

woorstanders wan de andree bij de tijd zijn. De mei is voor ouder nen de andree voor jongeren.

Hierelijkheden zijn belangrijk, er zijn aanzienlijk nuere kle-dingwinkels dan boekbandels, maar er zijn uiteenzettingen of betogen die vagen om een aanloop, om opbouwe en uitleg met geduld en kalmte. Verschillen in worm bangen in steike mate samen met inhoodelijke verschillen en geen enkele lezer lukt het om deze twee werdelen geschriden te houden, al was het naar omdat ze diwijn als omslagen en binnenwerken samen-gaan, zoals bij boeken en tjickehriffen. Ik den kda theel wenig gaan, zoals bij de verschillen de steiken de steiken de steiken de steiken de geen en de nei uit zijn en vaa beide searten van provontier. lezers er echt op uit zijn een van beide soorten van typografie te

Zo bezien is het niet verwonderlijk dat lezen van lange teksten Zo oezien is net met verwonderijk dat iezen van tange tekst uitgesproken liefhebbers kent en opwindende typografie in b voorbeeld tijdschriften overtuigde aanhangers lieeft. Evenmir is het verwonderlijk dat één en dezelfde lezer bereid is van eer

dikwijls met: 'Dit is niet te lezen'. Eigenlijk is de boodschap die zulke vormgeving uittraagt: 'Deze tekst is niet voor jou be-doeld, maar voor een ander'. Zoals mensen zich kunnen gedragen en kleden als toerist, discoganger, middelbare scholie biker, rijpere dame, excentriekeling of gevestigde heer, zo fu tioneren ook de pagina's van tijd

Patronen

abcdefg hijklmn opqrstu vwxyz

Pages from Terwijl je leest, 1997 17.5 X 24.5 CM It is intended that the reader should

learn more about fonts and typography in the book, and also enjoy the process of reading.

Design | Type design: Gerard Unger _Paradox

Frank Heine, U.O.R.G.

Location_Stuttgart, Germany
Established_1992
Founder|Type designer_Frank Heine

Distributors_Emigre, [T-26], FontHaus FontShop International (FSI)

Since 1992 Frank Heine has released fonts through different foundries. The fonts span a wide range of styles: curly headliners, crisp text faces, reinterpreted historical faces, as well as spontaneous, rough experiments. Though they share no obvious similarities, all the fonts have a love of detail and an emphasis on quality. Each font has hundreds of manually edited kerning pairs for each weight, numerous ligatures and alternative characters, all of which offer the user a rich source of individual and expressive typography.

Apart from the creation of new fonts, U.O.R.G.'s work includes graphic design projects such as corporate identities, logos, brochures, posters and designs for museums and exhibitions.

05

ranguility

07

Intro: Navigator detail from sequence on the first three pages.

01 - 10: 01 - 10:
France booklet, 1998
36 pages
14.5 x 21 cm
An illustrated diary of a threeweek trip to the south of France,
featuring typefaces that are still
under construction. Due to the
unfinished state of the fonts,
the pages reflect spontaneous
rough designs - more like small ${\tt rough\ designs-more\ like\ small}$ posters than an intimate booklet.

Design | Type design: Frank Heine _Coolage Bold _Desolation _Vespasian

The future

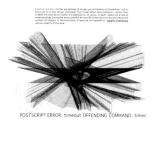

11.1 is a statut find from south of the point is easier and of the season south of the

05

09

The set of 1211 for the intermediation of properties or in plane in board in the set of

02

06

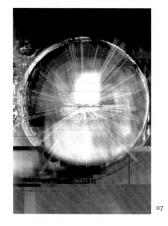

08

THE PREJUDICES
AGAINST THIS CO/
LOR ARE STILL SUF/
FICIENTLY STRONG
TO REQUIRE A DIS/
CUSSION OF THE
PROPER LES OF
BLACK AWAY VIRTUES.
BLANKET DENUN/
CTATION OF A CO/
LOR COMPLETELY
IGNORES THE RE/
LATIVE NATURE
OF ANY COLOR OR
FOR:

UNS OBLIEGET / nur das Gegen so kurt3 das es nicht zu messen / so wir mit den Sinnen begreiffen k theilbare Theile hat / jedoch aus de ob er wohl nicht zu theilen / denn die Ewigkeit bestehet. Welches mi und Linien vorgestellet worden / c die Ewigkeit. Wer sich zu erinner der gegenwärtigen Zeit zu verder

> Page o6: detail of Amplifier, by Arthur Henkel/ Albrecht Schöne (editors), Emblemata, Stuttgart, 1996.

"In designing← the »form of an object, we want to design it so: that we create the (user's) experience of itas well."

Detail from page o6 Text by Arthur Henkel/ Albrecht Schöne(editors), Emblemata, Stuttgart, 1996.

Type design: Frank Heine _Amplifier

Future is close booklet, 1997 36 pages 14.5 X 21 CM The booklet is an interpretation of quotations about typography, design, space and time. The design concept is based upon repetitions, with text and formal links going forwards and backwards between the pages. The booklet's typography is showing both, the text size qualities of Amplifier Light and the expressive headline capabilities of Amplifier Bold. Within the texts the use of ligatures, alternative letters and small caps demonstrate Amplifier's typographic details. Amplifier is a family of more than one thousand different characters.

Quotations from: o3 Colin Davis, Chicago, 1996 og Paul Rand, A Designer's Art, New Haven, 1985 22 John Rheinfrank/Katherine Welker, LookingCloser, New York, 1994

24

25

23

Design | Type design: Frank Heine _Amplifier Family _0psmarckt

abedeffzghijkkklinnoppgrøtt uvvisy Yzbet jiffffffhillschistyvn ABCDEFGHIJKLMNOPGRE STOVWAYZ ABCDETGHITK / MNGY2R SEVENZZ SEVENZZ MARAKERENINGGOODBERGUUUGGE MAAAAAKEEEEEIIIN OOOOOØ ŒSUUTYZ 123+507890 41/4/4 123+507856/123+507850
No of two & & & Mark to C.Fx. No.Ph. RF SCEY IMAGEATIN RUSS 15"*+ .,q...! 196, "****** = = OHRY **◆◆◆◆◆**◆○○○○

03

01 - 11: Interim compilation booklet, 1996 36 pages 14.5 X 21 CM The booklet presents an 'interim balance' of all typeface releases between 1992 and 1996. Each font is shown with a complete synopsis and a full-page design sample.

o2 Remedy o3 Remedy, design published o4 Chelsea o5 Chelsea, self-promotion o6 Determination o7 Determination, FUSE poster og Indecision, design for [T-26], text by Dan X.O'Neil, 11 Detail of Whole Little

ABÇDEFÇHİİKLMNOPQR ţiuvwxyzŋ chckctrirl.@oxpythttiz.w.w in Emigre #24 (Neomania) ABCDEFGHIIKI MNOPOR 000/," ÁÀÀÄÄÄÄÆÇÉÈÊËÍÌĨĬÑ o8 Indecision óòôôöøœúùûüÿ ÁÀÂÄÄÄÄÆÇÉÈĒĔÍÌĨĬÑ Ó Ô Ô Ô Ö Œ Ú Ù Û Ü Ÿ 10 Detail of Amplifier, ookiler@ox&ilhiiirén ookiler@ox&ilhiiirén Universe Design | Type design: Frank Heine

THE THE SHEET SHEET OF SHEET

07

abedetghijkfillilopqf StuvwzyzBfffi BCBEFGHIJKLMNOPO STUVWXYZ 1234567890 f1µ@@@™\$c£¥e1%‰°¶§*+† .: 1874." óddddaœúúûûÿ ÁÀÁÁÁÁÆÇÉÉÉÉ DOLDINANO ARCDEFENLIO AND PORSTOVACY 05

08

12 - 15: Documentation for [T-26], 1995-97, US letter keyboard maps, notes & tips. Pages used in [T-26] catalogues and as accompanying material for purchased disks to presentall necessary information to make best use of the fonts.

> 12 Opsmarckt, cover sheet 13 Opsmarckt Basic 14 Amplifier 15 Feltrinelli

Design | Type design: Frank Heine _Amplifier

_Feltrinelli

_Indecision

_Intolerance

_Kracklite

_0psmarckt

_Whole Little Universe

Openacoka Basic/Altern. Notes & Tips 2. There is no aesthetics for the capital letters. If you must capitalize, you will need manual adjustments. Both Opsmarckt text styles have more than goo manually edited kerning pairs; so most of the other combinations should come out well. 3. To avoid i- and j-dot conflicts, you can take the dotless i (i. shift option-b) and, in Opsmarckt, also a dotless i (option-j). Alternatively there's a single dot with zero width on option-b, to be typed before the dotless i/j: $i \rightarrow i$, $j \rightarrow j$, $dR \rightarrow dR i$, $dR j \rightarrow dR j$ 4. For a better look there's a Th Ugature in both styles (just type the backslash key):

This — This → Please refer to OpsmarcktAlternates' keyboard may for a synoptic view of all alternative characters. 8esic:
1. There's a long-s on option-s, therefore the
double-s (8) went to option-z—in Germany it's
"eszett."(There are certain grammatical rules for
the long-s—please refer to a dictionary.)
strange —firange tricky - tricky - tricky, fluffy - fluffy 4. All Ugatures are located under numerals key combina-tions, so you can easily test them while typing. There are three t-alternatives which are good for additional Ugatures: et - et, pt - pf, et - et, pt - pt, nti - hf potentialities - posentialities Atternates:

1. There's a special character on option-q that stands for q-u-e. Although it originates from Latin texts, you might like to use it for English words too (as long as you find it decipherable):

trchnique—trchniq;
? 3. Under option-o, shift/option-o and shift/option-q you will find flourishes with zero width which can be typed before charf's: $\vec{a}, \ \vec{n}, \ \vec{u}, \ \vec{a}', \vec{n}', \ \vec{u}', \ \vec{a}', \ \vec{n}', \ \vec{b}', \ \vec{b}'$ That's all—hope these tips are helpful.

		mative		Notes & Tips	
Basics	-	Small Caps	Extensions	3. ae means: the Extensions contain superior characters	aabcdee ffgghijkllmr
a	a			that can be used for abbrevia- tions in some languages, or	opgrstuvwxyzzßßchc
e	e,		-	for typical English ordinals:	
ย	g 1l			1st 2nd 3rd or 1st 2nd 3RD.	ctfbfffhfiffififkflffl
z	3	-		Additionally the underline position is harmonized with	ftfylywqushspsttttyt
B	Ř	SS		these superior characters:	
E	3	-		1st 2nd 3rd or 1st 2nd 3rd.	tzabcdefghijklmnopq
Q	Q.			There are five punctuation marks for the superior char's:	STUVWXYZSSFIFLABCDE
\$		\$		560.312 st,nd 8D-AVE (a) (3)	
¢		¢	•	(shift-, shift-, opt, ())	FGHIJKLMNOPQQRSTUV
£		£		4. Combinations:	WXYZOu abcdeehilmnorstvasc
¥		¥	-	the Extensions contain some characters for useful combi-	EÈHILMNORSTY "A" ÁÀ
% #	_	_	% ***	nations:	, , , aa
R.	8	₩.	®. Nō		âãåäæáàâãåäœçðéèê
@	0	- Co	0	(opt-' shift/opt-' ')	lilîïłñóòôõöøœbšúùûi
(a)	@		at	·····	ýÿžÁÀÂÃÅÄÆÇÐÉÈÊËÍÌ
323		2323	2323	(opt opt-, ')	• • • • • • • • • • • • • • • • • • • •
u me	eans: so	me comi	oina-	Print:	ÏÑÓÒÔÕÖØŒÚÙÛÜŸÁÀÂÃ
ions w	ith "l"	look bet	ter	(opt-l opt-m)	ÅÄÆÆCÐÉÈÊËÉÈÊËÍÌÎ
l" (on	opt-l),	for exam	iple:	☐ Tick here.	
loat	ing (Float	ing).	and there X.	ŁÑÓÒÔÕÖØŒŒÞŠÚÙÛÜŸ
939	Z moss	s: there	250	(x shift-x)	ŸŽ12345678901234567
ix diff	erent s	ets of n	umerals	→ ← - · → ← ·	
n Ampi		34567	2800	(opt-u/y f g opt-u/Y)	901234567890123456
ining		34567		s	8901234567890/12345678901/11/
	aps 12	34567	890	s , e	
abular		23456	7890	(opt-e/e opt-i/e opt-i/E	1/3 ² /3 ¹ /4 ³ /4 ¹ /8 ³ /8 ⁵ /8 ⁷ /8+-±
		4567890		opt-i/e opt-u/e)	×~ø∞=≋°%‰%\$\$\$¢¢°
		4567890 rals (in)	Evten	No lbs =	£ £¥¥ Ø DM Fr Pt Pts ₱ R RD tb
ions)	are the	same as	Lining,	NS Ubs	
nake th	iem stai	nd in eve	en	(opt-e/E opt-i/e opt-u/E opt-i/e shift/opt-p)	P G Tib Esi Inc % 20 cm cm
ther (often ne	et unde eded in		[::::::] - [:::::::]	NºNº&&&&&@**†#¶₹©@
	reports,	, etc.). infecio		(opt-x opt-y opt-z)	® @ @ @ at ™sм \$ µ. ·, ':; • •
umera	ls are al	so locat	ed in	(opt-x opt-y opt-2)	. , ,
sed fo	creati	—they ing cust		M-M-M - M - M - M	!;?¿,,"" ["] » « › ‹
ractio 7 ₈₅ 12	ns, e.g.			(opt-v opt-w shift/opt-v, in Light Extensions)	-O°[][]{}[] \//·→←
		ou can fi	nd		
often	ised) "f	ixed" for	ac-	क्तिकार्वा = क्तिकार्वा	
10ns u /4 5/8.		charac	cet, e.g.	(opt-v opt-w shift/opt-v in Bold Extensions)	~~~~~~ \$\$ @@@@@
hese f	ixed fra	ctions	ire	And a (simply) kerned combi-	@@@@@@@#+-*
rawn a	bit larg	ger to m	ake	nation:	
izes:				\$68.5 \$36.50 against	\$ NO , ¢ Ub
/B aga	inst %			\$68.95 \$36.50	Full overview of characters

	inelli	Key			Co		sites	Mac os 1
Key	Character	Shift	Option	Shift/Opt	Opt.	Char.		Shift Chec.
a	Α.	a	å	å	е	a	á	á
ь	6	28	100		٠.	a	à	à
c	·	C		Ç	n	a	ã	å
d	2	90	5	8	ï	a	â	â
-		€ \$000¢	,	,	ů	a	ä	â
e	e	0	0	-	-	-		8
f	f	*	f		е	e	é	3
g	9	98			Ľ	e	è	Š
h	1	18			i	e	ê	8
1	1	1	^	^	u	e	Ë	8
j	ż	of See Kale			e	i		1
k	R	X		×	,	i	1	1
1	1	90	2		i	i	÷	Ĵ
m	m	Va			u	i	v	j
n	~	K	Ĺ	~	n	n	ž.	×
-	0	0		Ø	1	0	6	Á
0		6	ø	10	e	-		ó ò õ ô
P	r	(,	-	8	Ė	0	ò	0
q	9	9	at		n	0	õ	0
r	*	K	8	900	i	0	ô	0
s		@ XD.B)8 †		u	0	ö	ö
t	t	4	1	~	e	u	ú	ú
u	~	u				u	ù	ù
v	~	γ			i	u	a	û
w	~	1 x y x x y &		-	u	u	ii.	ü
x	×	10	4		u	y		Ÿ.
		2	V		Ľ.	2	7	
y	7	1	¥ E		14	coef	9954	musp me of the
Z		0	C	G	97	***	LYWK!	المال عال عد
1	4		i	3	0	B	C908	34
2	2	@	TA	Jan Jan	4	34	8118	£2.2
3	3	\$	£	3	4	m K	009	Pos
	4	\$	6200		9	ūγ	WY	55.7
4		%	8	h		0	10.	200
-	5							
5 6	5	^	É	K		30	\$ 4	E
5	6	^	K.	K		26	300	w w
5 6 7	6		۲	* * *	0	RE	200	i te Y
5 6 7 8	6 7 8	*	K.	F	12	配	36789	1005E
5 6 7 8	8 9	^ &s *	۲	F	12 74	を対け	twe	1005E
5 6 7 8 9	8 9	*	۲	* 9 9 · ·	() 12 xx e)	を対り	twe	1005E
5 6 7 8 9 0	8 9	()	Ť	7	() 12 xx e)	を対け	twe	1005E
5 6 7 8 9 0	9	()	· ·	F	() 12 xx e)	を対り	twe	1005E
5 6 7 8 9 0	9	()	- 4	9-1-18	() 12 xx e)	を対り	twe	0014 0014 0014
5 6 7 8 9 0	9	()	· ·	7	し なずもにいる	かりかられ	900* † 4711:11:3 +=	1005E
5 6 7 8 9 0 -	6 7 8 9 • • • • •	() : {	- 4	9-1-18	(2 x + 0 17 17 64 66	10 1 1 1 1 1 1 1 1 1 1 1 1 1 1 1 1 1 1	900 + 1.	0613 0613
5 6 7 8 9 0 -	9	() : {	- 4	9-1-18	(2 x + 0 17 17 64 66	かりかられ	4 - + =	OLILI BOTA OLILI BERRELL BERRE
5 6 7 8 9 0 - ; [=	6 7 8 9 • • • • •	()		\$ 1 - E	C 12 14 0 19 1/ 66 60 C	2 + 5 + 5 + 5 + 5 + 5 + 5 + 5 + 5 + 5 +	ξμ© 90*†. μηπιτης μηπιτης μαςιέε μαςιέε μασιώ Δάι ΕΕΕ	01113 01113 01113 7000 7000 7000 7000 70
5 6 7 8 9 0 - ; [=	6 7 8 9 • • • • • • •	() () : £ + }	- A	\$ 1	C 12 14 0 19 1/ 66 60 C	10 1 1 1 1 1 1 1 1 1 1 1 1 1 1 1 1 1 1	ξμ© 90*†. μηπιτης μηπιτης μαςιέε μαςιέε μασιώ Δάι ΕΕΕ	01113 01113 01113 7000 7000 7000 7000 70
5 6 7 8 9 0 - ; [=	6 7 8 9 • • • • • • •	* () ; ; ; ; ; ; ; ; ; ; ; ; ; ; ; ; ; ;	- 4	\$ 1 - E	(12 x e 1 1 1 / 44 60 00 60	2 - 3 + 5 + 5 + 5 + 5 + 5 + 5 + 5 + 5 + 5 +	ine séé	oopse Ocifi Ocifi Auga Jae Jijija Auga Au
5 6 7 8 9 0 - ; [=	6 7 8 9 • • • • • • •	() () : £ + }		\$ 1	1 1 1 1 1 1 1 1 1 1 1 1 1 1 1 1 1 1 1	2 + 5 + 5 + 5 + 5 + 5 + 5 + 5 + 5 + 5 +	ξμ© 90*†. μηπιτης μηπιτης μαςιέε μαςιέε μασιώ Δάι ΕΕΕ	oopse Ocifi Ocifi Auga Jae Jijija Auga Au

Cherecter		matives	Notes & Tip
	Altern. 1	Altern. 2	1. Due to the lavish forms of
9	0		trinelli, the font is relationall within its em-square. C
2	9		pared with "normal" typefa Feltrinelli is about a half t
			Feltrinelli is about a half t third smaller (depending whet
1	1		you measure the x- or the c
-1	,	-	height). That means: 30 poi size of Feltrinelli is equival
6	ap	8	to 10-14 points size of m
9	9	14	other fonts. Also, due to the
	0	20	x-height, the leading appe unusually large (although the
R	R	E	ternative characters need t
	0		space). In order to get comp settings you will need to set
1	9		trinelli e.g. with 24/16 poir
			instead of 24/29.
	00		2. The use of alternative char
r	1		ters (as listed left) will or many attractive typographic
			tions:
*	-		Curly special mind, this
	20		3 0 V'
*	4		Curly afrected mind, their
			3. The capital alternatives
×	*		designed for use with vowels:
	-		Lazy Lazy Estias Folia
Xo	8		Lary Lary Corrac Cores
			 There is no aesthetics for capital letters. If you must ca
%	Q,		talize, you will need manual
20	~		justments. Feltrinelli has
			kerning pairs (manually edite so most of the other combi
ъ	3		tions should come out well.
ъ •	ŧ		tions should come out well.
ъ	ŧ W	ın	tions should come out well.
ĕ A	ž LM	ւթ	tions should come out well.
A	M	ıp	lifier
A	M	L	lifier
A	M	lp	lifier
A	M	lp weights	lifier
A fami	LM Ity with 2	1e	tions should come out well. Lifier (6 styles-1,000 different char
A fami	LM Ity with 2	1e	tions should come out well. Lifier (6 styles-1,000 different char
A fami	ly with 2	1e	tions should come out well. Lifier (8 styles—1,000 different chai Cifier C
A fami	ly with 2	1e	tions should come out well. Lifier (8 styles—1,000 different chai Cifier C
A fami	ly with 2	1e	tions should come out well. Lifier (8 styles—1,000 different chai Cifier C
A fami	ly with 2	1e ol	tions should come out well. Lifier (8 styles—1,000 different chai Cifier C
A fami	ly with 2	de ne element oL	tions should come out well. Lifier (8 styles—1,000 different char et simmed and express in the company of the
A fami	ly with 2	de ne element oL	tions should come out well. Lifier (8 styles—1,000 different char et simmed and express in the company of the
A fami	ly with 2	de ne element oL	tions should come out well. Lifier (8 styles—1,000 different char et simmed and express in the company of the
A fami	In the second se	de ne elemente de la colonia d	tions should come out well. Lifier (8 styles—1,000 different characteristics—1,000 different
A fami	In the second se	de ne elemente de la colonia d	tions should come out well. Lifier (8 styles—1,000 different characteristics—1,000 different
A fami	In the second se	de ne elemente de la colonia d	tions should come out well. Lifier (8 styles—1,000 different characteristics—1,000 different
A fami	In the second se	de ne elemente de la colonia d	tions should come out well. Lifier (8 styles—1,000 different char et simmed and express in the company of the
A familiary of the state of the	In It with 2 in the state of th	dene etemologie	tions should come out well. Lifier (8 styles—1,000 different characteristics—1,000 different

13

15

ABCDEFGHIJKLMNOPQRSTUVWXYZabcdefghijklmnopqrstuvwxyz

ABCDEFGHIJKLMNOPQRSTUVWXYZabcdefghijklmnopqrstuvwxyz

ABCDEFGHIJKLMNOPQRSTUVWXYZabcdefghijklmnopqrstuvwxyz 1234567890

Typefaces belonging to the font Trilogy DTC Hermes, Imperial and Joker. All the fonts have the same width. ABCDE

Type design: Volker Schnebel, 1997 _DTC Joker Light, Regular, Bold _DTC Hermes Light, Bold

(URW)++

Location_Hamburg, Germany

Established 1995

Founders_Svend Bang, Hans-Jochen Lau, Peter Rosenfeld
Dr Jürgen Willrodt

Type designers_Bigelow & Holmes, Frank Blokland, Albert Jan Pool Volker Schnebel, Gerard Unger, Jovica Veljović Hermann Zapf and many more

Distributors_URW America, (URW)++ France, (URW)++ España (URW)++ Australia, AIT, FontShop International (FSI)

The whole world of type!

(URW)++ is still a young enterprise that intends to establish itself further in the graphic design industry by continually developing and marketing innovative font and software products. In addition to the PostScript and TrueType font program, which consists of more than 3500 typefaces, (URW)++ offers services such as digitization of fonts and logos based on artwork, special character layouts and formats, multimedia fonts, production of personal scripts and corporate type design. (URW)++ also offers a collection of 4500 popular logos and symbols and supplies fonts from numerous other foundries, for instance Adobe, Agfa, Emigre, FontBureau, Linotype-Hell and Monotype.

The company's software products include Signus, a lettering system for signmakers; Linus, a program for the automatic digitization (auto-tracing) of logos, signets, pictograms and line art; and Ikarus, a system for the professional design and production of digital fonts. The company will develop and license new versions of Ikarus to meet the requirements of Asian markets, as well as the production demands of high-quality screen representation.

URW Design collection and CD-ROM, 1994 catalogue: 21 x 29.7 cm 681 pages

Design: Sigrid Büter

XI

IOPORST

URW | collection

Pages from <u>URW Design</u>
<u>collection</u>, 1994
21 x 29.7 cm

Design: Sigrid Büter
Type design: Joseph Churchward _Churchward Brush Regular Italic
Georg Trump _City Stencil D medium

ALLES MÜLLER? SCHÖN WÄR'S!

ALLES MÜLLER? SCHÖN IST ES! City Stencil D medium

ABCDEFGHIJ KLMNOPQSTV URWXYZ abcdefghijklm nopqrstuvwxyz 1234567890

ÄÄÄÁÁÄÇËÈÉÊ ÏÌÍÎÑÖÒÓÔÕ ÜÙÚÛŸÆŒØ ääàáâãçëèéêïìíîñöòóôõ üùúûÿæœøıß

.,:;... ---'',"" / <>«» !? £\$¢% & [*†§¶] (B@™)

URW DeSign Collection

ntiane

Pages from <u>URW Design</u>
collection, 1994
21 x 29.7 cm

Design: Sigrid Büter
Type design: Aldo Novarese _Stop Round D

Alan Birch _Rubber Stamp Solid T

Sand Wycht,?

ABCDEFGHUCLMNOPORSTUVWXYZ

1234567890 £5¢% &---.;;...",""/ O«» !? [*†\$¶] (®©™)

ÀÄÀÁÁÁÇËÈÉÉÏÌÍÎÑÖÒÓÔÕÜÙÚÛŸÆŒØ

DIE ERFAHRUNG VON URW AUF DEM GEBIET DER SCHRIFTZEICHEN-HERSTELLUNG INNERHALB DES ICARUS SYSTEMS UMFASST JETZT MEHR ALS 20 JAHRE. MIT DEN MANNIGFALTIGEN MÖGLICHGEITEN DER MODI-FICATION UND DES INTERPOLIERENS WURDEN NEUE WEGE FÜR DIE ENTWICCLUNG VON GANZEN SCHRIFTFAMILIEN AUSGEARBEITET. URW RUBBER STAMP SOLID T

ABCDEF GHIJKLM NOPQSTV URWXYZ 123456789

ÅÄÄÁÄÄÇËÈÉÊ ÏÌÍÎÑÖÒÓÔÕ ÜÙÚÛŸÆŒØ

£\$¢% & [*†§¶]

URW DeSign Collection

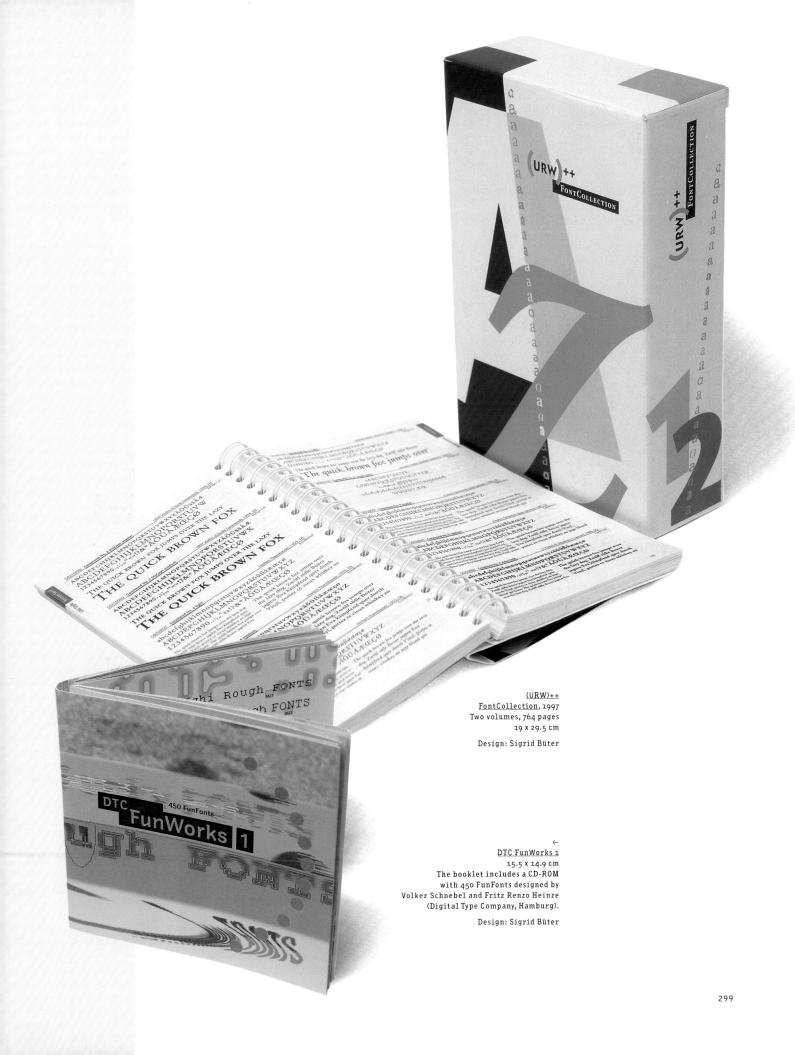

Catalogue, 1997 21 x 29.7 cm Design|Type design: Jonathan Barnbrook _Delux _False Idol Plain, Script

Virus

Location_London, UK

Established_1997

Founder|Type designer_Jonathan Barnbrook

Distributors_Virus, Fontworks

love first, money last

The philosophy of Virus is to produce experimental typography without consideration for commercial gain. It is not governed in any way by the desire to make money. The printed work Virus produces is a vehicle to make people think about the cultural and political place of a graphic designer, to draw them out of the vacuum that they work in most of the time.

Virus was founded by Jonathan Barnbrook, a font designer, graphic designer and advertising director. He releases his typefaces through his own foundry and is known for the fonts Exocet and Ma(n)son, released by Emigre. He recently finished designing the major monograph on Damien Hirst entitled <u>I Want to Spend the Rest of My Life Everywhere with Everyone</u>, One to One, Always, Forever, Now.

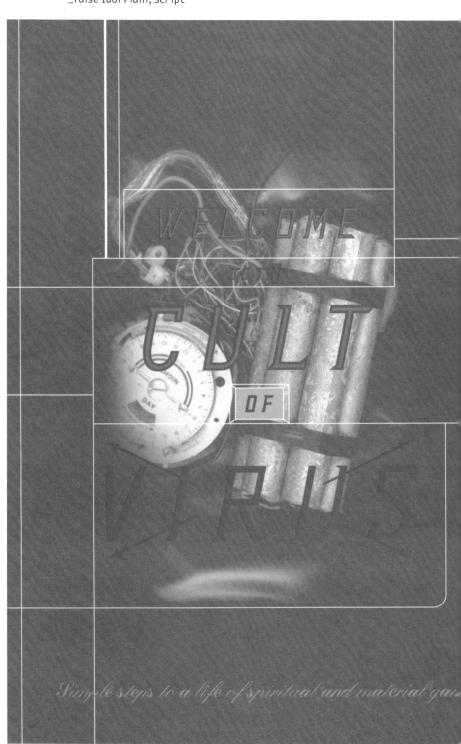

Pages from the catalogue, 1997 21 x 29.7 cm

Design | Type design: Jonathan Barnbrook _NixonScript

- _Patriot
- _False Idol Plain, Script
- _Drone

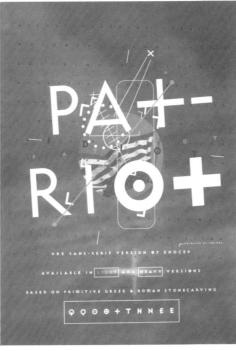

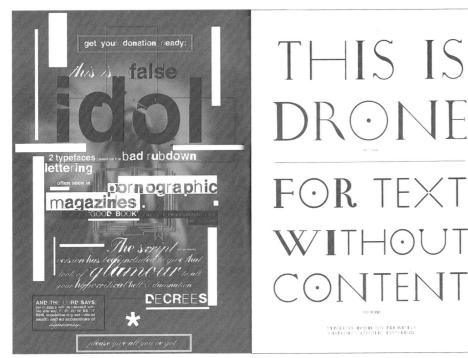

Back of the catalogue, 1997 21 x 29.7 cm

Design|Type design:Jonathan Barnbrook _False Idol Script

CONGI

¥өи н THE

NOW YOU A CONTACT AF AS ALL OU

Website, 1998 www.virus.net

Design: Jonathan Barnbrook/axcess media Type design: Jonathan Barnbrook _Draylon

_Patriot

_Delux

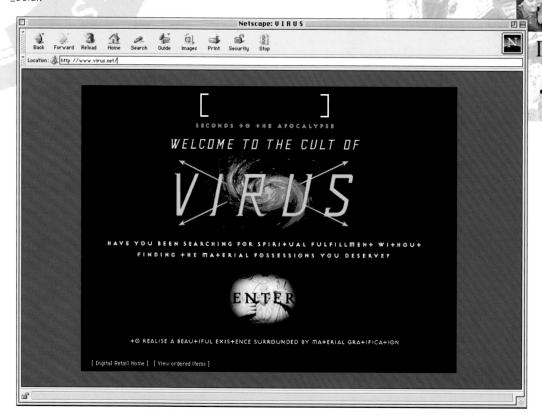

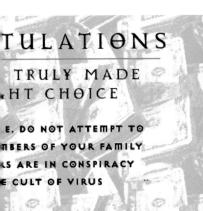

タ ρ c d δ t g fi i j K L M

ZIWDIILH OII WAQUINC

ZIWDIIEH PII WAPNINC

Click the graphic to place on order

prozec is a way of simplifying your life. prozec take things back to basics prozec is a foolish experiment, prozec affects the meaning of what you say prozec takes the alphabet down to six basic shapes, prozec forms were designed by scientists in strelle environments without ethics, prozec is available without prescription in life and max versions.

CHOOSE DESTINY

Specimens presented on the website, 1998.

Design | Type design: Jonathan Barnbrook _Prozac

- _False Idol
- _Nylon/Draylon
- _NixonScript
- _Drone
- Patriot

False Idol

ABCDEFG abcdefghij

ABCDEFG abcdefghijklm

Confess your sins to the False idol

Confess your sins to the False idol

Click the graphic to place on order

false idol is an illusory object of worship, a failed attempt at glamourise your life bed rubdown lettering taken from 1970s pomographic magazines [which i haven't seen] that try to mimic an atmosphere of elegance and sophistication but achieve only a seedliness.

NYLON + DRAYLON

GHIKLM GHII

TYPE FOR MANIC DEPRESSIVES

TYPE FOR MANIC DEPRESSIVES

Click the graphic to place on order

nylon is taken from letterforms in paintings from the 13-16th century, they seemed to have this manic range of shapes which had very little to do with the classic ideal draylon is much more restrained based on 17-18th century letterforms, both have been drawn to reflect they were produced on a computer and designed so that you can mix or plunder letterforms from different centuries in the same word.

<u>abcd&FGHU</u>K <u>ahedefghijklm</u>r

Tolllian with Mixon Script Tall lies with Nixon Script

Click the graphic to place on order

nixonscript is very loosely based on a piece of lettering seen on an old 1960s camera bought in a junk shop, it is typography from the vatican [piety] that meets "the price is right" [self-celebration], nixonscript is for while piec with.

DRONE

A B C D F F G

FOR TEXT WITHOUT CONTENT

FOR TEXT WITHOUT CONTENT

Click the graphic to place on order

drone is something you just don't want to hear, drone is a primitive senif font based on lettering seen in hispanic catholic churches, drone is a religious dogmae spoken at you for hours on end, drone is the sound of impending disaster, drone is a technology that is programmed to kill all life-drone is available in cut number 666 or 9021.

PA+RIO+

E В Δ

SHOOT 'EM DOWN WI+H PATRIOT

SHOOT 'EM DOWN WI+H PATRIOT

Click the graphic to place on order

petriot is a stupid unthinking being that shouts the same message, patriot is the sans version of 'exocet', a font released through emigre. [patriot missiles shoot down other missiles, so there must be some logic there] petriot letterforms are based on primitive greek stonecarving.

__Addresses

2Rebels
4623 Harvard
Montreal, Quebec, H4A 2X3
Canada
T +1/5 14/4 81 09 84
F +1/5 14/4 86 86 57
E info@2rebels.com
W http://www.login.net/2rebels

Adobe Systems
345 Park Avenue
San Jose, CA 95110-2704, USA
T +1/408/536 6000
F +1/408/537 6000
W http://www.adobe.com/type/

Agfa/Creative Alliance
90 Industrial Way
Wilmington
MA 01887, USA
T +1/978/658 5600
F +1/978/657 8568
W http://www.agfahome.com

Apply Design Group Thomas Sokolowski Krugstraße 16 30435 Hannover, Germany T +49/511/4 85 02 90 F +49/511/4 85 02 99 W http://www.apply.de

Bitstream
Athenaeum House
215 First Street
Cambridge, MA 02142, USA
T +1/617/520 8627
F +1/617/868 0784
W http://www.bitstream.com

brass_fonts Friesenwall 24 50672 Cologne, Germany T +49/221/2 57 77 33 F +49/221/2 57 77 03 W http://www.brass-fonts.de

Command (Z)
Ian Swift (Swifty)
Unit 66, Pall Mall Deposit
124-128 Barlby Rd
London, W10 6BL, UK
T +44/181/968 1931
F +44/181/968 1932
W http://www.swifty.co.uk

Creative Alliance /
Monotype Typography
Unit 2, Perrywood Business Park
Salfords, Redhill, Surrey
RH1 5DZ, UK
T +44/1737/765 959
F +44/1737/769 243
E enquire@monotypeuk.com
W http://www.monotype.com

Device
Rian Hughes
6 Salem Road
London, W2 4BU, UK
T +44/171/221 9580
F +44/171/221 9589
W http://www.devicefonts.co.uk.

Dutch Design
Albert-Jan Pool
Phoenixhof
Ruhrstraße 11
22761 Hamburg, Germany
T +49/40/85 37 43 00
F +49/40/8 51 53 08
E farbtontm@aol.com

Dutch Type Library
Kruisstraat 33
5211 DT 's-Hertogenbosch, The Netherlands
T +31/73/6 14 95 36
F +31/73/6 13 98 23
E dtl@euronet.nl

Elliott Peter Earls
82 East Elmstreet
Greenwich, CT 06830, USA
T +1/203/861 7075
F +1/203/861 7079
E elliott@www.theapolloprogram.com
W http://www.theapolloprogram.com

Elsner+Flake Friedensalle 44

22765 Hamburg, Germany T +49/40/39 88 39 88 F +49/40/39 88 39 99 W http://www.ef-fonts.de W http://www.ef-fonts.com

Emigre Zuzana Licko 4475 D Street

Sacramento, CA 95819, USA

T +1/916/451 4344 F +1/916/451 4351

W http://www.emigre.com

Face2Face xplicit ffm Ludwigstraße 31

60327 Frankfurt a.M., Germany

T +49/69/97 57 27-0 F +49/69/97 57 27-27

W http://www.xplicit.de/xxface2face.html

Face2Face Moniteurs

Nollendorfstraße 11/12 10777 Berlin, Germany T +49/30/2 15 00 88 F +49/30/2 15 00 89

W http://www.moniteurs.de

Faith
Paul Sych

1179a King St. West. # 202 Toronto, M6K 3C5, Canada T +1/416/539 9977

F +1/416/539 9255 E faith@faith.ca

Font Bureau

326 A Street, Suite 6C Boston, MA 02210, USA T +1/617/423 8770 F +1/617/423 8771

W http://www.fontbureau.com

fontBoy

Aufuldish & Warinner 183 the Alameda

San Anselmo, CA 94960, USA

T +1/415/721 7921 F +1/415/721 7965 E bob@fontboy.com W http://www.fontBoy.com FontFabrik

Apostel-Paulus-Straße 32 10823 Berlin, Germany T +49/30/78 70 30 97 F +49/30/78 70 58 78

W http://www.FontFabrik.com

Fontolgy

Fabrizio Schiavi Via Vignola, 31 29100 Piacenza, Italy T +39/0523/75 89 34 F +39/0523/75 89 34

W http://www.agonet.it/fabrizioschiavi/tve.htm

Fontolgy

Alessio Leonardi Böckhstraße 21 10967 Berlin, Germany T +49/30/69 80 93-3 F +49/30/69 80 93-55

W http://www.leowol.de/alessio/types.html

FontShop International (FSI)

Bergmannstraße 102 10961 Berlin, Germany T +49/30/69 58 95 F +49/306 92 88 65 W http://www.fontShop.de

The Foundry Studio 12

10-11 Archer Street London, W1V 7HG, UK T +44/171/734 6925 F +44/171/734 2607

E dqfs@thefoundrystudio.co.uk

GarageFonts P.O. Box 3101

Del Mar, CA 92014, USA T +1/619/755 4761 F +1/619/755 4761

E info@garagefonts.com W http://www.garagefonts.com

garcia fonts & co.
P.O. Box 167
08107 Martorelles
Barcelona, Spain
T +43/93/5 79 09 59
F +43/93/5 79 09 59

E typerware@seker.es

W http://www.typerware.com/garciafonts

House Industries

P.O. Box 30000

Wilmington, DE 19805-7000, USA

T +1/302/888 1218

F +1/302/888 1605

W http://www.houseind.com

ITC (International Typeface Corporation)

229 East 45th Street

New York, NY 10017, USA

T +1/212/949 8072

F +1/212/949 8485

W http://www.itcfonts.com

kametype

Joachim Müller-Lancé

1635 Mason Street #3

San Francisco, CA 94133, USA

T +1/415/931 3160

F +1/415/931 3160

E kame@wenet.net

Alessio Leonardi

Leonardi.Wollein

Böckhstraße 21

10967 Berlin, Germany

T +49/30/69 80 93-3

F +49/30/69 80 93 - 55

W http://www.leowol.de/alessio/types.html

LetterPerfect Fonts

Garrett Boge

526 First Ave. S. #227

Seattle, WA 98104, USA

T +1/206/467 7275

F +1/206/467 7275

W http://www.letterspace.com/

LETTERPERFECT FONTS

LettError

Erik van Blokland

Molenstraat 67

2513 BJ The Hague, The Netherlands

T +31/70/3 60 50 25

F +31/70/3 10 66 85

E erik@letterror.com

W http://www.letterror.com

LettError

Just van Rossum

Koediefstraat 17

2511 CG The Hague, The Netherlands

T +31/70/3 62 51 47

F +31/70/3 46 29 76

 $\hbox{\tt E just@letterror.com}$

W http://www.letterror.com

lineto

Cornel Windlin

Pfingstweidstraße 6

8005 Zürich, Switzerland

T +41/1/2 71 90 66

F +41/1/2719065

E cornel@lineto.com

W http://www.lineto.com

lineto

Stephan Müller (Pronto)

Lützowufer 12

10785 Berlin, Germany

T +49/30/26 48 02 82

F +49/30/26 48 02 82

1 +47/30/20 40 02 02

E pronto@lineto.com

W http://www.lineto.com

Linotype Library

Du-Pont-Straße 1

61352 Bad Homburg, Germany

T +49/61/72 48 44 24

F +49/61/72 48 44 29

E Linotype@internet.de

W http://www.LinotypeLibrary.com

LUST

Pastorswarande 56

2513 TZ, The Hague, The Netherlands

T +31/70/3 63 57 76

F +31/70/3 46 98 92

W http://www.lust.nl

0ptimo

24 Côtes de Montbenon 24

1003 Lausanne, Switzerland

T +41/21/3 11 51 45

F +41/21/3 11 52 03

E service@optimo.ch

W http://www.optimo.ch

Dennis Ortiz-Lopez

267 west 70th street / #2-C

New York, NY 10023, USA

T +1/212/877 6918

F +1/212/769 3783

E sini4me2@soho.ios.com

W http://soho.ios.com/~sini4me2

ParaType

47 Nakhimovsky Ave, 19th floor

Moscow, 117418, Russia

T +7/95/3 32 40 01

F +7/95/1 29 09 11

E fonts@paratype.com

W http://www.paratype.com

Porchez Typofonderie

38 bis avenue Augustin-Dumont

92240, Malakoff, France T +33/1/46 54 26 92

F +33/1/46 54 26 92 E jfporchez@hol.fr

W http://www.porcheztypo.com

Fabrizio Schiavi Via Vignola, 31

29100 Piacenza, Italy T +39/0523/75 89 34 F +39/0523/75 89 34

W http://www.agonet.it/fabrizioschiavi/tve.htm

Stone Type Foundry 626 Middlefield Road Palo Alto, CA 94301, USA T +1/650/324 1807

+1/800/557 8663 F +1/650/324 1783 E stonefndry@aol.com

Judith Sutcliffe

The Electric Typographer

P.O. Box 224

Audubon, IA 50025, USA T +1/712/563 3799 F +1/712/563 3799 E electtype@aol.com

[T-26]

Carlos Segura

1110 North Milwaukee Avenue, 1st Floor

Chicago, IL 60622-4017, USA

T +1/773/862 1201 F +1/773/862 1214 E T26font@aol.com

W http://www.T26font.com

Thirstype

117 South Cook #333 Barrington, IL 60010, USA T +1/847/842 0222

F +1/847/842 0220 E Thirstype@aol.com W http://www.3st.com

Type-Ø-Tones Sant Agustí, 3-5, 3d 08012 Barcelona, Spain T +34/93/2 37 68 56 F +34/93/4 16 15 88

E info@type-o-tones.com W http://www.type-o-tones.com Typerware

Anselm Clavé, 7

08106 Santa Maria de Martorelles

Barcelona, Spain T +34/93/5 79 09 59 F +34/93/5 79 09 59

E typerware@seker.es W http://www.typerware.com

Typerware

Bertrellans, 4 baixos 08002 Barcelona, Spain T +34/93/3 02 40 27 F +34/93/3 02 40 27 E typerware@seker.es

W http://www.typerware.com

Typomatic

Ian Swift (Swifty)

Unit 66, Pall Mall Deposit

124-128 Barlby Rd London, W10 6BL, UK T +44/181/968 1931 F +44/181/968 1932

W http://www.swifty.co.uk

Gerard Unger Parklaan 29A

1405 GN Bussum, The Netherlands

T +31/35/6 93 66 21 F +31/35/6 93 91 21

U.O.R.G. Frank Heine

Seidenstraße 65

70174 Stuttgart, Germany T +49/7 11/2 23 89 37 F +49/7 11/2 23 89 38 E frank@uorg.com

(URW)++

Design & Development Poppenbütteler Bogen 29A 22399 Hamburg, Germany T +49/40/60 60 50 F +49/40/60 60 51 11

W http://www.urwpp.de

Virus

Jonathan arnbrook 10 Archer Street London, W1V 7HG, UK T +44/171/287 3848 F +44/171/287 3601 W http://www.virus.net

__Type designers

Albers, Josef _137 Alexei, Tylevich _134 Andresen, Mark _79

Aufuldish, Bob_81,102,103,104,105

Baar, Lutz _200 Bain, Mike _141,143

Balius, Andreu _148,149,150,151,152,

153,154,272,275,276 Barber, Ken _157,161 Barendse, Jeroen _204,206 Barjau, Joan _264,269

Barnbrook, Jonathan _300,301,302,303

Bastien, Annie _19 Beiße, Petra _73

Benton, Morris Fuller _132
Bergmann, Sine _200
Berlow, David _113
Birch, Alan _298
Blokland, Frank E. _60,61
Boge, Garrett _181,182
Booth, Tony _125,126
Boss, Steven _30
Boton, Albert _24

Brand, Chris_61

Brody, Neville _125,130,134,135

Bruhn, Peter _248
Burlile, Marcus _248
Butterick, Matthew _114
Cabarga, Leslie _110,113,114
Carichini, Mauro _247

Casasin, Joan Carles P. _272, 275, 276

Castro, Thomas _204,206 Cavazos, Rodrigo _247 Chekoulaev, Alexej _201 Chester _256,257,260 Churchward, Joseph _297 Closs, James _248 Critchley, John _124,126 Crow, David _134 Crouwel, Wim _136

Cruz, Andy _156,157,158,159,160

czyk _90,93,94,96
Da Lomba, Luiz _248,208
Darden, Josh _145
Daucher, Vera _134
Dávilla, Juan _264,266,270
de Bara, Adela _266,270

de Groot, Luc(as) _116,117,118,125,126

de Roos, Sjoerd _60
Dean, Jeremy _157,159,160
Deck, Barry _254,257,259

Delgado, Stéphane _212,213,215 di Sciullo, Pierre _25,124,126,134,135

Diesel, Chank _208 Donaldson, Tim _20 Donelan, Eric _81 DS Design _208

Dulude, Denis _16,17,18,248

Earls, Elliott Peter _62,64,65,66,67,68,69,70

Ellenberger, Hans Jürgen _201

Elliman, Paul _134 Enami, Naomi _134 Erler, Johannes _126 Evans, Jean _113

Faulkner, Kirsten _160,161

Fehsenfeld, Rodney Sheldon _140,142,143

Ford, Frank _257,260 The Foundry _136 Frahm, Manuela _73

Fuchs, Andrea _60

Frere-Jones, Tobias _43,110,112,113,134 Frutiger, Adrian _8,59,196,198,200

Function _134,135 Gallardo, Miguel _263 Gavillet, Gilles _212,213,215 Gehlhaar, Jens _29,31 Gerlach, Verena _72 Giasson, Patrick _18 Gilardino, Fabrizio _17 Glaser, Timothy _145 Goudy, Frederic _208,211 Goulsbra, Roland John _201 Grimshaw, Phill _165,167 Grundy, Peter _134 Hägerling, Stefan _130

Heine, Frank _134, 247, 291, 293, 294

Heiß, Florian _134,135 Hersey, John _83 Hingston, Tom _134 Hoffmann, Thomas _201 Holzman, Elizabeth Cory _114

Hansson, Lennart _24,43

Hauser, Stefan _93,96

Hoppe, Jessica _72

Hughes, Rian _46, 48, 51, 53, 55, 57

Iontef, Yanek _28
Jalleau, Franck _24,25

Jardi, Enric _263,264,266,268,270

Jones, Sam _134
Kahan, Teri _167
Karl, Andreas _201
Kelly, Brian _140,141,142
King, Mary Ann _145
King, Patric _254,257
Klein, Manfred _31
Kurz, Dieter _200

Kuznetsova, Lyubov _222

Laberge-Milot, Marie-F. _16,18,19

Leary, Mike _32 Leif, Thomas _201

Leonardi, Alessio _90,93,96,120,123,

124, 176, 178, 200, 201

Licko, Zuzana _76,79,81,83,84,85 Linotype Designstudio _196,198 Lipton, Richard _20,43,110,115

Lucid, Brian _114
Maestre, Jennifer _33
Mahdavi, Monib _247
Majoor, Martin _125,126
Matteson, Steve _43,208,211

Mazzei, Nancy _141 Melichar, Uwe _73

Mercer, Allen _156,157,158,159,160,161

Meseguer, Laura _264, 266, 270 MetaDesign Berlin _130 Michels, Nicole _161 Miedinger, Max _198 Miladinov, Slobodan _167

Mitch _284,285 Moniteurs _134

Monotype Typography _210

Morelli, Anna _17

Müller, Stephan _125,126

Müller-Lancé, Joachim 20,172,173

Munch, Gary _198
Nagel, Thomas _90,93,96
Nehl, Haike _90,93,96
Niemeyer, Dan-André _201
Nineuil, Olivier _24
Novarese, Aldo _208

Novarese, Aldo _298 Nowak-Nova, Dariusz _200 Oehlerking, Harald _28 Olyff, Clotilde _18

Ortiz-Lopez, Dennis _216,217,219

Pendrell, Frank _32
Pool, Albert-Jan _58,59

Porchez, Jean-Francois _224, 225, 226, 227, 229

Puyfoulhoux, Thierry _24
Python _184,186,188,189
Quay, David _136,137
Randle, John _134
Reichel, Hans _125

Rickner, Tom _42 Robbins, Dave _32

Roe, Adam _248 Ros, Jaume _266 Rust, David _215 Ryan, George _32

Sack, Freda _136,137 Safaev, Tagir _220

Sagorski, David _168,169 Scarano, Jane _208 Schäfer, Ole _124,126,130

Schiavi, Fabrizio _120,122,123,275,276

Schlaich, Sibylle _93 Schnaebele, Thomas _145 Schnebel, Volker _296,299 Schneider, Guido _34,35 Scholing, Alex _126

Schönecker, Anna-Lisa _134,135

Schöpp, Simone _130 Scott, Darren _134 Scott, Jake _208 Shaw, Paul _181, 182 Siddle, John _124 Siegel, David _21

Slimbach, Robert _20,21,23 Smeijers, Fred _60,124

Spiekermann, Erik _124,125,126,130,166

Stebbing, Francis _134 Stein, Olaf _126

Stone, Sumner _240,241 Sutcliffe, Judith _242,243

Swifty $_{2}6,37,38,40,280,281,282,283$

Tarbeev, Alexander 220,222

Sych, Paul _98,101,125,257 Synstelien, Don _28 Szumilas, Ted _42

Taylor, Christine _145
Thompson, Greg _260
Tillmann, René _35
Torrent, Pere _264
Trump, Georg _297
Tschichold, Jan _137
Twombly, Carol _21,23
Tylevich, Alexei _134
Type-Ø-Tones _262

Typerware _148,150,151,152,154,155

Ungarte, Gustavo _145

Unger, Gerard _61, 286, 287, 288, 289 Urós, José M. _263, 266, 270

Valicenti, Rick _256, 257, 259, 260

van Blokland, Erik _124,125,184,186,188,189

van Krimpen, Jan _60,61

van Rossum, Just _124,125,184,186,188,189

Veljović, Jovica _21,22 Verheul, Peter _125 Vermeulen, Rick _134 Voss, Svenja _200,201 Warinner, Kathy _102
Warren, Peter _124
Wasco, Jim _21
Wass, Chip _252
Waters, Julian _20
Weeb, Malcolm _153
Weisheit, Thorsten _201
Weltin, Jürgen _136
Wenzel, Martin _125
Wickens, Brett _134
Windlin, Cornel _125,126
Wozencroft, Jon _134
Wright, Ian _40
xplicit ffm _132,134

__Fonts

2Rebels Deux_17 2Rebels Un_17, 18 A Lazy Day_130 Adelita 266 Adelita dibujitos_270 Adobe Jenson_21 Agency_113 Agrafie_201 Agrofont_116 Albertina 61 Ale Ornaments_201 Alexie 201 AlRetto_90 Alternativo Franklin Gothic_178 Amanda Bold_42 Amnesia_35 Amoeba 124 Amoebia_29 Amorpheus_55 Amplifier_247,293,294 Amsterdam_120,123 Angie Sans_226 Anisette_226 Anorexia_35 Apolline_224,225 Aranea_72 Architype Albers_137 Architype Tschichold_137 Arepo_240,241 Argo_61 Armature_103,104 Aspera_28 Asphalt Black_43,112 Aurora CW_123 Aurora Nintendo_123 Autofont_57 Autologic_212 Avalon_43 Babymine_247

Bariton_201 Base Monospace_76 Base Nine_81 Base Twelve 81 Battery_34 Baufy_103 Baukasten_178 Beata_182 BellczykMonoMed_94 Belter_152,155 Beluga_201 Beorama_167 Beowolf_124 Berliner_134 Bickham Script_20 Big Eyed Beans_134 Bits_134 Blackcurrant_55 Bland Serif Bland_67 Blockhead_83 BoneR-Book 96 Boomshanker_124 Brok_114 Brokenscript_124 Bronzo_256,257,259 Bull_124,126 Burnout Chaos_93 Burnthouse_157 Cafe Retro_145 Calvino Hand 67 Canadian Photographer Script_140,142 Carpediem_72 CaseSeraSera_28 Chaos_134 Chip_212 Chippies_252 Chophouse_161 Churchward_297 Cicéro_24 Cicopaco_134 Citadel_113 City_134 City Stencil D_297 Coconio_167 Coltrane_282 Comedia 24 Commerce_260 Condemnedhouse_157 Condition Birth 134 Conectdadots Interleave_145 Confidential_125 Coolage Bold_291 Corpa Gothic_34 Cortada_270 Crackhouse_157,160 Cratilo_123

Cratilo Sans 178

Bad Excuse_254
Balder_200

Cresci_181,182 Crux95_134 Curlz_43

Custom type_156,157,158,159,160 Customised Foonky Starred_57

Cut It Out_280
Cuty_17

Cyber Static_134
Cyberdelic_48
Cyberotica_254,257
Czykago Light_93,96
Daly Hand_242,243
Daylilies_243
DeconStruct_31
Delux_300,302
Deseada_263,270
Desolation_291
Despatxada_266

Determination_134

Detroit_212,215 Dig_125 DIN_58 Dingbats_126 Dino_103

DIY Foundation, Skeleton_134

Dizzy_113
DNA_30
Dog_125
Doghouse_161
Dogma Outline_76,83
Dolce Vita_36,37,38,40

Dome_125
Donatello_182
Dot Matrix_125,126
Dralon_302,303
Drone_301,303
DTC Hermes_296,114
DTC Joker_296
Dualis Italic_145
Dumpster_248
Dysphasia_62,66
EbuScript_263,270
Echo_134,135
El Dee Cons_93
Electric Stamps_242

Electron_51

Elleonora d'un Tondo_120

Engine 2_126
Ergo_198
Escher_270
Ex Ponto_21,22
False Idol_300,301,303

Fat Arse_284 FaxFont_275 Feltrinelli_294 Filosofia_76 Fix_98,257 Flood_20 Flourish_243 Flux_247

Fontology [E]_122 FontSoup_151,272

Foonky Heavy, Starred_46
Foundry Gridnik_136
Foundry Journal_137
Foundry Old Style_137
Foundry Sans_136,137
Frankie_264,266,270
Franklin Gothic_132
Fred_16,18,19

Fritz Dittert_73
Frontpage Four_93
Frutiger_200
Funhouse_161
Funkhouse_160
Gagamond_31
Galaxy_32
Gallard_263,269
Garamond Cyrillic_220

Garcia_151,154 Gateway_125 Geäb Oil_234

Genetics Second Generation_134

Ghiberti_182 Giacometti_200 Gladys_141.142 Gonza Family_17 Graffio_124,176 Greene_242,243 Gulliver_286,287

Gun_98

Gunshot 6 Bore_283 Haakonsen_93 Haarlemmer_60,61 HaManga_200 Hand Job_40 Handwriter_176 Hate Note 256

Heads of the Household_161

Hegemonic_145 Ho Tom_201 Holistics_167 Horatio_158 Housearrest_157 Housemaid 161

Hypnopaedia Pattern Illustrations_76,84,85

Indecision_294
Index Italic_145
Info_124,126,130
Info Pict_130
Info Produkt_130
Insecta_242,243
Interstate_110
Intolerance_294
Irish Text_201
ITC Stone 239

Jaruselsky 34

Jesus Loves You All 116,118

Jet_59 Joost_266

Juan Castillo_152,154

Juice_168
Kabin_212
Kathouse_160
Kepler_20
Kid Type_208
Kiilani_242
Kilin_134
K.O. dirty_18
Kornkuh_212,213
Kracklite_294
Le Gararond_25
Le Monde_229
Lego-Stoned_90
Leonardo Hand_243
Letterine Archetipetti_124

License Plate_280

Linotype Univers_196,198

Littles_130 Lomba_248 Love_259

Love/Hate Note Collection_260

Lovegrid_96 Lucpicto_117 Lunar Twits_248 Lusta_51,53

LUSTBlockbuster_204 LUSTBlowout_204,206 LUSTGrotesk_206 LUSTIncidenz_204,206 LUSTPure_204,206 Mac Dings_51 Madame-Butterfly_90

Madzine-Dirt_90,96
Magneto_110
Mail Box Heavy_201
Manomessa_17
Mariam_222
Mastertext_48

Matilde Script_150,154

Matthia_200
Matto_178
Mayaruler 1_134
Mayayo_266
Me Mima_269
Mega-Family_134
Mekanik Amente_93

Menace_17
Meno_110
Meta_125
Metaplus_130
Microphone_134
Miles Ahead_36,38,40
Minimum_124,126
Minion_21

MittelczykHole_94

MMMteurs_134

Mode 01_234 Modula Remix_76 Monako Stoned_93 Monotype Bulmer_210 Mothra Paralax_68

Motive_130
Motorcity_57
MoveMe_117
Mr.Frisky_208
Myriad_21,23
Nameless_18
Narcissus_114
Naskh Ahmad_222
Nebulae_117
NeonStream_110
Network_153
Neue Helvetica_198

Nobel_60 Nobody_35 Non Linear_17 Not Caslon_79

NixonScript_301,303

NotTypeWriterButPrinter_275

NoveAteny_200 Nurse Ratchet_28 Nylon/Draylon_303 OCR-AlexczykShake_90

OCR-F_{_59} Oculus_247 Officina_166

Oldstyle Chewed_242,243

Ooga Booga_257 Opsmarckt_293,294,

Ouch!_172 Ovidius Demi_42 Oxalis_25 Ozó Type_148,150 Paradox_289,288 Parakalein_122 Parisine_227 Parkinson_151 Patriot_301,302,303 Penal Code_62,67

Perles_18
Peter Sellers_266
Petras Script_73
Petroglyph Hawaii_242

Pic Format_48
Pierre Bonnard_208
Pietra_181,182
Pizzicato_248
Plastic Man_17,248

Playtext_148,149,151,150,152,153

Poca_264 Pollock_222 Pontif_181,182 Poorhouse_157 Post_232 Postino_20 Proton 18

Prototipa-Multipla_96

Prozac_303
Pure_142,143
Quadraat_124
Radiente_140,142
Radiorama_264
Reasonist_55
Regulator_57
Rekord 125

Renfield's Lunch Dingbats_145

Repo-Thin_285

Rheostat °Celsius_257 Rheostat °Fahrenheit_257 Rian's Dingbats_53,55 RoarShock 103,104

Rocket_114 Rodchenko_220 Rondom_117 Rougfhouse_160

Rubber Stamp Solid T_298

Runa_24,43 Sale_125,126 Scala Sans_125,126 Schampel Black_243

Scherzo_24 Schmalhans_125

Schwennel lila + negro_200,201

ScratchNsniff_19 Screen-Scream_96 Scritto_17 Scübyzhouse_160 Semaphore_32 SemiSans_19 Shakkarakk_96 Sheriff_125 Shimano_115 Shinjuku_134,135

Shpeetz_90 Shuriken Boy_172,173 Shuriken Boy, Girl_173 Six Gun Shootout_248

Skrawl_280

Slice of Cake_280,281

Sloop_110 Smile_257 Smog 1_134 Snap_169 Soda Script_79 Sofa_19 SoloSans_34 Space_32 Spell Me_134,135 Spiegel_117 Stadia_55

Stamp Gothic 125

Starter Kid_93

Stoclet_167 Stop Round D_298 Streamline_113 Stroke_257,260 Styletti_93

Sublaxation Bland_68 Surveillance_134,135 Synaesthesis_132,134 Tagliatelle-Sugo_96 Tagliente_243 Teenager_140

Tekton_21
Telegraph Junction_248
The Distillation Family_69,70
The Dysphasia Family_66

The Sans Black_117

The Subluxation Family_64,65,69,70

TheMix_118,125
TheSans_117,118
TheSans Typewriter_126

TheSerif_118
Thingbat_83
ThinMan_17

Tiparracus_148,150 Toohey and Wynand_62

Tooth_141,143
Traffity_201
Transit_130
Treehouse_161
Trinity_134
Trixie Plain_125
Truesdell_208,211
Truth_254,259
Twins_90
Tyrell-Corp_90
Unica_248
Univers_196,198

Universitas Studii Salamantini_276

Useh_257
Vespasian_291
Virgile_24
Viscosity_102,105
Vision_201
Vizente Fuster_154
Warehouse_160
Washed_120
Waters Titling_20

Where The Dog is $Buried_{134,135}$

Whiplash_103,104 Whirligig_81

White No Sugar_134,135 Whole Little Universe_294

Wilma_268 Wit_98,101

Xiquets Forever_264 Xiquets Primis_264

Zeitguys_81 Zodiac_33